SANTOS AND SAINTS

SANTOS AND SAINTS

The Religious Folk Art of Hispanic New Mexico

Thomas J. Steele, S.J.

Ancient City Press
Santa Fe, New Mexico

International Standard Book Number
0-941270-84-X
Library of Congress Catalog Number
74-75452

Cover design by Connie Durand
Book design by Mary Powell

Cover illustration: El Santo Niño de Atocha (The Holy Child of Atocha, #7 in Appendix B) by Rafael Aragon (active 1820-62). This exemplary little panel must be the happy outcome of Aragon's having painted the subject many times. He won through to the total artistic control that gives the Niño his air of modest juvenile self-confidence. Aragon may have left his fingerprint at the bottom left when the paint was still moist. The Regis University Collection.

10 9 8 7 6 5 4 3 2 1

Contents

Preface

Santos and Saints is a new book, though the title has been around for exactly twenty years. Calvin Horn published *Santos and Saints: Essays and Handbook* in 1974, and in 1982 Ancient City Press issued a paperback second edition, newly subtitled *The Religious Folk Art of Hispanic New Mexico,* with an updated preface and a few necessary revisions. For this present version, I have dropped the chapter on land grants, rearranged the remaining chapters, totally rewritten everything, updated all the content (perhaps most noticeably in a few of the appendices), and added numerous references to most of the many works of excellent scholarship that have appeared in the last score of years. Consequently, this truly is a new book.

I commented in a prefatory note to the original edition that the New Mexican Hispanic culture of the mid-nineteenth century had been so unified that studying any part of it gave access to the whole. I hoped therefore that my study of the santos would significantly illuminate the life of the people by and for whom they were made, especially by highlighting the social and cultural implications of this popular religious art. I have the same hope for this new edition.

There is an old saying about persons of a later age seeing more than their predecessors because they are standing on the shoulders of giants. Gilberto Espinosa and José Edmundo Espinosa have served as the principal giants in my own career as a lover of New Mexican santos. I count myself their disciple above all, for they introduced me to the way the santos fit into the spirituality of the Hispanic people: how their people held the faith of the Church, how they led the life of Christian morality, and above all, how they said their prayers within a context composed of the sacred persons whom the santos represent and make present. The santos and

saints were and are a central component in the people's religious lives: that is what this present book is about, what its earlier versions were about.

As I said in prefacing the 1982 edition, I will always be grateful for the many nice words written and spoken about the old *Santos and Saints*. I would like in this newest version to acknowledge also my longstanding debts of gratitude to a list of good people: my family back in Saint Louis—at the wrong end of the Santa Fe Trail; the whole of the Tompkins and Barbieri clans; my Jesuit brethren at Regis University in Denver and at Immaculate Conception Church in Albuquerque; Charlie and Debbie, Larry and Alyce, Fred and Kelly, Phil and Mollie, Pat and Pauline; Nat; the Tuesday Book Club of Denver; Dr. Randy and my Regis students and Dr. Andy and my University of New Mexico students over the years; the helpful people at the Regis and University of New Mexico libraries, the archdiocesan archives of Santa Fe and Denver, and the New Mexico State Records and Archives; Jim and his friends and Bob and Aurora and their friends; and Mary and Marta at Ancient City Press. Casey Stengel admitted once, in all due humility, that he could not have won the pennant and Series without the players. So from me: thanks, team! Even if I *could* have done it without you (and I could not), it would have been far less fun.

Albuquerque and Denver
Fiesta de San Francisco de Asís, 1994

SANTOS AND SAINTS

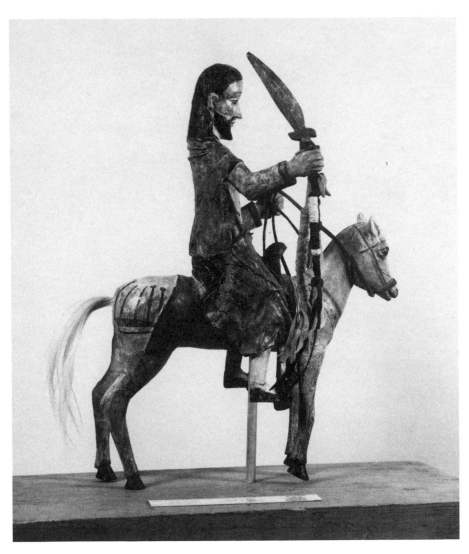

Saint James the Greater (Santiago; #115 in Appendix B) by an anonymous early nineteenth-century santero. The saint carries a couple of quirts in his sword hand. The lovely bulto, in the Santuario de Chimayó, was listed in an 1818 inventory and mentioned in Willa Cather's *Death Comes for the Archbishop*. Photo courtesy of Museum of New Mexico.

I

Holy Art, Holy Artist

The flourishing tradition of New Mexico Hispanic vernacular art began toward the end of the eighteenth century when New Mexican artisans imitated to the best of their abilities the statues, paintings, and popular prints imported from the south. These fine-art prototypes exemplified the Baroque phase of the great European Renaissance. Their New Mexican imitations differed not only in formal techniques but more importantly in their very being. A Renaissance religious painting or sculpture created in Madrid or in Mexico City, however poorly crafted, is primarily meant to be and is an aesthetic object, but its New Mexican equivalent, however artistically successful, is not. The latter has a different relationship to painter and viewer since it is meant to operate in a different range of experience from the aesthetic. It is part of religion.

The Renaissance placed so high a premium on aesthetic quality that it subordinated holiness to beauty and excluded intrinsic sacredness even from religious art. The people of the Renaissance insisted that art ought to be real*istic*, but the people of New Mexico, being still very medieval in their outlook, demanded art that was

real. To them, art was part of the religious domain; art participated
—granted, to a limited degree—in the very being, in both the
essence and the existence, of one or another of the heavenly per-
sons: God and His angels and saints. In this sense, a santo is holy
art because it was fashioned according to a holy prototype and for
a holy purpose.

The ultimate objects of imitation, then, were the sacred persons
of salvation history and of heaven. William Wroth makes a very
helpful statement: "The accounts of miraculous images 'made with-
out hands' provide the basis for the traditional theory and practice
of Christian image-making. The image which the artist creates is, in
a symbolic sense, made without hands, for its Divine prototype pre-
exists and is discovered—not created—by the artist." This discovery
occurs when the artist, united with the Divine and assisted by
grace, contemplates the heavenly person to be represented.[1]

The proximate objects of imitation were the previous portrayals
of a given subject from outside the colony, by earlier santeros, or
by the santero himself. New Mexican santero art imitated art and
not nature. Older images determined most aspects of how a par-
ticular retablo or bulto would look. For instance, San Gerónimo
was not shown as European art generally showed him, dressed as
a cardinal and seated in his study reading a book or writing at a
desk. Instead, he nearly always knelt in some nondescript space,
wearing a hermit's robe and striking his breast with a penitential
stone while the trumpet of God's voice spoke in his ear and a lion-
monster lay at his feet.

In the New Mexican santero tradition, a painting was judged
holy if it repeated the previous paintings of the same subject in its
tradition, and it thereby resembles the icon of Greek Byzantium and
Russia. The theory of icons in the Orthodox Churches was based
on the Neoplatonic doctrine of participation, and so it interpreted
the icon as a dependent entity that shared the being, holiness,
power, intelligibility, beauty, life, and purpose of its model.[2] In New
Mexico, even the relatively and naively naturalistic late-nineteenth-
century bultos developed within a folk-Platonic mentality.[3]

The tradition of the icon (and that of the santo) lay poles apart from the Renaissance, which committed itself and the art it produced to a realistic representation of the earth-archetypes that guided its era. When the Western Renaissance finally impacted Eastern-Church art, Van der Leeuw notes, "The degeneration is irremediable as soon as images of saints become portraits of saints." Symeon of Thessalonika had feared just such an outcome when he came into contact with the fifteenth-century Italian Renaissance:

> What else have [the Latin Catholics] created contrary to church custom? The sacred and august [Greek] images are devoutly offered to the believers so that they might pay due honor to their godly prototypes, according to the nature of the sacred icons and the truth of iconic appearances. For the icons depict the Word who became incarnate for our sake, all his godly works and sufferings for us, all his miracles and mysteries, as well as the most holy form of his holy ever-virgin mother, the shape of his saints, and everything that the gospel narratives and the other divine scriptures propose. And the icons teach all of this in an iconic manner, with colors and the rest of the artist's materials, a sort of alternate alphabet. But as we have said, these [Latins] change things, often making even the sacred images in some alien style, ignoring the customary rules and prettying their statues up with human hair and human clothes instead of showing them with painted hair and garments—not the *image* of hair and clothing but the hair and clothes of some actual human, certainly not the image and shape of the prototypes. And so [the Latins] create and decorate their images contrary to the pious way of doing things, thus really demeaning the holy icons, as the canon of the Seventh Ecumenical Council has it, for it forbids the manufacture of any images that cannot help simple believers. What is done contrary to order is not done aright, and the Fathers [of the Church] do not sanction it.

But what Symeon feared came to pass, and "the art of icons as painting was eliminated in favor of autonomous art, which made humans for humans." Wroth quotes Frithjof Schuon: "In the sixteenth century the Patriarch Nikon ordered the destruction of icons influenced by the Renaissance and threatened with excommunication those who painted or owned such paintings. After him, the Patriarch Joachim required by his will that icons should always be painted according to ancient models and not 'follow Latin or German models, which are invented according to the personal whim of the artist and corrupt the tradition of the Church.'"[4]

The santeros took levy of the material world, its earths and its vegetation, for the wood, gesso, and pigments from which they crafted their santos. Not being romantics, they did not view nature as sacred in itself. But when portions of nature became the substance of the holy images, these materials actuated the incarnational ability of matter to partake even of the celestial, even of the divine. Willard Hougland tells of a man who acquired a bulto of Santiago, which "came to him with almost all the hair gone. In his search for a suitable source of additional hair, his eyes lighted on a small white dog belonging to a neighbor. He obtained the needed hair, and thenceforth the dog was regarded with greatly increased respect by all of the neighbors."[5]

The painter of a retablo or the shaper of a bulto was occasionally an amateur, trying his hand at one or two works and then abandoning his career. To understand more clearly why the number of santeros is in fact quite limited, we need only consider the amount of effort a beginner would need to paint one retablo and fashion one bulto from scratch. First, the would-be santero cuts down a pine tree and digs up the roots of a cottonwood tree. After letting them dry for a couple of years, he saws off a log as long as his panel or statue is to be tall. With a hatchet, froe, or saw he shapes the front, back, and sides of the panel and roughs out the carving. Next he does some trimming of each piece of wood with a drawknife, carves the statue to within a millimenter or two of its proper shape with a pocketknife, and smoothes the front of the retablo or the front

Death-Cart (Doña Sebastiana; #143
in Appendix B) perhaps by
Nasario Guadalupe López of
Córdova. This masterpiece dates
from around 1860. Photo by Jesse
L. Nusbaum, courtesy Museum of
New Mexico, neg. #13671.

and sides of the statue with a rough stone used like sandpaper.

His next step is to manufacture gesso—the santero would have called it *yeso* or *jaspe*—by searching out some gypsum (fairly common in New Mexico), baking it to drive off all moisture, and grinding it in a mortar to extreme fineness. He then boils rabbit hides or the hoofs or horns of cattle and mixes the resulting casein glue with the powdered gypsum. He then brushes it in thin coats onto the surface of the wood and smoothes it with a smooth rock when it is dry.

The santero makes his water-base paints from various materials: some from dyes imported into the colony for tinting woolen cloth (indigo, Prussian blue, cochineal, and brazilwood), some from local earths (Zuni azurite, and red and yellow ochers and oxides), and some from local plants (chamisa, snakeweed, madderroot, walnut hulls, and juniper bark). The blacks come from charcoal and soot.

Paint brushes were variously yucca fronds or willow shoots chewed to produce the correct texture of "bristle," chicken feathers bound together, or animal hair tied in neat bunches. And if our hypothetical santero has persevered this far, he may finally begin to paint.[6]

Because our imaginary santero fashioned his images according to the religious iconography of the Spanish Empire, he formed them in such a way as to fit purposefully into the harsh but beautiful world of the *vecinos* (settlers) at the farthest and most ragged rim of Christendom. The Renaissance arrived late in Spain, so the Hispanic settlers in the New World were only lightly touched by the vision of the world which classical Greece began and the Renaissance completed. The few external influences that brought themselves to bear in the outlying colonies such as New Mexico were indeed Renaissance-Baroque, but these were submerged in a hostile and alien environment, a world that the New Mexican *vecinos* ritualized so that they could tolerate forces they could neither analyze by means of science nor control by means of technology.

Traditional New Mexico did not assert that the natural order was identical with the supernatural, but the line between these two

realms, so clear in the Reformation and Counterreformation theologies of Europe, lost its clarity in New Mexico. The everyday and the miraculous were differentiated only as the usual and the unusual, and they were expected to interpenetrate regularly. God and his saints were familiar and familial in eighteenth and nineteenth century New Mexico.

Above all, the santero's art did not exist merely for art's sake. In the eyes of the people of New Mexico during the last century, santos were instruments within a network of related activities like prayer, penance, pilgrimages, processions, and the like. Through this network of magico-religious technologies, the adept can exert a powerful persuasive force on the sacred powers—the God of the New Mexcan Hispanics, along with his saints—that control the world.

Far from being an object created for detached aesthetic contemplation, *ars gratia artis,* the santo entered intimately into the lives of the family or community to which it belonged—the morada chapter of the penitential Brotherhood of Our Father Jesus the Nazarene, the townspeople who worshiped together in the chapel, the family members who prayed at the altar in their home. If the people needed something, they besought the saint in the person of his or her santo; if they did not receive the favor at once, they might take the santo in procession to the site of the difficulty. It is said that a Holy Child was so impressed by the sad sight of dry fields that he responded with a great rainstorm that flooded the fields; the next day the people carried the figure of Our Lady out to see the havoc her son had caused: "Look what your bad little boy did!" In cases of illness, the santo might even have a few slivers of its wood burned so that the ashes might imbue the patient's food or drink with the holiness and power of the saint and hasten the return to health.

When the favor arrived with appropriate speed and restraint, the recipient would reward the santo and thus the saint with a new dress or some costume jewelry, a lighted candle, or a brass "milagro" in the shape of the healed leg or arm or eyes, the recovered horse or burro or cow. For some really impressive favor, the favored party

might provide an all-night *velorio* (vigil) of prayers and hymns.
Lorin Brown tells of the wise Córdova sacristan Tía Lupe:

> She lavished especial care on the various images of the
> saints, whom she loved and with whom she carried on
> a loving, though familiar, conversation. Each was a
> distinct personality to her, and she knew the respon-
> sibilities each had assumed. She would tell San Antonio,
> as she gave the child in his arms a loving pat on the
> cheek, "Be careful with that child; do not let him fall,
> good San Antonio." She would promise the Virgin a
> new dress because the one she wore had a spot of
> melted wax from the taper that stood by it. San
> Miguel, with the writhing serpent under foot, would
> receive the most enthusiastic and admiring praises for
> his courage and heroism in subduing the monster, and
> he would also be admonished, "*¡Ay, ten ese feo, no lo dejes
> ir!*—Keep that ugly one under foot, do not turn him
> loose!" Then she shook an admonitory finger in the
> face of Santa Inés and said, "*¡Mira!*—Look! I will not
> make you that new dress if you do not help my nephew
> Manuel find his burro so his family will not lack
> wood!" At this an unobserved witness chuckled, where-
> upon Tía Lupe turned with an exclamation
>
> She was asked, "Are you not afraid of the good
> saint's anger if you treat her that way?"
>
> And Tía Lupe said charmingly, "No. I didn't mean it,
> and Santa Inés knew that I didn't." Just the same, Tía
> Lupe made haste to light a fresh candle in front of Santa
> Inés, whose aid is sought in locating animals that have
> strayed.[7]

If the saint seemed to refuse the favor or even subject the devotee
to an unreasonable delay, the santo might suffer a punishment of
shame by being turned to the wall, put out of sight, or deprived
of some ornament. But such behavior could not have been typical
of a people too intelligent and reverent and realistic to be childishly
petulant when disappointed. Since spirit is always personal and
persons are always at least partly spiritual, the people attributed
personal traits such as free will (and free wilfulness) to the santos.

Because santos always represent persons and participated in their personhood, these wooden images belong intrinsically to the world of Hispanic spirituality.[8]

The New Mexico tradition of religious folk art grew out of and away from the provincial Baroque phase of the Renaissance where the artist's function was to achieve his individual vision of the subject matter and produce an artifact of maximum aesthetic value. The Renaissance period made tremendous technical advances in technical advances in painting, especially the discovery and perfecting of linear perspective. But its stress on purely artistic and aesthetic attainment excluded or at least subordinated many other values important to the greater human context, including some that the subject matter called for.

In Renaissance-Baroque painting it does not matter whether the painter is a good man (Fra Angelico) or a bad one (Fra Filippo Lippi). Oscar Wilde summed this attitude up perfectly by saying, "The fact of a man's being a poisoner is nothing against his prose." It is of no consequence to purely formal, intrinsic criteria whether the subject matter be Virgin and Child or Venus and Cupid, Magdalen and Christ or Venus and Adonis.[9] Wroth notes, by contrast, how the icon tradition makes stringent moral demands on its sacred artists:

> In the ancient Church and in the Eastern Churches
> down to our times, icon painters prepared themselves
> for their work by fasting, by prayer, and by sacraments;
> to the inspiration which had fixed the immutable type
> of the picture they added their own humble and pious
> inspirations; scrupulously they respected the symbolism
> —always susceptible of an endless series of precious
> nuances—of the forms and colors. They drew their
> creative joy not from inventing pretentious novelties
> but from a loving recreation of the revealed prototypes,
> and hence came a spiritual and artistic perfection such
> as no individual genius could ever attain.[10]

The tradition of New Mexico santos likewise assumed and de-

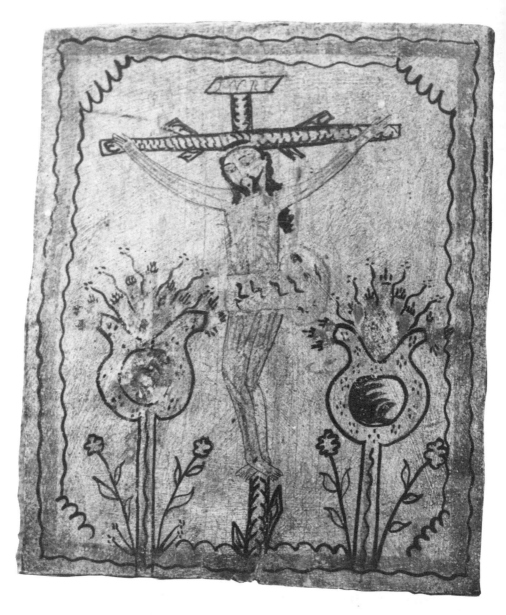

Esquípulas Crucifixion (#16a in Appendix B) by Pedro Fresquis. The traditional space-filling flowerpots have grown into splendid life-forms. From a private collection, with permission.

manded that the santero was a holy man, for only thus could the santo be holy and powerful in the religious sphere due both to its maker's holiness and to the holiness of its subject matter.

In fact, each santero had a personal style, a set of artistic idiosyncrasies (like his handwriting) that stayed with him from painting to painting, however little he reflected on them. But if he began his work within the santero tradition of iconography and remained within it as his career continued, he became a living part of that tradition. And thus every time he painted or sculpted some given saint, it resembled (by intention) the santos of the tradition and (by force of idiosyncrasy) his own earlier work. Hence he operated more and more according to the norms of a two-fold tradition.

Within this matrix, the holiness of the santero and the holiness of the pictures he copied issued into new paintings and statues that were objects holy in themselves, intrinsically sacred by reason of the man who made them, the materials they were made from, the models they imitated, and the purpose for which they were intended. The bulto or retablo was not merely a reminder of some edifying and instructive holy person from legend or the past history of the church; a santo properly made by a holy santero had a sacredness of its own. In this context, it should be increasingly clear why the santero, as the producer of an intrinsically sacred and powerful artifact, needed to possess personal sanctity and even a quasi-priestly character.

The majority of extant eighteenth- and nineteenth-century santos seem to be the work of a couple of dozen dedicated men for whom the making of santos was an abiding profession—indeed, a vocation. The santero's calling restricted him to a fairly narrow subject range of holy personages,[11] for authentic New Mexican folk santeros never portrayed secular subjects, with very few exceptions such as toys, animals, and other tourist items of the sort.

Whatever the earlier santeros might have thought of their artistic ability, they seem to have viewed their activity as intrinsically holy, and the people seem to have expected them to be holy in their personal lives. E. Boyd found a document granting Pedro Fresquis' petition for permission to be buried in the Santuario of Chimayó, recording as the motive the fact that he "has labored with devo-

tion in various material works of our churches and and in the chapels of Las Truchas and the Santuario of Our Lord of in Esquípulas [Chimayó] without having required any recompense at all, and instead merely having been praised for his zeal by the former father visitor." Of some later artists we learn that "to be successful, at least in the San Luis Valley, a santero had to lead an exemplary life. There was the belief that the better the personal and religious life of the santero the more merit there was to be found in a specimen of his work." And it was said of a santero who worked about 1910-30, "Celso Gallegos was also in in demand as a reader of prayers among his neighbors."[12]

When a contemporary santero moved to a small Spanish mountain village in the mid-1960s he received, he told me, marked expressions of respect and even reverence when the people discovered what he was about. There is no need to suggest that the santero had to be the very holiest man in the region or even the village, and he was certainly not held to be anything like an "inspired magician," but it seems to have been felt that he should be in some way removed from the average. We are at any rate, obviously, a long way from Oscar Wilde and "the fact of a man being a poisoner."

The main thrust of the santero's art is, then, toward the holy and powerful rather than toward the beautiful. Unreflectively using the talent at his disposal, the santero tried to make his retablo or bulto as honestly as possible, and he generally achieved a deftness and strength of portrayal that few artists in the era could match. For it was not his personal talent, his unique vision, his individualistic self-expression, his own reputation that occupied his attention, but only the rightness of the work at hand. And this was guaranteed for him so long as he worked as well as he could within the tradition that nourished him and which was in practice his whole world of art. The complete adequacy of its iconographic system sustained him in his efforts in such a way as to take precedence over his reflective self-awareness: most of the santeros never signed a work, and those who did signed only a tiny minimum of their productions. It was not the name Pedro Fresquis or José Rafael Aragón that guaranteed the work, nor was it the

artist's unique imagination; it was the living model, the saint himself or herself existing in the everlasting eternity of heaven and (more proximately) in the abiding tradition of sacred iconography the santero had learned from his mentors.

Just as the largest landowner of an area served as the villagers' link to the larger world of Santa Fe, just as the padre connected his flock to the larger Catholic Church, so the santos connected every chapel and every home in the whole colony to the eternally validating domain of heaven. Divine and saintly power became most especially present and actual in the images. It drew near to the beholder who could in turn draw near to it, for with and through the santos men and women could share in the blest life of God and his angels and saints.

Notes

1. William Wroth, *Christian Images in Hispanic New Mexico: The Taylor Museum Collection of Santos* (Colorado Springs: Taylor Museum of the Colorado Springs Fine Arts Center, 1982), 6. This remark follows mention of King Abgar's Holy Face of Edessa, Veronica's Veil, and the Shroud of Turin. In the New World, the Guadalupe tilma is the prime example of the image "not made by hands."

The modern theology of narrative has recently begun to touch upon the lives of the ordinary saints, who are the majority of the ultimate objects of imitation, but so far it is interested only in what it fondly calls "real" saints. Granted that they incarnate Christ in changing ages and cultures, exemplify church teachings, act as foci of fellowship, and edify the church, yet these "real" saints serve mainly as Pelagian models for imitation in the moral-ethical order. Thus they are "real" like characters in novels: three-dimensional personalities set firmly into their appropriate historical backgrounds.

By contrast, medieval and New Mexican saints are much more like characters in romances: two-dimensional emblems more to be utterly astonished at than to be imitated (nearly unthinkable!). They embody power because holiness is power; they have been constructed out of nothing (Librada, Barbara, Philomena, George) or next to nothing (Acacio, Christopher, Cecilia, Santiago) in precisely such a way as to be *other* (*aliter, anders,* alien) and transcendent. See Lawrence S. Cunningham, "A Decade of Research on the Saints, 1980-1990," *Theological Studies* 53 (1992), 517-33.

2. Neoplatonism systematizes a worldview that is very religious, allegorical, symbolic, and sacramental, for it continues the age-old primal and tribal view of the world (Mircea Eliade, *The Myth of the Eternal Return* [New York: Bollingen, 1971], 34).

Although the theologians were consciously and reflectively Neoplatonic, the common people (who insisted on the icons when the scholars waffled) did not, of course, subscribe to Neoplatonism or any other systematic philosophy.

3. George Mills, *The People of the Saints* (Colorado Springs: Taylor Museum, 1967), 58.

4. Gerardus van der Leeuw, *Sacred and Profane Beauty* (London: Weidenfeld and Nicolson, 1963), 176; Symeon, *Contra Haereses* 23 (from Migne, *Patrologium Graecum,* vol. 155, col. 112), my translation; van der Leeuw, 176, 178; Wroth, *Christian Images,* 23-44; Kay F. Turner, "The Cultural Semiotics of Religious Icons: La Virgen de San Juan de los Lagos," *Semiotica* 47 (1983), 319.

In the Symeon quote, I suspect him of making a nifty pun between "they build up, raise up, make" (ana + histemi, anistorousin) and "they are ignorant of history" (an + historeo, anistorousin). Furthermore, "raise up" is often used in church Greek to speak of birth or resurrection, bringing life out of the nonliving—an apt metaphor for the creation of art, whether secular or sacred, icon or santo.

After noting that "Religion fears the presence of an idol" (178), Gerardus van der Leeuw goes on to say that the Greeks of the classical era therefore "preferred the *xoanon* [the primitive statue which recalled in its stiff shape the block of stone or wood from which it had been carved] to the works of art of one of their great masters."

5. Willard Hougland, *Santos: A Primitive American Art* (New York: Kleijkamp and Monroe, 1946), 32.

6. See Rutherford J. Gettens and Evan H. Turner, "The Materials and Methods of Some Religions Paintings of Early Nineteenth-Century New Mexico," *El Palacio* 58 (1951), 3-16; José E. Espinosa, *Saints in the Valleys* (Albuquerque: University of New Mexico Press, 1960), 53-58; E. Boyd, "The New Mexico Santero," *El Palacio* 76, 1 (Spring 1969), 5-6.

Most of what I have said in this section of the book I owe to Charles Carrillo, presently the leading expert on these matters.

7. Lorin W. Brown, "Tia Lupe," WPA Writers' Project, New Mexico State Records and Archives. It has been published in a slightly different form in Brown, *Hispano Folklife of New Mexico,* ed. Charles L. Briggs and Marta Weigle (Albuquerque: University of New Mexico Press, 1978), 131-32, and in Marta Weigle, *Two Guadalupes* (Santa Fe: Ancient City Press, 1987), 5. See also Nina Otero Warren, *Old Spain in Our Southwest* (New York: Harcourt Brace, 1936), 23-24; George Mills, *People of the Saints,* 58-59; Nasario García, *Abuelitos: Stories of the Río Puerco Valley* (Albuquerque: University of New Mexico Press, 1992), 76-77; and Larry Frank, *New Kingdom of the Saints* (Santa Fe: Red Crane Books, 1992), 19-20.

8. For reputable reports of "punishment" of santos, see Gilberto Espinosa, "New Mexico Saints," *New Mexico Magazine* 13, 3 (March 1935), 11; José E. Espinosa, *Saints in the Valleys,* 85; Mills, *People of the Saints,* 58-59; Roland M. Dickey, *New Mexico Village Arts* (Albuquerque: University of New Mexico Press, 1970), 185.

On an artifact as quasi-personal, see Martin Buber, *I and Thou* (New York: Charles Scribner's Sons, 1958), 7-10, 33, 124-26.

Dr. Jack Kevorkian's girl friend Doña Sebastiana is an apparent exception to the rule that a santo represents a holy person, for she is merely an allegorical personification of death riding in an old-style ox-cart. But she is only a *memento mori*, a reminder of death, and knowledgeable New Mexicans do not pray to her; hence she is not exactly a santo. See Louisa R. Stark, "The Origin of the Penitente 'Death Cart,'" *Journal of American Folklore* 84 (1971), 304-10; Thomas J. Steele, S.J., "The Death Cart: Its Place Among the Santos," *Colorado Magazine* 55, 1 (Winter 1978), 1-14; Wroth, *Images of Penance, Images of Mercy* (Norman: University of Oklahoma Press, 1991), 149-59.

9. Oscar Wilde, *Intentions* (New York: Brentano's, 1907), 90; T.E. Hulme, *Speculations* (London: Routledge and Kegan Paul, 1936), 9; Murray Roston, *The Soul of Wit: A Study of John Donne* (Oxford: Clarendon Press, 1974), 160-61.

10. Wroth, *Christian Images*, 10, quoting Frithjof Schuon, *Spiritual Perspectives and Human Facts* (London: Perennial Books, 1969), 36-37.

11. For a study of needed innovation within an apparently closed system, see Steele, "The Death Cart," 1-14.

12. Archives of the Archdiocese of Santa Fe, *Patentes*, Book 70, Box 4, Official Acts of Vicar Rascón, 1829-33, 25, quoted in E. Boyd, *Popular Arts of Spanish New Mexico* (Santa Fe: Museum of New Mexico Press, 1974), 329; William J. Wallrich, "The Santero Tradition in the San Luis Valley," *Western Folklore* 10 (1951), 155, 157; Boyd, "The New Mexico Santero," 22.

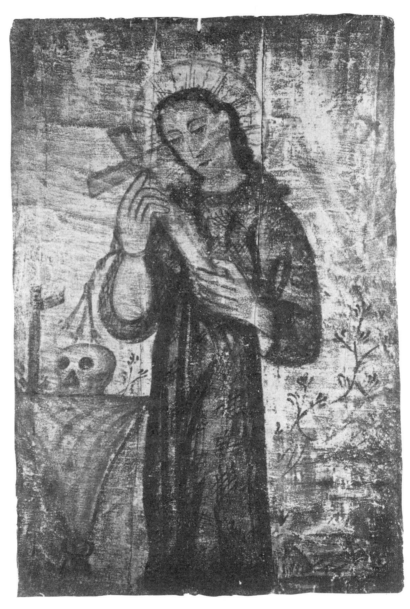

Saint Rosalie of Palermo (#137 in Appendix B) by Molleno, painted early in his long career. Collections of the School of American Research at the Museum of International Folk Art, Museum of New Mexico.

II

Santo Space
Pre-Renaissance and Post-Renaissance

T he Renaissance was a tradition of visual realism and linear perspective which dominated European-American art from the end of the Middle Ages (1415 or so) to the advent of the Post-Impressionists and the Cubists (1890 or so). By contrast, the nineteenth-century New Mexican Spanish painters had in many ways developed into medieval styles, so by mere accident they anticipated the vision of post-Renaissance painting. Much of what Gauguin sought in the South Pacific and Picasso found in African artifacts the untutored New Mexicans discovered merely by doing art in their own cultural context, and their vigorous synthesis became a true if temporary post-Renaissance tradition.

The statement that the nineteenth-century New Mexican santos emerged from the Indian cultures of the region has been denied time and again, but it continues to recur in popular treatments of this vernacular religious art. Granted that the santeros used the same materials to make their santos that the Pueblos used to make their kachinas and tablitas, granted that the Quill Pen Santero used some purely decorative motifs that are probably Native American, and granted that many of the santeros had Indian forebears, no one

has yet made an even slightly plausible case that the santos are culturally Native American. Perhaps the error of thinking that santos stem from the Native American tradition gives, by its very persistence, a clue to a deep truth about the santos that even persons familiar with them and with contemporary art fail at times to notice: Santos do indeed come from a culture vastly different from the European-American mainstream, so different that careless popularizers continue to seek their cultural origin in some people without European cultural roots.[1]

The almost exotic character of the santos was a result of several factors: New Mexico's long isolation from the larger world, the loss of the cultural infrastructure that had supported Renaissance styles, the medieval cast of Franciscan spirituality, the people's rural traditionalism, and a severe limitation of artistic training, tools, and materials.[2] The length and depth of New Mexican isolation is hard to overestimate. The first Spanish settled in New Mexico in 1598, and when their descendants were expelled from 1680 to 1693, those who hoped to return retreated only to El Paso, in the southern part of the colony. During the eighteenth century, visitors to New Mexico were rare and newcomers were few except for the governor and his entourage and the Franciscan missionary pastors. Carey McWilliams describes the extent of the most important factor:

> Isolation is the key to the New Mexico cultural complex. The deepest penetration of civilized man in North America, New Mexico was a lonely outpost of Spanish settlement for three hundred years, isolated from Mexico, California, Texas, and Arizona, isolated by deserts, mountain ranges, and hostile Indian tribes. It would be difficult, in fact, to imagine an isolation more nearly complete than that which encompassed New Mexico from 1598 to 1820. For its isolation was multiple and compound: geographic isolation bred social and cultural isolation; isolated in space, New Mexico was also in time. Primitive means of transportation and the lack of navigable streams extended distances a thousandfold. It took the New Mexicans five months to make the 1200-mile round trip, along the Turquoise

Trail, from Santa Fe to Chihuahua.[3]

This isolation continued into the first part of the nineteenth century, when even the most important news could not travel from Mexico City to Santa Fe in less than a month. Under these circumstances it is not surprising that art in general and painting in particular retreated toward medieval styles. But in doing so it happened to anticipate certain minor features of Cubism, the movement that put an end to the Renaissance.

Besides the obviously Catholic subjects and the basic iconography, New Mexican art retained only the Renaissance trait of painting "easel" pictures—paintings done not on walls and other functional things but on stretched canvases and wooden panels that had been made solely to be painted on. The change to this new kind of "bearer" of paint as a standard practice is an innovation of the Renaissance. It is a step typical of the period in that it exemplifies the tendency of the era toward visual abstraction, for during all previous ages painting and all similar decorating was done upon something which was a functional object in its own right. The human body was tattooed or covered with war paint; a pipe, warclub, shield, or some other tool was decorated with a painted or incised design; a container like a pottery bowl was embellished with a pattern before or after firing; a mural or mosaic adorned a wall or ceiling; stained glass enhanced a window; a design was woven into a rug or blanket or basket. The New Mexico Spanish santeros painted on specially prepared wooden panels, thereby retaining the Renaissance innovation of what might be called "picture-space" (on the analogy of Marshall McLuhan's "page-space"), but in most other respects their work became almost wholly a folk form.

New Mexican church architecture, by contrast, consciously attempted to imitate the European Renaissance styles of New Spain which the missionary pastors had seen. Both interior and exterior vistas are deliberately planned; the door is set opposite the main altar, and the floor, walls, and roof frame the altar to the viewer as he enters. In like manner, the facade of the church is properly viewed from the gateway to the cemetery in the walled enclosure in front of the church. The point of view is controlled, and in turn

it controls what is seen so that it may be appreciated to the maximum. But these Renaissance traits occur only in New Mexico churches, not in vernacular and domestic architecture such as moradas, small oratorios, and family homes.

Other Renaissance characteristics were conspicuously lacking in late-eighteenth- and early-nineteenth-century New Mexico. The Gutenberg age, which in Europe formed with architectural vista and lineal perspective the bulk of the visualist Renaissance syndrome, did not come to New Mexico until 1832, when lawyer and politician Antonio Barreiro set up the territory's first printing press, the only one for fifteen years. Furthermore, the mercantile aspect of the European Renaissance was also very slow in touching New Mexico, which struggled along with a barter economy and a noncompetitive system of gift-exchanging within extended-family villages where offering or asking wages for work fell somewhere between the unthinkable and the insulting.

Thus in general, the individualistic point of view which is the hallmark of the Renaissance, interiorized only very slightly by the sixteenth-century European Spanish, eroded almost totally in the isolated colony of New Mexico, so that by the nineteenth century the inhabitants of most small villages were more like medieval peasants than they were like the Anglos who arrived with the traders' wagons across the Santa Fe Trail, with Kearny's and Doniphan's armies, or in their wake. The Spanish were immersed in a highly familial religion, in an extended family appropriate to their peasant economy of subsistence agriculture, and in a view of time that deemphasized the future as something controllable less by man than by God and the saints and that validated the present through its relation with events in a "timeless time past" or with eternal entities.

The Baroque phase of the total Renaissance prevailed in the parts of New Spain around the City of Mexico during the formative years of the New Mexican colony, reconquered and resettled after the 1680-1693 period of Pueblo independence. The Reniassance in general and Baroque style in particular were far too sophisticated for the New Mexicans to sustain. A Renaissance person must grasp cultural history clearly enough to distinguish the classical and the

medieval and choose the former. By contrast, although practically everything in New Mexican culture was borrowed from Europe by way of New Spain, the culture knew neither new nor old, possessing everything in a timeless, non-linear time in such a way as to lack a reflective historical sense of itself or its origins.[4]

The three main pillars of medievalism were certain survivals of Latin classicism, the Roman Catholic religion, and the Germanic peoples who retribalized Western Europe before giving way to detribalization and acculturation into the new cultural synthesis. In eighteenth- and nineteenth century New Mexico, these three factors were repeated. Traditional New Mexican Hispanic culture was characterized by certain survivals of the Baroque and Neo-classical, by Franciscan Christianity of a very strongly medieval cast, and by the tribal cultures (both Pueblo and nomadic) that dominated the colony well into the eighteenth century before the Hispanic cultural synthesis prevailed.[5]

William Wroth notes that Christian folk art appeared in Europe as a survival of medievalism when the Renaissance began to create art that was not compatible with the popular religion of the majority of the people: "Religious folk art is the inheritor and preserver of medieval religious art."[6] But this choice of the medieval was not reflective and deliberate as the Renaissance choice of the classical had been, and so the choosing is transformed into narratives by the "cycle of the shepherds" stories about finding statues that were lost or hidden in past ages (the Laguna tale of the Nuestra Señora bulto wailing in an abandoned house), statues that returned from enforced exile (La Conquistadora), statues that were not made by human hands (the various Chimayó stories of the finding of the Esquípulas crucifix).[7] These statues are hieratic, stiff, formal, unrealistic—which is to say, perfectly suited to be objects of religious devotion.

For reasons which this book will explore at length, the New Mexico Spanish of the eighteenth and nineteenth centuries practiced Catholicism in a way that required a large number of images— statues and paintings of the divine persons and the saints. A church or chapel which was not decorated with a score of images of holy persons would have seemed poor indeed; a private household

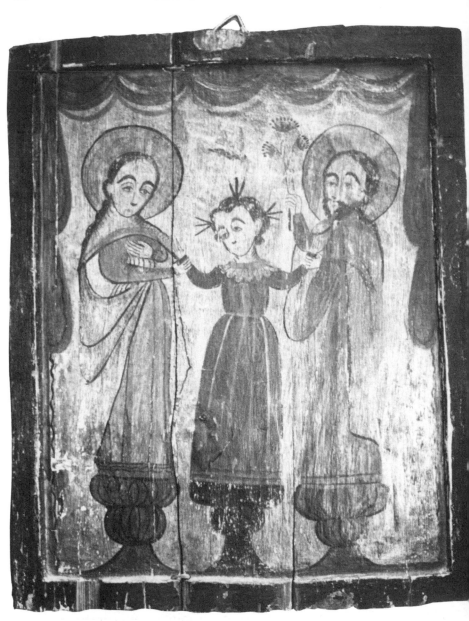

The Holy Family (#5 in Appendix B) by Rafael Aragon. The bases on which the three figures stand are carefully though imprecisely modeled, but at the bottom they simply merge into the encircling border. From a private collection, with permission.

which did not display several saints would have been liable to the suspicion of not being very religiously inclined. But at the same time, the influx of holy images from Mexico and beyond had dwindled to a mere trickle as the support provided by the mother country for her least favored stepchild fell far below any pretense of adequacy. Under these circumstances, the Spanish in New Mexico began to produce sacred art for themselves.

The comparatively few works of art imported into the colony during the eighteenth century were mainly oil paintings on canvas for churches and the homes of the wealthier laity, and the surviving examples seem almost all to have been Mexican in origin and religious in subject. In the context of European painting of the time, these are themselves plainly provincial (rather than metropolitan), but many of them are fairly adept at depicting a third dimension through realistic portrayal of garments and background draperies, the chiaroscuro on limbs and other rounded objects, and the exact management of linear perspective. The earliest Hispanic painting done in New Mexico was consequently provincial as well, since it was produced by persons so totally under the influence of the wider European-Mexican art world that its criteria served (for better or worse) as the original criteria of New Mexican painting.

The history of eighteenth- and nineteenth-century New Mexican painting is best told by tracing the loss of that great Renaissance artistic invention, the illusion of a third dimension. This return from Spanish and Spanish-American mainstream artists to their medieval progenitors is most characterized by painting on hides and wooden panels (retablos). A brief history of the draftmanship of these paintings, with a few notes on sculpture, thus traces the development of a vernacular village art from its metropolitan and provincial roots.

The earliest extant Christian paintings done in New Mexico were drawn and painted on the hides of large animals, mainly elk and buffalo. These may have received an extra impetus after two different artists produced the Segesser hide paintings, one of which shows the disastrous 1720 defeat of the Pueblos and Spanish under Villasur by the French and Pawnees. One Franciscan friar and one

Mexico-City-born shoemaker, Francisco Xavier Romero, probably painted most of the religious paintings on hide that decorated the churches and chapels and served as illustrations for catechism. Even though these artists had little or no academic training, they still strove to elicit all the impact of the religious paintings done in other lands despite their own limited ability and the intractable materials at hand. Garments are insistently modeled, for the hide-paintings attempt to give the illusion of space, and even though the techniques used to this end—linear perspective in floor tiling, architectural "frames," placing of items before and behind the main figure, and shading of rounded objects—are usually handled imprecisely, they were at least rough approximations of the techniques that were taught and used properly in studios in the metropolitan cities of Europe and New Spain.[8]

An early work created in the colony itself which ought nevertheless to be considered with the imports is the 1761 altarscreen now in the Church of Cristo Rey in Santa Fe. This great stone structure was donated by Governor and Captain-General Francisco Antonio Marín del Valle and his wife María Ignacia Martínez de Ugarte to the chapel of Nuestra Señora de la Luz, later known as the Castrense. These two benefactors commissioned two Spanish or Mexican artists to travel to Santa Fe and create the great reredos from local stone, which they carved in low relief, gessoed, and painted. A small semicircular panel at the apex shows God the Father, and just below him is Nuestra Señora de Valvanera. On the next tier down three panels show San José Patriarca holding the Santo Niño, Santiago (the soldiers' patron), and San Juan Nepomuceno (a patron of the Jesuit order). The lowest tier contains a panel of San Ignacio Loyola (founder of the Jesuits, whose namesake the governor's wife was), a central niche originally occupied by an oil painting of Nuestra Señora de la Luz, and a final stone relief of Francisco Solano, patron of the governor himself. This altarscreen fits right in with the Mexican provincial work of the era; the garments are realistically draped, and the treatment of anatomy sets the figures into some illusion of space. These techniques, of course, were not to be matched by later santeros, but the general structure of the altarscreen, particularly columns to frame the

panels on each side, may be seen in folk repetitions on nearly every later New Mexican altarscreen. By its effect on the gesso reliefs and altarscreens, the Castrense altarscreen influenced the whole tradition of New Mexican santero art.[9]

Two artists of the period, Fray Andrés García (in New Mexico from 1748 to 1778) and Captain Bernardo Miera y Pacheco (there from 1756 to his death in 1785), were both painters and sculptors whose works superficially resemble mainstream Renaissance art. As painters, they began the New Mexican tradition of painting on wood covered with gesso (gypsum and glue), perhaps borrowing several techniques from the Pueblo Indians, who used pine panels for tablitas and cottonwood root for kachina figures, used gesso, and made pigments from locally-available materials. García and Miera had at least occasional access to oil paint, but they painted many of their works with these homemade waterbased paints that would become the staple of nineteenth-century santero art. Their paintings surpass the hide paintings technically because of their far more tractable medium, for the hides were so absorbent that no painter could have achieved refined effects. Judged by Renaissance norms, their stylistic inadequacies stand out all the more sharply, but they both brought some important skills to their part-time occupation (Miera was a military cartographer by trade, García a priest); they both handled lineal perspective tolerably, and both had some grasp of aerial perspective—giving the illusion of spatial depth by depicting a distant object more blue than it is, of nearness by making it more red.[10]

During this same early period, the movement from the dramatic and realistic Baroque to the static and iconic vernacular had not yet begun in New Mexico; the late eighteenth-century statuettes show only the Bernini-like poses of mannerist Baroque, made awkward by the provincial and frontier limitations of their makers. Indeed, provincialism seems the hallmark of eighteenth-century painting and sculpture both done in and imported into New Mexico. None of the work is very dynamic; all of it stays alive by containing a feeble spark of the great Baroque tradition it imitates. It is the umbilicus connecting the elder tradition to a weak infant destined to become strong and independent, for the history of New

Mexico's santero tradition is one of forgetting its provincial origin and nearly all the techniques practiced in the provinces dependent on the European school of fifteenth- to eighteenth-century art. Though a few such traits remained well into the nineteenth century, the tradition changed so basically as it became indigenous to New Mexico that it assimilated all the painters' patterns and all the saints' attributes into an independent new tradition. Despite their traces of Mexican provincialism, New Mexico santos of the first half of the nineteenth century are not provincial art but vernacular.[11]

This art, fashioned almost exclusively from home-crafted local materials, is of three sorts: retablos, bultos, and altarscreens. A retablo is a painting made on a pine panel, sawed at top and bottom, the rest split or sawed or hand-adzed and the front smoothed, covered with gesso (a mixture of gypsum and animal glue) and painted with water colors, many of them homemade from carbons, earth oxides, and organic substances, some made from dyes imported into the colony. A bulto is a statue assembled from carved cottonwood root, covered with gesso, and painted like a retablo; bultos were frequently clothed, so at times the nether portions were constructed of small pine laths covered with cloth that was then sized with gesso and painted when dry. An altarscreen (reredos) is a large structure of pine columns, niches, and panels to be placed above and behind an altar and finished like retablos.

With the anonymous artists of the first half (1785-1820) of the "classical" period, principally the Eighteenth-Century Novice, the Laguna Santero, and the makers of the gesso relief panels, the local tradition accomplished its transition from provincial to vernacular art. The Novice may have apprenticed with Miera y Pacheco. His retablos show built-up lighter areas over a dark-red-bole underpainting so as to try to model faces, limbs, and pedestals, but the artist never really grasps the strategies needed for roundness. One of his paintings manifests an attempt to place a crucifix effectively "on" a table, but lines that ought to be either parallel or convergent on the canvas diverge instead.

The anonymous Laguna Santero's name derives from the type piece of his work, the altarscreen at the Laguna Pueblo Church of San José, perhaps his last work and certainly his best (until it was

unfortunately overpainted after an expert cleaning). Some of his early more realistic works seem to strive after a third dimension only in non-stylized flowers flowers and in the modeling of the patterned garments. The background occasionally includes a tiled floor; since tiles were not used in New Mexico, this trait clearly shows the influence of Mexican models. The gesso-relief santeros take care of the roundness problem by building up a figure modeled in the actual third dimension of wet gesso with a drying agent of starch, but the relief panels that depict tiled floors fail totally to convey an illusion of depth because the lines are painted parallel, hence making the tiles seem to stand on edge.[12]

Antonio Molleno bestrode the small world of colonial New Mexico. He was if not the best perhaps the most prolific and the most experimental santero, and his career summed up the leading features of the era. The uncertainty about his name is typical: he knew how to letter, but he signed only his last name and that only on one known painting, and his first name is only known from oral tradition. He may have been born further south in the viceroyalty and migrated into New Mexico, and he likely lived somewhere between Chimayó and Taos.

Molleno's career perfectly ran the gamut from the from the conclusion of provincialism to the sparest and most "folk" of vernacular iconographies. He seems to have begun as an apprentice of the Laguna Santero, but as E. Boyd noted, even his earliest work "lacks the latter's organized composition and sense of the third dimension." Molleno's earliest work, by contrast, is characterized by variegated backgrounds, draperies, posed figures, and a pervasive darkness stylish in metropolitan and provincial painting during the Baroque era. As his career continued, he less and less differentiated the picture into foreground and background, and his picture surfaces became increasingly dominated by areas of untinted gesso and the purely decorative red wedges ("chili pods") that gave him his earlier descriptive name "The Chili Painter." The anatomy of his subjects also became more stylized and notational as he grew older. By the time he arrived at what Boyd called his "abbreviated manner of drawing figures—a shorthand presentation which is more like a code than a human image," he thoroughly exemplifies "the

deliberate preference among folk artists of New Mexico for the two-dimensional treatment of the picture plane when painting on a flat surface."[13]

One of the most recognizable features of Molleno's style is his treatment of the beards of male figures in three-quarter presentations: the farther side is a single, nearly straight very heavy line. Larry Frank suggested that this technique achieves a three-dimensionality that is neither geometric nor aerial but more like modern cartooning.[14] This insight very perceptively points out the draftsman-like rather than painterly nub of santero art: the black lines carry the picture, for the colors, rarely shaded, fill in previously-structured areas rather than form them in a painterly manner.

The "Quill Pen Santero," probably a Molleno disciple, regularly used an ink-pen made from a feather to draw the finer lines of his design, switching to brushes when he added the colors. He occasionally used Indian design motifs of the type used on Pueblo pottery.

Pedro Fresquis (1749-1831) was probably the first santero born in New Mexico. A couple of Baroque traits common in his earlier work, dark backgrounds and *sgraffito* (scraping away lines in moist paint to expose the different-colored surface beneath), disappear from most of his later pieces. In certain of his panels the tiling is stylized by being given wavy joints which do not attempt to show perspective at all; what had been tiling has become merely a space-filling pattern, much like the stylized flowers that float upon his backgrounds and suggest that Fresquis had a strong abhorrence for empty spaces. In many a retablo of his, highly stylized trees "stand on top of" the pattern of tiling. The trees are sketched so that they refrain from putting their branches behind the main figure, for they stand not in a background but rather in the same plane, or perhaps better, in the same mode of two-dimensionality. The kind of space they fill is to be measured only in the square inches of the actual gessoed surface, not in the illusory cubic feet of three dimensions.

Fresquis occasionally modeled draperies and portions of anatomy, but in at least one version of the most "pat" picture possible, a Nuestra Señora de Guadalupe, his copying of some Mexican woodcut or engraving seems uninspired, suggesting a lack of technical understanding of what the earlier artist was about but still producing a pleasing variation. Fresquis retained some perception of Renaissance picture-space, but like some other painters, he never signed more than his initials to a few of his santos. But he must have been known and respected, for variations in the style and quality of pieces attributed to him strongly suggest that he trained some anonymous students in the techniques of his art.[15]

With the next few santeros, we meet the most pleasant santeros of the latter half (1820-50) of the "classical" period. José Aragon and his followers, especially the Arroyo Hondo artist or artists, and José Rafael Aragon and his followers, especially the anonymous "Santo Niño Santero," consistently composed pictures that are simple, uncrowded, pleasingly colored, and very easy to like.

José Aragon is said to have been born in Spain, but apart from the near-certainty of his having at least one apprentice and probably half a dozen or more, he was not a provincial but a vernacular artist. He fitted completely into the New Mexican tradition except for a slightly greater tendency than other painters to work from engravings and to letter on the retablos and even sign them—often making use of the cartouche (another definitely Baroque borrowing that disappears shortly). His style incorporates cross-hatching, an engraver's rather than a draftsman's or especially a painter's technique. Even when he seems not to be copying an engraving he employs cross-hatching in inappropriate places and sometimes produces rather too busy a design. But in each case the New Mexican style is absolutely clear, and the translation from the Mexican-European engraver's idiom to the New Mexican draftsman's is nearly complete: a weaker tradition has met a stronger, and Aragon is no more constrained by the provincial's style than Shakespeare is by Belleforest's or Holinshed's.

In addition to a spread of works attributed to a set of followers

of José Aragon, certain works point to a single artist or perhaps a painter and a carver: the Arroyo Hondo style very likely stemmed from José Aragon's workshop. With the santeros in the Arroyo Hondo branch of the José Aragon tradition, we move into a different age because of a significant change in the market for santos. The production of retablos falls off sharply, since Currier and Ives lithographs and other inexpensive graphics imported across the Santa Fe Trail found a readier market than the handmade and therefore more expensive panels. On the other hand, the production of bultos continued unchecked—or even increased—until the railroad introduced plaster statues, which were too heavy and too fragile for the Santa Fe Trail wagons. Such santeros as Miguel Herrera are not known to have done any retablos, and the two-dimensional work of most of the others is decidedly inferior in technique to their carvings, which maintain as high a level as ever.

The painting moves hereafter in two different directions. Under the impact of the new prints flooding into the territory, retablos become notably fewer in number, and the few that are made tend either to become provincial or to revert to the near-primitive.[16] José Benito Ortega lived in the Mora County town of La Cueva, near Mora, until he moved to Raton in 1907, took wage work, and pretty much retired as a santero. His retablos and those of his contemporaries push so far in the direction of stylized notation that some of them remind the viewer of Matisse's paintings with their deliberate denial of a third dimension in favor of achieving decorative values and maintaining an integral picture-surface: the figures shatter into many equidistant planes of total depthlessness.

However, the energy that failed to go into painting released itself into marvelous sculpture. Some of the most powerful New Mexican bultos date from the period between the flourishing of the Santa Fe Trail and the arrival of the Santa Fe Railroad with its boxcars full of statues. Ortega's bultos are splendid witness to this energy. Though the hands leave something to be desired and the feet often look comical to us in their stylish factory-made high-topped shoes—Nuestra Señora de Pansy Yokum— the faces are expressive of an exalted saintliness, especially those of his passiontide virgins and his hieratic crucifixes. There is enough variation

The Holy Child of Atocha (#7 in Appendix B) by the Santo Niño Santero.
The draftsmanship is simply unearthly. Bequest of Cady Wells to the
Museum of New Mexico, Museum of International Folk Art.

of quality in work attributed to Ortega that he has also been suspected of having a pupil or two.

The folk bultos of this latter period (1850-1930)—the works of Ortega, of José Inés Herrera, of Juan Ramón Velásquez, and of the many other sculptors of the era—break free from the archaic *xoanon,* the rigid and "frontal" wooden statue whose lines so closely follow those of original material that a wooden statue resembles in general shape a piece of firewood. Whereas the more rigid and frontal statues of the earlier period had tended often to be very lovely, the trump card of the later period was not honest simplicity but the literally raw-flesh power of the suffering Christ as as presented in the crucifixes and Jesús Nazareno bultos made particularly for the Penitente moradas (chapels). Archaic purity of line gave way to real hair and teeth, porcelain eyes, and all the possible paraphernalia of public suffering.[17]

José Aragon and José Rafael Aragon share many many characteristics, though Rafael Aragon worked later, dying in 1862. Rafael does not so often sign or letter his paintings as does José, and he seems to use parallel lines more than cross-hatching, thus suggesting woodcut rather than engraving. He often paints a support under the halo on a retablo, thereby hinting that he may have been copying a bulto or at least thinking strongly in terms of the many exquisite ones he himself fashioned.

Like José Aragon and many other santeros of the time, Rafael Aragon paints almost entirely in two dimensions, rarely attempting to provide any illusion of a background or to round his figures except when he adds some slightly excessive attempt at flesh-tones *(encarnación)* in his more finely crafted pieces. The decorative devices that fill out the panel are highly stylized, especially if they are meant to be architectural, and so are most of his saints' attributes. But nearly always, Rafael Aragon presents his beautiful aristocratic saints so as to convey each saint's heavenly meaning to the devout mind rather than the saint's earthly appearance to the physical eye. The large number of altarscreens Rafael Aragon was invited to create, each of them representing a major commitment of a community's

resources, suggest the high esteem the people of his own day held him in—an esteem rightly accorded him still today.

The anonymous Santo Niño Santero rounds out the classical period of santero work. The Santo Niño Santero was very likely Rafael's follower, somewhat like the shadowy Miguel Aragon, who was not only Rafael's son but apparently his student and helper as well. The Santo Niño Santero earned his descriptive name from his frequent depictions of the Christ Child Lost (El Niño Perdido), the Christ Child of Atocha, and the Christ Child of Prague. His retablos are as weird and wonderful as his bultos are lovely; along with Ortega, the Santo Niño Santero is a perfect instance of mastery in three dimensions failing to translate even into minimal competency in two. Other painters of the era, named in Appendix A, differ little from the other classical santeros except that their backgrounds tend to be even more undifferentiated, leaving the figure standing within a painted border in a space of its own, completely incommensurate with real three-dimensional space or any painterly illusion of it.

José de Gracia Gonzales, a native of Guaymas, Sonora, Mexico, migrated into the Peñasco region shortly after the American Civil War and the Mexican expulsion of the French. He painted in oil paints, either completely overpainting older santero work as with the main Trampas altarscreen or painting canvases and panels, carving and casting statues, and crafting new altarscreens. In the early 1880s he moved to Trinidad, Colorado, took a railroad job, and carved and painted intermittently on the side, thereby influencing some southern Colorado santeros.

Thus came the near-end of a great and vital tradition. For more than two centuries priests born and educated outside the territory have been getting rid of the native santos from many of New Mexico's churches, especially those in the larger towns, to replace them with plaster "bathrobe art" from Mexico City, from Saint Louis, or from Europe. In 1869, the Italian Jesuits at San Felipe Neri Church in Albuquerque collected money from the parishioners for this purpose, then gave the old bultos away to those donors who wanted them.[18]

But today more and more people have come to appreciate this art-form that defied most of the most holy canons of nineteenth-century European-American art because it operated with a different space-conception than that of academic art, a space conception worth our further examination.

No tile was made or used in traditional New Mexico, so tile-patterns that the New Mexican santeros copied from imported images soon became mere stylizations, depicting not the everyday world that the santero and his customers inhabited but the special mode of otherworldly space where the God, the angels, and the saints dwelt. Because tiling had no counterpart in their actual experience, the santeros betrayed a good deal about their conception of space in handling it. Their tile-lines never converge to a vanishing point so as to generate true Renaissance perspective.

In the typical retablo of the classical period, painting other than the border and the main figure or figures is not to be taken as background or foreground so much as space-filling—elements added to balance the composition, which may have more attributes of the saint on one side than the other. The background was nearly always painted after the figure was drawn in, further evidence of the linear rather than painterly New Mexican approach. The afterthought status of the saint's surroundings (together with the seeming practice of working from the bottom area on one side of the figure around it to the other bottom area) results in many inconsistencies even apart from those of tiling, so that a retablo may present a stylized landscape of bumps, trees, and flowers to the left of the figure and a purely decorative pattern of curlicues to the right, or it may present a stylized tile pattern to the left and a piece of what seems to be plowed ground to the right.

Parallel lines and crosshatching have been mentioned above as a modeling and decorative device, especially in painting derivative from woodcuts and engravings; in some New Mexican retablos, these techniques serve to depict the scales of serpents and monsters, especially in representations of San Miguel. But though the pattern generally begins from the left of the beast and fills itself

out cogently and carefully, it usually becomes perfunctory and casual and ends up supplying the wrong modeling entirely. Other than this, crosshatching and parallel lines are used very often merely for patterning.

Another instance of the non-Renaissance quality of New Mexican painting is the almost total absence of stop-action painting— of scenes presented as if a still camera had caught a "slice of life," one crucial moment of an important event in a saint's earthly career. Perhaps only Fresquis' Santa Apolonia in the International Folk Art Collection has such implicit narrative appeal: the wicked soldier is caught in the act of wrenching the saint's teeth out with a great pliers. By contrast, any depiction of the Flight into Egypt is filled with peace and repose; the Holy Family is not hurrying to escape from the dread pursuit of Herod's soldiers. Granted Santiago's brandished spear and granted his horse's lifted forefoot, the warrior-saint is not engaged in mortal combat; the Moors are not his deadly enemies but only his inert attributes.[19]

We have judged the painting mainly by the criterion of the loss of three-dimensional illusion. E. Boyd wrote:

> In little more than one generation three-dimensional painting was discarded for the single picture plane, linear composition, and static rather than animated poses. Narrative compositions were also discarded. Iconographic elements were retained in nearly abstract form, and the folk artists developed styles comparable to those of medieval or preGothic Europe. While this was an anachronism in the nineteenth-century western world it was not in New Mexico where austerity and hazards of living were in many ways comparable to those of the middle ages.[20]

The foregoing corroborates this quotation and suggests a further synthesis: The move from Renaissance perspective into non-Renaissance modes is a consequence of the inability of the vernacular tradition to retain what the provisional tradition of Mexican Baroque had tried falteringly to teach it, namely, the primacy

of the individual eye which judges reality from a fixed point of view in a single instant of time. Visual realism of the sort that was natural for the highly literate, print-oriented, historical-minded Renaissance culture gave way to the conception of space and time appropriate to the post-literate, non-historically-aware culture of traditional New Mexico.

New Mexican art also transcends or at least evades time by its lack of caught motion and of narrative appeal. The statue or painting does not really tell an event of earthly time or show the appearance of an earthly being. It presents instead the eternal condition that has resulted from historical holiness. New Mexican retablos share with Byzantine icons and Romanesque and Gothic painting the tendency to represent Heaven as some depthless two-dimensional habitat of the saint or blessed, but it differs from icons and Gothic art by retaining firmly the *abstraction* from wall (or bowl or earth or shield or body) which we have referred to as picture-space. Just as the pre-literate Pueblo Indians abstracted pottery from storage-cyst and abstracted house from pit-dwelling, so the slightly more visual post-literate Spanish clung to the decidedly more visual Renaissance abstraction which first appeared as easel painting. Thus, due to the geographical isolation and the consequent loss of all need and aptitude for three-dimensional illusion, nineteenth-century New Mexico retablo painting united in its unique combination of approaches to space the Renaissance and the primitive traditions of art; and by pure accident it anticipated cubism and other modern styles of art that have trained even us Anglos to appreciate the work of these Spanish-American masters of deftness and strength.

Notes

1. Marianne Stoller, "The Early Santeros of New Mexico: A Problem in Ethnic Identity and Artistic Tradition," paper delivered to the American Society of Ethnohistory, Albuquerque, 9 October 1976, 32, 36, 46-57, makes a plausible case that early santeros Pedro Fresquis, the anonymous Laguna Santero, and Antonio Molleno were significantly Native American. (The anonymous Quill Pen Santero, likely a Molleno disciple, used quite a few design motifs like those

on Pueblo pottery.) But whatever the santeros' degree of Native American ethnic inheritance, Stoller notes, santos still belong to the Hispanic tradition of religious culture—which of course the Pueblos adhered to along with their own religion.

2. William Wroth, *Christian Images in Hispanic New Mexico* (Colorado Springs: Taylor Museum of the Colorado Springs Fine Arts Center, 1982), 35-39.

3. Carey McWilliams, *North from Mexico* (New York: J.B. Lippincott, 1949), 63.

4. Christine R. Mather, "Religious Folk Art in New Mexico," in Jean Stern, ed., *The Cross and the Sword* (San Diego: Fine Arts Society, 1976), 24.

Of course culture is a human product. But the first three great eras of Western culture, the primitive (tribal), the classical (urban), and the medieval, emerged neither from reflective human awareness nor from free choices based on such awareness. By contrast, the Renaissance was *reflective*, thematic, and deliberate in origin, for it grew both out of men's historical knowledge of two previous periods, the classical and the medieval, and out of their deliberate choice of the former and rejection of the latter. At that moment, the human race began knowingly and freely to choose its cultural destiny—a circumstance that gave rise to the "headiness" and sense of control that marked the High Renaissance.

5. Fray Angélico Chávez, "Genízaros," in *Handbook of North American Indians: The Southwest*, Alfonso Ortiz, ed. (Washington: Smithsonian, 1979), 9:198-200.

6. Wroth, *Christian Images*, 25.

7. Stephen Sharbrough, "El Ciclo de los Pastores," *History of Religions at UCLA Newsletter* 3 (1975), 7-11; E. Boyd, *Popular Arts of Spanish New Mexico* (Santa Fe: Museum of New Mexico Press, 1974), 377, 381, 384, and Francis A. Sullivan, S.J., "The Hidden Madonna of Laguna Pueblo," *Immaculata* (January 1978), 22-24; Fray Angélico Chávez, *Our Lady of the Conquest* (Santa Fe: Historical Society of New Mexico, 1948); Stephen F. de Borhegyi, "El Santuario de Chimayó" (Santa Fe: Spanish Colonial Arts Society, 1956), the six finding stories on 17-19.

8. Thomas E. Chávez, "The Segesser Hide Paintings: History, Discovery, Art," *El Palacio* 92 #2 (Winter 1986), 18-27, and "History Comes Home," *El Palacio* 95 #1 (Fall-Winter 1989), 44-49; Chávez, ed., *Segesser Anthology* (Santa Fe: Museum of New Mexico Press, 1994); Boyd, *Popular Arts of Spanish New Mexico*, 116-43; Wroth, *Christian Images*, 47-50.

9. See Alexander von Wuthenau, "The Spanish Military Chapels in Santa Fe and the Reredos of Our Lady of Light," *New Mexico Historical Review* 10 (1936), 179-94; Eleanor B. Adams, "The Chapel and Cofradía of Our Lady of Light in Santa Fe," *New Mexico Historical Review* 22 (1947), 327-41; and Pál Kelemen, "The Significance of the Stone Retablo of Cristo Rey," *El Palacio* 61 (1954), 243-72.

10. The citations for all of my cursory history of New Mexican santeros will be found in Appendix A.

The first synoptic view of santero styles appeared in José Edmundo Espinosa's "The Discovery of the Bulto-maker Ramón Velásquez of Canjilón," *El Palacio* 61 (1954), 185-90. While writing the first edition of this work and down to the present, I have especially relied on E. Boyd's work, especially the 1969 Museum of

New Mexico International Folk Art exhibit "The New Mexico Santero," the ac-
companying *El Palacio* article "The New Mexico Santero," (76, 1 [Spring 1969],
1-24, also issued as a booklet), the subsequent *magnum opus Popular Arts of Spanish
New Mexico,* and E's gracious and generous personal help.

11. Christine Mather, *Baroque to Folk* (Santa Fe: Museum of New Mexico In-
ternational Folk Art Museum, 1980), esp. 15-16.

12. Yvonne Lange conjectured that early santero art was modeled on the
inexpensive woodcuts of the eighteenth century, not on the more expensive et-
chings and engravings of that period or on nineteenth-century lithographs
because the latter were too sophisticated for New Mexican santeros to follow;
"Lithography, an Agent of Technological Change in Religious Folk Art," *Western
Folklore* 33 (1974), 51-64, and "In Search of San Acacio: The Impact of Industrializa-
tion on Santos Worldwide," *El Palacio* 94, 1 (Summer-Fall 1988), 18-24. As a possi-
ble extension of that thesis, let me speculate that the early New Mexican santeros
made gesso-relief panels in an attempt to retain some of the three-dimensionality
of the better eighteenth-century graphics from Europe and New Spain. But as
Lange makes clear, in the long run the simpler woodcuts and other popular prints
prevailed.

13. Boyd, "The New Mexico Santero," 11-12.

14. Conversation of May 1969; *New Kingdom of the Saints,* 85, 87.

15. A love of the theater may have led Fresquis to depict a number number
of rare subjects that appeared in the religious folk drama of the era: The Flight
into Egypt, Christ's Triumphal Entry into Jerusalem, Veronica's Triple Rostro, San
Longino, Nuestra Señora de la Manga, and the Mass of St. Gregory.

16. Following up on note 12, another addendum to Yvonne Lange's thesis
might go like this: About twenty-five years after the Santa Fe Trail opened up,
retablo painting tapered off due (1) to the excessive sophistication of the
lithographs as models—too hard for the santeros to follow, and (2) to the abun-
dance of inexpensive prints which undersold and simply preempted the market
for new retablos ("economic factors," 57 in the *Western Folklore* article). There were
some early borrowings from the lithographs—swags of drapery and pedestals
(*New Kingdom of the Saints,* 212, plate 189) and some deflection into bultos with
niche-like body-halos to compensate for the deep-background illusion the
lithographs presented by their realistic depictions of architecture, statuary, and
landscape.

17. Compare Gerardus van der Leeuw, *Sacred and Profane Beauty* (London:
Weidenfeld and Nicolson, 1963), 178: "In a work of art, religion fears the presence
of an idol, and with good cause. Therefore, 'the rough and ugly image is of more
service to it than the beautiful one; it does not draw the spirit out into the fullness
of the world, where it can enjoy itself in freedom, but throws it back upon itself
with a violent shove.' For this reason the Greeks preferred the *xoanon* [rigidly
non-realistic statue] to the works of art of one of their great masters."

18. Sister Lilliana Owens, S.L., *Jesuit Beginnings in New Mexico, 1867-1882* (El
Paso: Revista Católica Press, 1950), 117; Thomas J. Steele, S.J., *Works and Days:
A History of San Felipe Neri Church, 1867-1895* (Albuquerque: Albuquerque

Museum, 1983), 69, 104. A descendant of Don Ambrosio Armijo and Doña Candelaria Griego de Armijo still has the Nuestra Señora de los Dolores, a late-eighteenth-century Mexican hollow-frame bulto.

Noting that the prevailing wisdom half a century ago held that the ejection of santos from the church was "credited to some sort of order from Bishop Lamy," Willard Hougland concludes that "there is no proof" that such an order ever existed; "Santos — 1948," *Saints of the Land* (Santa Fe: San Vicente Foundation, 1948), 6. Indeed, neither the purported document nor any reference to it has been discovered up to the present.

Following up on notes 12 and 16, a final grace-note to Lange's thesis: about a quarter of a century after the arrival of the railroad (1879-80), bulto-making tapered off except for the specialties made for morada processions and dramatizations. Hence from the 1910s to the 1960s (with the exception of the brief W.P.A. revival of the 1930s) santo-making shrank to unpainted bultos, with very few retablos being made except unpainted low-relief panels.

19. For a long recital of particular examples, the reader is referred to pages 19-25 of the earlier editions of *Santos and Saints*.

20. Boyd, "New Mexico Folk Arts in Art History," *El Palacio* 72 (1965), 12.

Saint Isidore the Farmer (#89 in Appendix B) by José Benito Ortega. The tininess of oxen and angel, mere attributes of the saint, indicates Isidro's relative importance. Bequest of Cady Wells to the Museum of New Mexico, Museum of International Folk Art. Art.

III

The Holy Persons
God, Virgin, Angels, Saints

B etween the late eighteenth century and the beginning of the twentieth, New Mexican santeros depicted a hundred and sixty-odd subjects that fall into five main groups: (1) the divine persons—God the Father, Christ, and the Holy Spirit; (2) Mary according to various titles or advocations; (3) the angels; (4) the male and female saints; and (5) the impersonal and allegorical subjects.[1] Examination of the four groups of holy persons leads me to conclude that, with rare but important exceptions as noted, these subjects operate at three levels of human need: the divine persons act in a preserve of their own, that of eternal salvation, the Virgin and the angels act in a middle realm, and the saints take care of more earthly needs.

DIVINE PERSONS

The Trinity and most titles of the adult Christ tend to be strongly associated with general and transcendent needs. The people of New Mexico commonly prayed to the Trinity, for instance, for enlightenment, favors of immediate need, thanksgiving, faith, harmony and peace, and protection against all temptations and all enemies.

Granted always the concrete character of the person's present need, only in prayers for protection from storms and from "locusts, earthquakes, and famine" is the request particularized; it is as if the Christian collective unconscious remembers the elemental thunder-and-lightning sky-god who lies slightly beneath the surface of Genesis, Exodus, and some of the older psalms. Indeed, when the Trinity is represented as three men's heads sprouting from a single torso or as three equal men standing or sitting side by side, they are often shown grasping a single bar, which is both a symbol of unity-in-multiplicity and a literal (if stylized) lightning bolt.[2] The general and transcendent nature of the power of Christ, as the New Mexican people understood it during the last century, is suggested as well by petitions concerning the salvation of the world, acceptance of suffering, faith, pardon for sins, sanctity, "all needs," and a peaceful death.

God the Father, the Holy Family (Joseph and Mary flanking the child Jesus, a kind of alternate earthly trinity), and the Sacred Heart tended to foster and protect the family. The most popular of the three, the Holy Family, was keyed most strongly to the needs of the family; the Sacred Heart was seldom represented by the santeros.[3] God the Father and Saint Joseph are strong father figures.

Certain representations of Christ are connected with the devotional practices of the Brotherhood of Our Father Jesus. That expiatory confraternity practiced severe penances for the sins of all the people of their village, and on Good Friday they sometimes reenacted the crucifixion of Christ by tying one of the Brothers to the full-sized cross he had carried to their "Calvary." Especially apt to have strong or exclusive Brotherhood interest are Jesus Burdened with the Cross, Jesus the Nazarene, and the crucifix that emphasizes the wounds and blood, particularly if they are large statues with hinged shoulders that can be put through the various actions of the Passion like nearly-lifesized puppets. At any rate, these artifacts were intimately related to the Brothers' concerns, and in them Christ probably took on much of the father-figure status that is suggested by their title for him as patron of their confraternity, Nuestro Padre Jesús Nazareno. It may be possible to read this protective, pater-

nal status into the Sacred Heart images just mentioned.

Christ as a child appears with his mother in various of her titles, with his parents in the Flight into Egypt and Holy Family tableaux, and by himself as the Santo Niño, the Santo Niño de Atocha, the Niño Perdido, and the Niño de Praga. When Christ appears as an infant with Mary, he is an attribute of his mother rather than a subject in his own right. In the Holy Family and Flight into Egypt representations, the child is inserted into a family constellation as the son (though of course "secret-father" and "hidden-life" associations complicate the son-archetype a great deal). Especially as Niño de Atocha and Niño Perdido, the Christ Child operates as a figure in his own right, the patron of travelers, of those who are lost, and especially of those who are held captive by Indians. As such he seems a younger-brother figure.

When he is an adult, by contrast, Christ participates fully in the transcendence of the godhead. By his passion and death, he causes the sacramental actions of his Church on earth and the resulting supernatural transformations of believers, and thereby he is the source of life everlasting. Hence the people of New Mexico call him Nuestro *Padre* Jesús.[4]

TITLES OF MARY

The Madonna occupied in nineteenth-century New Mexican piety a position superior to that of the angels and saints but not equal to that of the Father or Christ. She was not deified, but she was regarded as superior to any other created person, for she was a personage of great power, not a sentimental figure of mere maternal good wishes.

Specific requests connect with various titles. Our Lady of the Angels (Nuestra Señora de los Angeles) did assume a certain maternal aspect by implication, since angels were traditionally associated with the particular care of children, becoming as it were their powerful elder foster-brothers and indeed generally assisting all Christians of all ages. Our Lady of the Candlesticks (Nuestra Señora de las Candelarias) was associated with blessed candles and with Lent, and hence perhaps with the activity of the penitential Brotherhood.[5] The Immaculate Conception (Nuestra Señora de la

Purísima Concepción) tended to be associated with purity, Our Lady of Help (Nuestra Señora del Socorro) with curing illnesses, and Our Lady of the Rosary (Nuestra Señora del Rosario) with consolation in bereavement. On the other hand, certain titles of Our Lady such as Our Lady Refuge of Sinners (Nuestra Señora Refugio de Pecadores) seem to have had penitential Brotherhood connections, and Our Lady of Sorrows (Nuestra Señora de los Dolores) and Our Lady of Solitude (Nuestra Señora de la Soledad, Mary dressed as a nun after the death of Christ) took a leading role in the Brothers' reenactments of the Passion. Nuestra Señora de la Soledad is Our Lady as crone, as daughter, wife, and mother now orphaned, widowed, and childless, and so she is the powerful patron and model of elderly women living alone.

In certain of her forms, Our Lady took on the function of controlling monsters. In this role, she appeared under the titles of Our Lady of Angels, of Mount Carmel, of Light, of the Immaculate Conception, and (by implication, as has been said) of Guadalupe. The first four Madonnas are all shown overcoming dangers of various sorts on behalf of mankind. Our Lady of Angels and of the Immaculate Conception appear with serpents at their feet to symbolize their power over the devil; Our Lady of Light draws a soul (an unclothed or scantily clothed young person) from the mouth of a monster; and Our Lady of Mount Carmel helps souls that are trapped in the flames of Purgatory. In general, these titles deal with the human fear of being trapped in close confinement of any sort, and in the Catholic setting of last-century New Mexican piety they clearly suggest death, devils, and hell. The whale-like monster of Our Lady of Light retablos is in effect the same whale that swallowed Jonah in the Old Testament and which as a sign of death formed the "sign of Jonah" in the New (Matthew 12:39; Luke 11:29). Along with the snakes and flames, it is akin to the lion which Carl Jung says is "an emblem of the devil and stands for the danger of being swallowed by the unconscious," and which Erich Neumann says "bears all the marks of the uroboros. It is masculine and feminine at once. The fight with the dragon is thus the fight with the First Parents, a fight in which the murders of both father and mother, but not of one alone, have their ritually prescribed

place."[6] These activities of Nuestra Señora suggest gender rever-
sal, for she performs the task of conquering monsters usually
assigned to male figures.

Whether in her own person or through her close association
with the suffering Christ, Our Lady in certain of her titles saves
the petitioner from monsters. In one of the alabados, the great
hymns of Hispanic New Mexico especially dear to the penitential
Brotherhood of Our Father Jesus the Nazarene, Our Lady of
Solitude is addressed as follows:

> your power is so great
> Against the wicked Satan
> That you save the souls
> From eternal fire. . . .
>
> If to Purgatory our colleagues go,
> We pray you, oh Mary,
> That you immediately save them.

The Virgin of Mount Carmel is shown in santero art holding her
scapular, a religious badge of cloth and ribbons and worn around
the neck in dedication to the SeNora de Monte Carmen. An alaban-
za addresses her thus:

> Your scapular is the
> Sacred chain
> With which the big dragon
> Can be bound.

In alabanzas sung to Our Lady of the Immaculate Conception, por-
trayed by the santeros standing either on a serpent or on a cres-
cent moon, these stanzas occur:

> From that most cruel snake
> That aims to destroy us
> You must deliver us
>
> Being the most loved daughter
> Of the beloved Eternal Father,
> Deliver us from Hell
>
>

> Satan finds himself
> In greater pains,
> Since Mary binds him
> With stronger chains.[7]

Thus the Lady stands very conspicuously to the forefront in the scheme of salvation according to New Mexican folk theology, but she does not so much provide the positive benefits as remove the dangers, Satan and Hell and their various serpent and monster symbols.

THE ANGELS

The angel in New Mexican santero art serves as God's messenger or his theophany, and he is associated with lightning, serpents, and a quite ambiguous masculinity. Four angels appear in New Mexican folk art: Gabriel, Michael, Raphael, and the Guardian Angel. San Gabriel and the Guardian Angel are infrequently represented; of the nine Gabriels, five were originally attached to crucifixes, holding a cup under the wound in the side of the dead Christ.[8] Rafael is clearly a soul-guide (psychopempsos) as in the Book of Tobit, where he served as traveling companion, guardian against monsters, and healer for the humans in his care.

San Miguel Arcángel's iconography defines him as a military guardian battling against evil and especially against the devil. This function derives from the Apocalypse of the New Testament: "Michael and his angels fought against the dragon" (Rev. 12:7), and manifests itself in the usual depiction of Michael standing on a serpent—in New Mexico, often a giant rattlesnake—treading it down as Guadalupe does her moon and angel. It is interesting to speculate that in this characteristic Michael joins the Blessed Mother under the titles of Angels, Light, Mount Carmel, Immaculate Conception, and Guadalupe in being a specific protector against cosmic dangers—devils, Hell, the irruption of the unconscious, the fearsome unknown agencies that most people prefer not to think about. That Michael and Mary work together against these forces is strongly suggested by the lettering on a Fresquis retablo of the archangel: "Lord Saint Michael, First Colonel of the Squadron of Most Holy Mary, Defend Us."[9]

THE MALE AND FEMALE SAINTS

The majority of the santo subjects are male and female saints, holy men and women from earlier days of the Christian era—and some few from the Old Testament period—down to the sixteenth and seventeenth centuries. By and large, these saints prove to be far less generalized and transcendent in their function than are most of the titles of God and Christ, and far less concerned with protection from cosmic evil than the archangels and the titles of Our Lady studied above.

There is almost no monster material among these saints. There are three exceptions to this rule: Giles, Jerome, and Ignatius Loyola. San Gil Atenogenes (Aegidius, Giles born in Athens), shown in the few santos of him that are extant with a doe that took refuge with him when it was pursued by hunters, sometimes appears to be in the company of a monster of some sort, since the "doe" has often been metamorphosed into a misshapen, deformed creature.

San Gerónimo is almost always shown with a lion at his feet, following a European convention of iconography where the lion was a benevolent animal because the saint had removed a thorn from his paw, and so in gratitude it acted as wrangler for the monastery's donkey. The application of the traditional Androclus-and-the-lion tale to Jerome suggests a reversal of the division between man and animal that began with the original sin; this kind of story is to be expected in connection with founders of religious orders, who have restored Eden, reconciled men and women with God, among themselves, and with subhuman nature. But New Mexican santeros were so unfamiliar with lions that the beasts soon turned into monsters, so Jerome became a monster-controller as well as a patron of penance. Further, the trumpet of God's voice sounding in his ear has sometimes been identified as the archangel Gabriel's trumpet announcing the end of the world, and one respondent identified Jerome as patron of orphaned children, a task assigned to angels; if there is anything to either of these interpretations, then the angelic associations could reinforce the saint's status as protector from diabolical forces.

San Ignacio de Loyola became for New Mexican Spanish of past centuries a protector against witchcraft. This power derives from

an earlier version of his biography and his powers still popular only in New Mexico, where he still defends his clients against the threat of witchcraft. He is also credited, strangely, with founding or at least organizing the Brotherhood of Our Father Jesus.

Certain of the advocations of Christ and Mary are special patrons for the penitential Brotherhood of Our Father Jesus the Nazarene. A fair number of ordinary saints possess similar associations. The mythical Saint Acatius and St. Liberata were both supposed to have been crucified, and so they participated (in a folk-Platonic manner) in the crucifixion of the Lord.[10] Saint Philip of Jesus was tied to a cross and then killed with spears. Longinus, whose name derived from the Greek word for a lance, was traditionally assigned to the centurion at Christ's death who "with a spear pierced his side, and straightway there came out blood and water" (John 19:34). Saint Veronica (name and story both folkloric) was the woman who wiped the face of Christ on the Way of the Cross and found that he had left an imprint (or three imprints) of his face on the cloth.

Saint John Nepomucene and Raymond Nonnatus were the Brothers' patrons of privacy and secrecy, San Juan because he was drowned for refusing to reveal to the wicked king of Bohemia the contents of the queen's confession, San Ramón because his captors padlocked his lips shut when he refused to stop preaching while in Moorish slavery.[11] Saints Rita of Cascia, Rosalia of Palermo, and Jerome (the last little thought of in New Mexico as a scholar and doctor of the church) were noted for their practice of penance. Saint Francis of Assisi is regularly shown with the skull and stigmata connecting him with the Passion, and he was the major patron of the penitential Brotherhood; the birds and bunnies are twentieth-century romantic substitutions for his authentic attributes. Saint Peter was a special patron of a happy death, and the Brothers seem to have had an exclusive interest in Doña Sebastiana, an allegorical image of death as a skeletal woman seated in a cart to be found in every morada a century ago.[13]

Other saints aided the New Mexican vecinos in their unending struggle with a recalcitrant earth. "Can we even begin to realize," asks J.H. Plumb,

Saint Isidore the Farmer (#89 in Appendix B) by Luis Aragon. This later santero, who died in 1977, worked mainly in natural woods. Regis University Collection.

the anxiety of an agrarian society which lived on the
margin of existence, dependent entirely upon the
whims of weather? One year may be an abundance, a
glut of food, for all; and the next year maybe with
crops shrivelled or blackened on the stalk; starvation
certain for all and death for the old, the weak, and the
young. And yet this is how our ancestors lived in
Western Europe and Africa. The vast majority never
knew security in their basic needs. The average span of
life in Elizabethan England was twenty-six, less than
the poorest and most famine-ridden Indian peasant of
today. The pot bellies and protruding eyes of starving
children were more a part of the Elizabethan scene
than madrigals.

Such fears about the harvest bred anxiety, heighten-
ed fear, and made the peasant hysterical, hag-ridden
with fearsome specters. The terrors of hell, of Ar-
mageddon, of sorcery, of witchcraft, of devilment
everywhere abounded.[14]

Even bracketing all the preternatural terrors, the natural obstacles
to subsistence and survival were ample in the New Mexico of the
late eighteenth and early nineteenth centuries to keep the saints
busy. Fostering the crops was particularly the job of Saint Isidore
of Madrid, the year-round patron of farmers, but Lawrence gave
him some temporary help during the month of August.

A central component of the food-raising efforts of the New Mex-
ican peasant communities of the last centuries was the communal
irrigation system, a feature of every Spanish and Pueblo village.
Saint John Nepomucene suffered martyrdom by drowning, and
therefore he became the patron of the communal work of ditching
and irrigating which was so important in sustaining the village. In
like manner, Saint John the Baptist, whose epithet suggests water,
was the patron of water in all its forms, and on his feast day in June
all the water in the world became purified of all disease.

The New Mexicans were herders as well as farmers, and their
cattle and sheep needed several special patrons. Santa Inés del
Campo (Saint Agnes of Benigamin) is an Artemis-Diana figure, a

patroness of purity, of the outdoors, and especially of sheep and shepherds (perhaps because of the likeness of "Agnes" to the Latin word for lamb, *agnus*). Santa Inés is shown in santero art with some lambs in the background, and she thus resembles Our Lady as a Shepherdess (Nuestra Señora como Pastora or La Divina Pastora). Saint Anthony of Padua and Saint John the Baptist also seem to have served as patrons for all domesticated animals. For horses and mares and for men and women riding horses, Saint James and Saint Anne were the patrons, Santiago because he always appears on horseback in santero art, Santa Ana because her feast day falls on 26 July, the day after Santiago's. Saint Pascual Baylon, due to his having worked as a shepherd before he joined a religious order, served as patron of shepherds and sheep.

Until the First World War, a great many New Mexican villagers lived in an unmechanized agrarian world much like that of the Chinese peasants described by Fred Cottrell:

> The size of farm that can be worked by a man and his wife alone is too small to support a family. As a result children must work; in the absence of children the older adults will starve . . Economic reciprocity between parents and children tends to become a necessity in societies that are dependent on organic converters. Children supply in these areas what is secured in in- dustrial societies through unemployment, health, and disability insurance, and old-age allowances. Parents develop in the child values that will ensure their own survival.[15]

Hence in New Mexican villages, strong family ties, obedience of young children to their parents in the prime of their lives, and generosity of grown children to their aged parents were very im- portant values, and so the saints served often as patrons and sup- porters of the traditional family values of the agrarian world.

God the Father and Saint Joseph, frequently in New Mexico accorded the epithet "Patriarca—patriarch," have been mentioned already as father-figures, and the Sacred Heart and the Holy Family were patrons of the entire family. In addition to these four subjects, Santa Ana is the patroness of mothers and grandmothers, the lat-

ter an extremely important function in an extended family. Saint Rita of Cascia, although she was the victim of an unhappy marriage unwillingly entered into (she had wanted to become a nun), is patroness of young women in need of a husband; Anthony of Padua and Rosalie of Palermo aid a young woman in the selection of a husband, and Rosalie is also the patroness of engaged couples. Inés especially guards the purity of young girls, and Mary Magdalene aids the unchaste to repent and reform. Saint Raymond Nonnatus, a Caesarian birth from a dead mother as his name suggests, is patron of the unborn, of women during pregnancy and childbirth, and of midwives. Saints Stanislaus and Aloysius Gonzaga, boy saints of the Jesuit order, are patrons of growing children along with Philip of Jesus and Gertrude.

In a society which had to rely on the most primitive sorts of folk medicine, the people often called on the saints for help in combating illness. In this wide field a number of the saints became very definitely specific to certain definite disorders or areas of the body. Thus Saint Roch protects against troubles of the skin, plague, and especially smallpox; Saint Rosalie of Palermo defended her devotes against the plague. Saint Blaise guards against throat trouble, Saint Apollonia against toothache, Saint Lucy against disease of the eye. Saint Lawrence, who was burned to death, protects from burns, and Saint Barbara guards persons against lightning. Thus the New Mexico saints fend off the most important threats to the health of the body.

In summary, the santero subjects who save their clients from monsters occupy a kind of middle position within the complex structure of the New Mexico Spanish patronage system. Above these subjects are the Trinity, God the Father, the Spirit, and the adult Christ in his passion. Beneath them are the ordinary saints who deal with more natural, less ultimate, less heroic matters.

The protectors from monsters that have been isolated for study arc Our Lady under the titles Ángeles, Carmen, Guadalupe, Luz, and Purísima Concepción; the archangels Miguel and Rafael; and the saints Gerónimo, Gil, and Ignacio. The count of these ten fair-

ly popular subjects from my study of a thousand santos reveals a total of 189, with 44 from the earliest period, 110 from the 1815-1850 era, and 22 from the concluding period of santero folk art; another thirteen cannot be assigned to a period. Omitting this last group of 13, we find that 12.5% of the santos representing monster-saviors derive from the concluding period, though 17.9% of the total sample does. The lessening demand for these santos probably suggests the better protection from such real danger as roving Indians that resulted early on from improved Santa Fe Trail trade and later from the protective presence of the United States Army. But the protector saints may have lost a lot of their popularity because of the newly introduced Anglo world-view, which took a self-confident and optimistic attitude toward the human condition in this world. This attitude tended to scoff at villagers' global fearfulness and their tendency to interpret the course of daily events as being largely governed by the power of devils and witches.

It may be that when these fears disappeared, they did not so much cease to exist as lower their profile. Robert Bellah, writing in the classic *People of Rimrock,* suggests as much: "Belief in the devil, witches, and ghosts is strong in Atrisco [San Rafael in Cíbola County] These beliefs are strongest in women and are in some degree a projection of the fear of possible sexual attack by males." And Ari Kiev, studying the psychological aspects of Texas-Mexican curanderismo, corroborates Robert Bellah when he says, "There are a number of standardized and culturally acceptable objects of fear such as ghosts, witches and snakes. They provide individuals with ready-made, culturally acceptable fears, thus reducing the need to develop idiosyncratic fears and phobias."[16] The survival of such fears, taken together with the decline of traditional santo-making, points to the breakdown of the coherent system of patron saints attuned to the principal hopes and fears of traditional society. When large numbers of printed pictures of saints to whom no veneration had been paid before arrived in Santa Fe Trail wagons, they undercut the demand for painted retablos, and when plaster statues of saints previously unvenerated in New Mexico arrived on the railroad, they undercut the demand for bultos. But equally, this plethora of new saints destroyed the inner coherence of the old

Saint George (#91 in Appendix B) by Luis Aragon. Compare this rare subject with the illustration on page 17 of Willard Hougland, American Primitive Art. Regis University Collection.

system of patrons of hopes and protectors against fears.

Finally, what is to be made of the relative status of the various personages who made up this old system, as they appeared to the people of the time? George Mills and Richard Grove, writing about the penitential Brotherhood, offer a starting point for answering this question for the wider culture:

> The saints and holy figures link human needs, God's transcendence, and the recalcitrancy of human nature. In the Spanish-American view, the saints function in a special way, leaving God an aloof, inscrutable, and unpredictable authority. Numerous stories suggest that the saints have three characteristics: 1) being humanized, they are made aware of local conditions as if by means of human senses, 2) they exercise direct power, 3) their exercise of power may have wrong consequences.[17]

A respondent to my questionnaire volunteered that in the view of the older generations, the saints had independent power in certain areas given them by God to use as they saw fit.

I would like to suggest that the people fairly clearly differentiated the four groups—the divine persons, the Blessed Mother, the angels, the saints—into three clusters on the basis of needs, of hopes and fears, associated principally with each group. As already noted, these clusterings were perhaps best described in terms of the three traditional realms of being: the supernatural, the preternatural, and the natural. Santos representing the Deity—the Trinity, God the Father, God the Spirit, and the adult Christ in his Passion—were most at home in granting favors in the realm of the strictly supernatural, which had to do with faith, charity, holiness, and eternal happiness. The Christ Child concerned himself with family coherence, the safety of travelers, the release of prisoners, the return of those who had gotten lost. Whereas a "mature" divine person served as a father-figure (Nuestro Padre Jesús Nazareno), the divine Niño served as a brother figure.

The second level, the preternatural, included first of all Nuestra Señora under the various titles that identify her as the one who

saves us from the serpent-devil, with whom she was sharply contrasted in the old Roman Catholic translation of Genesis 3:15: "I will put enmities between thee and the woman, and thy seed and her seed: she shall crush thy head, and thou shalt lie in wait for her heel." But Our Lady also served as a figure of security in a peasant world in which everywhere one looked was frontier in the American sense of that word: the vague boundary of all that is unbounded, undefined, beset by unknown and unknowable dangers from demons, imaginary monsters, witches, ghosts, snakes, and centipedes. And the Señora also had duties closer to the supernatural realm, having to do with some of the conditions and occasions of salvation as such. All in all, she was the protective mother perceived as the strong helper and sturdy defender; there was little of the merely sentimental in the New Mexican view of her.

The angels as saviors from monsters protect from preternatural evil and moreover serve to guide the soul into the afterlife. As the Virgin is the maternal figure, they are the elder-brother figures, the protective hermanos mayores of each man's and woman's pilgrimage through this world and into the next.

The saints were elder brothers and elder sisters to mankind; even the youngest of them, Stanislaus and Aloysius, Flora and Inés, were older than the children whose special patrons they were. Their realm of activity was for the most part restricted to the natural world of crops and animals and family serenity and health—the less ultimate, less cosmic, less salvation-oriented matters of the people's lives.

Thus the saints as patrons and protectors summarized quite coherently and quite completely the New Mexican hopes and fears of the late eighteenth and early nineteenth centuries. These were the hard-won values of a peasant world surrounded by hostile Indians, farming and ranching arid lands in the environs of small villages, living in family homes adorned with wooden saints. And these holy persons validated, protected, and enhanced every important aspect of this life which the people could bring to consciousness, and their roots sank deep into the universal human psychic substratum so as to unify the experience of their people

and form it into the comprehensive, coherent, and meaningful lives of Catholic Christian men and women.

Notes

1. These five groups make up Appendix B. The addendum to Appendix B lists the thirty most popular subjects.

The questionnaire I circulated to certain selected persons in northern New Mexico, southern Colorado, and the Hispanic neighborhoods of Denver during the early 1970s requested information concerning eighty subjects from this list; in the 1974 and 1982 editions of Santos and Saints, the eighty are marked in the appendix by asterisks.

2. Corroborated by E. Boyd, conversation of 10 August 1972. God the Father holds such a bolt in the Taylor Museum's #1232, shown in Robert Shalkop, *Wooden Saints* (Colorado Springs: Taylor Museum, 1967), 55. Although on 54 Shalkop identifies the item as merely a scepter, I think it is a lightning-bolt used as a sky-god's power symbol.

On 11 August 1628, Pope Urban VIII forbade the representation of the Trinity as three male heads sprouting from a single trunk; he quoted the argument of Antoninus of Florence (*Summa Theologica Moralis* 3.8.4.11) that "it is a monstrosity by the very nature of things—quod monstrum est in rerum natura." On 1 October 1745, Benedict XIV repeated this prohibition, allowed the toleration of the dead Christ in the Father's lap with the Spirit as dove, and decreed that the representation of the Trinity as three equal men seated side by side should not be fostered but that it had to be tolerated because God appeared to Abraham as three angels (Genesis 18); "Sollicitudini Nostrae," # 28. On 16 March 1928, giving no reasons, the Holy See forbade this last representation; *Acta Apostolicae Sedis* 20 (1928), 103. New Mexico seems never to have gotten any of these messages. See Shalkop, *Wooden Saints*, 60; Donna Pierce, "The Holy Trinity in the Art of Rafael Aragon," *New Mexico Studies in the Arts* 3 (1978), 29-33.

3. The devotion to the heart of Christ was long connected to the thirteenth-century Santa Gertrudis, and the heart forms part of her iconography; but the present devotion dates only from seventeenth-century France. A few Sagrado Corazón retablos date from the classical santero period (1790-1865), but the subject became highly popular only in the latter part of the nineteenth century with the arrival of European-American prints, contemporary European pieties, and the Italian Jesuits (1867).

4. William Wroth suggests in *Christian Images in Hispanic New Mexico* (Colorado Springs: Taylor Museum, 1982), 10-18, that the principal emphasis in Eastern Christianity from the apostolic age until the present and in the West until Bernard of Clairvaux was to raise mankind to God by divinization, but that since Bernard the West has emphasized God's coming down to the place of guilt—of sin and the need for forgiveness. We might add that in New Mexico until recently

the Western emphasis has included bringing the heavenly saints down to the time and place of shame—of lack of control and the need for help.

5. Nuestra Señora de los Candelarios is the name sometimes mistakenly given to images of Nuestra Señora de San Juan de los Lagos (a city in Mexico); see E. Boyd and Frances Breese, *New Mexico Santos and How to Name Them* (Santa Fe: Museum of New Mexico Press, 1966); letter of E. Boyd, 27 July 1972. See items 29 and 45 in Appendix B for further information.

Why the mind-boggling multiplicity of Mary's titles? As Christian folklore has developed him, the devil is a shapeshifter, and we might conjecture that in order to keep up with him Mary has to assume a multitude of local names and iconographic forms. Or alternately, Mary the type of the Church might need to localize and particularize herself in all the regions where the church wishes to be real. Her two dozen or so New Mexican advocations are only a trifling sample of her worldwide repertoire; Frederick G. Holweck, *Calendarium Liturgicum Festorum Dei et Dei Matris Mariae* (Philadelphia: American Ecclesiastical Review, 1925), listed about 300 pages of titles of Christ and Mary, each with its feast day, and three-quarters of these were Mary's.

6. Carl G. Jung, *Psychology and Alchemy* (New York: Pantheon, 1953), 172; Erich Neumann, The Origins and History of Consciousness (New York: Pantheon, 1954), 153.

7. I found all the stanzas in Laurence F. Lee, "Los Hermanos Penitentes," *El Palacio* 8 (1920), 13-16. The first two stanzas are odd insertions in "Venid Almas Devotas"; the third is from "Salve Virgen Pura"; the fourth and fifth are from "Ave María Purísima"; the last from "Concebida en Gracia."

8. This is my identification. It is suggested by Gabriel's association with the start of Christ's earthly life in being the messenger of the sky-god's fertility and by his attribute of a chalice when he is not attached to a crucifix (though, incidentally, he usually appears only as one of the three major archangels in a painting or altarscreen). See Denver Art Museum collection, A.US.18.XIX.110; José Aragon reredos in the Santuario at Chimayó, identified as item h of reredos A in Stephen F. Borhegyi, "The Miraculous Shrines of Our Lord of Esquipulas in Guatemala and Chimayó, New Mexico," *El Palacio* 60 (1953), 107; and Rafael Aragon's San Miguel del Valle altarscreen.

9. Erich Neumann, *Origins*, 162, refers to the destructive maternal-unconscious as "the archenemy of the hero who, as horseman or knight, tames the horse of unconscious instinct, or, as Michael, destroys the dragon. He is the bringer of light, form, and order out of the monstrous, pullulating chaos." Walter J. Ong, S. J., conjectures that the Romantic movement became possible only when Western learning and technology had advanced enough that men could "face into the unknown with courage or at least equanimity as never before," *Rhetoric, Romance and Technology* (Ithaca: Cornell University Press, 1971), 278. The Fresquis retablo is #2865 of the Museum of New Mexico collection.

10. For the sources of the legends, see Roland F. Dickey, *New Mexico Village Arts* (Albuquerque: University of New Mexico Press, 1949), 157; José E. Espinosa, *Saints in the Valleys* (Albuquerque: University of New Mexico Press, 1967 [orig.

1961]), 92-94; and Hippolyte Delahaye, S.J., *The Legends of the Saints* (Notre Dame: University of Notre Dame Press, 1961), 109-10, 206, 209.

11. For San Juan Nepomuceno: E. Boyd, *Saints and Saint Makers of New Mexico* (Santa Fe: Laboratory of Anthropology, 1946), 133; Richard E. Ahlborn, The Penitente Moradas of Abiquiú (Washington: Smithsonian Institution Press, 1968), 139-40. For San Ramon Nonato: intrinsic evidence backed by questionnaire information.

12. See the comments of Robert L. Shalkop, *Arroyo Hondo: The Folk Art of a New Mexican Village* (Colorado Springs: Taylor Museum, 1969), 42, on the retablo of San Pedro (Taylor Museum collection #1676) with notations on the back of the deaths of members of the lower morada, 1916-43. The keys also suggest Peter as a psychopempsos figure, and see Acts of the Apostles 12:6-11 and the widespread notion that Peter keeps the door of heaven.

13. On the Death Cart as nearly always and only found in moradas or in chapels controlled by the Brotherhood, I have the word of informants and no evidence to the contrary. Ahlborn, *Penitente Moradas,* 138, states that the presence of the image "clearly marks a building as a penitente sanctuary." The late E. Boyd told me in a conversation of 10 August 1972 that a tradition in the family of santeros José Dolores and George López tells José's father Nasario Guadalupe made the first New Mexican death-image about 1860. See also Margaret Miller, "Religious Folk Art of the Southwest," *Bulletin of the Museum of Modern Art* 10 ## 5-6 (May-June 1943), 5, and Thomas J. Steele, S.J., "The Death Cart: Its Place among the Santos of New Mexico," *Colorado Magazine* 55 (1978), 1-14.

14. J.H. Plumb, *In the Light of History* (Boston: Houghton Mifflin, 1973), 197-98.

15. Fred Cottrell, *Energy and Society* (New York: McGraw-Hill, 1955), 37. Cottrell adds in the full version of the fourth commandment, "Honor your father and mother that you may have a long life upon the land."

16. Evon Z. Vogt and Ethel M. Albert, eds., *People of Rimrock* (Cambridge: Harvard University Press, 1966), 252; Ari Kiev, Curanderismo: Mexican-American Folk Psychiatry (New York: Free Press, 1968), 99.

17. George Mills and Richard Grove, *Lucifer and the Crucifer: The Enigma of the Penitentes* (Colorado Springs: Taylor Museum, 1966), 34-35.

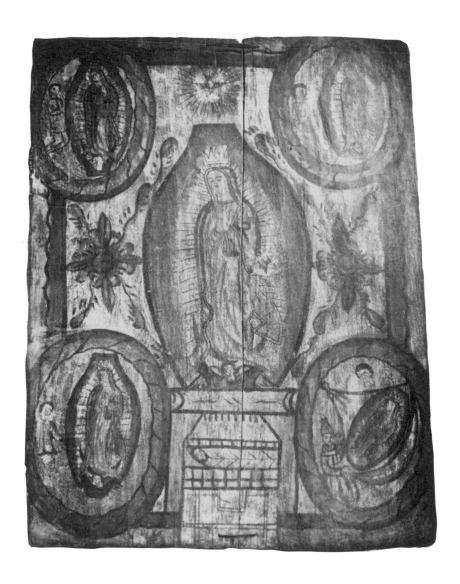

Our Lady of Guadalupe (#33 in Appendix B) by José Aragon. The cartouches in the corners show the principal episodes of the series of apparitions. From a private collection, with permission.

IV

Old Saints in a New Land

Spain's special manner of being Roman Catholic and the group of saints she addressed in prayer and depicted in art evolved during her seven-century-long domestic crusade against the Islamic Moors. The successful conclusion of this "holy war," in the same year that Columbus discovered America, turned the prodigious Spanish energies outward, especially into the western hemisphere, and they flowed ceaselesssly in the track of such men as Pizarro and Cortés until, just over a century later, a terminal Spanish settlement began in northern New Mexico among the Pueblo Indians. The colony was an oasis of agriculturalism and pastoralism surrounded by vast areas dominated by hunting and gathering tribes—the Navajos and other Apaches, the Comanches, Utes, and Pawnees, and the dozens of other nomadic peoples who made contact during the following centuries with the Pueblos and Hispanics through occasional trade and frequent skirmishing.

Understandably, many of the religious and cultural configurations which the Hispanic people had developed during those many centuries of struggle against the Muslims traveled into the New world with the conquistadores and the settlers who were their heirs.

Here, of course, the attitudes had to be reapplied so they could be brought to bear upon situations that no longer dealt with Muslim "infidels." Many of the old Spanish patron saints against Moorish problems became Americanized on the New Mexican frontier as patrons against troublesome Indians—whom the early colonizers even referred to occasionally as "Moors."

This conversion was quite unlike the syncretism said to be characteristic of Mexican popular religion. For example, Eric Wolf claims in *Sons of the Shaking Earth* that the Aztec deity Huitzilipochtli (Hummingbird-on-the-left), a fearsome wizard-warrior, "became a Spanish Saint James riding down upon the heathens,"[1] Whether that was so or not in southern New Spain, it has always been quite clear that no New Mexican saint is simply a pre-existent indigenous sacred personage with a thin veneer of Christianity. No Pueblo war-god *became* the military patron Santiago; no fertility goddess *became* the Blessed Virgin—or vice versa. Most of the indigenous Pueblo Indians accepted Christianity on its terms while continuing to live and worship primarily as Indians, compartmentalizing the two religions and not syncretizing them, juxtaposing without mixing them. The Pueblos had too firm a self-definition and too deep a commitment to their native religion to let any of their sacred personages be captured by the newcomers and enveloped within some imported figure of their new religion.

All or practically all of the New Mexican adjustment of Catholicism was made from within the Spanish culture, by its own mechanism. The present chapter will suggest how the New Mexican Hispanics reapplied Our Lady of Guadalupe, the Holy Child of Atocha, and Santiago (the same Saint James who supposedly became syncretized down in the Valley of Mexico with an analogous Aztec deity) to serve their New Mexican needs.

OUR LADY OF GUADALUPE

Our Lady of Guadalupe is shown in the original picture as a young woman wearing a rose-colored gown and a greenish-blue robe, her hands clasped at her breast. The story about the origin of the picture bears repeating.

Juan Diego, a young Indian convert, was walking to mass in the early hours of 9 December 1531 when he heard singing from a bright cloud at a hill held sacred to Tonantzin, an Aztec goddess. A voice from the cloud summoned Juan Diego, and he saw a young woman whose brilliance made the brambles and rocks of the hilltop look like jewels. She identified herself as the Virgin Mary and promised her help to the native peoples if the bishop would build a chapel to her at the hill.

Juan Diego took her message to the bishop as instructed, but the prelate disbelieved his story. Juan reported to the lady that evening on his way homeward; she asked him to try again the next day, though Juan Diego suggested that she send someone more influential than he.

At the next interview, the bishop requested some sign, as Juan Diego reported to the lady at a third apparition. She promised to respond to the bishop, telling Juan Diego to return the following morning.

But the young man had to spend the whole of the next day tending his uncle, who had fallen ill, and when the old man took a turn for the worse during the night and seemed about to die, Juan Diego set out at daybreak on 12 December to summon a priest to administer the last rites of the Church. As he approached the hill, he tried to skirt it as widely as possible so as to avoid the woman, but she descended the hill to meet him. She assured him she had appeared to his uncle and cured him, then she bade Juan Diego climb to the top of the hill and pick the flowers he would find blooming there, and arranged them in his tilma when he returned to her. He took them to the bishop, and when he loosened his tilma to drop the flowers before him, the likeness of Our Lady of Guadalupe was displayed upon it.[2]

We can see a European "third-time's-the-charm' structure if we concentrate on the three interviews with the bishop.[3] If however we read the story from Juan Diego's point of view, it has not only a four-day time span but also a four-part plot, suggesting that this basic account may have been composed by a Native American, who would have resonated to any such four-part structure. The narrative's four-part structure often appears visually in the form of four vignettes at the corners of New Mexican santero paintings, surrounding the culminating fifth appearance, the Virgin of Guadalupe permanently imprinted on Juan Diego's tilma.

There is good evidence that except for the vaguely Semitic face (in Mexico, the Virgin is often known as La Morena), the hands, the European dress, and the European robe, all the other features of the iconography are mid- to-late-sixteenth-century additions to the tilma's original image: the angel, the moon, the belt, the brooch, the sunburst body-halo, and the clouds. Certain pro-apparitionists, men and women of good faith, great imagination, and laudable pastoral impulses who wish to spread the devotion to Guadalupe, ignore this good evidence and interpret the picture in its present form as if it were a set of heavenly messages couched in indigenous symbols, in a sort of Aztec code; but all the additions are more simply and thoroughly explained as European—the normal Italo-Gothic decorative tradition of fifteenth- and sixteenth-century Spanish art. Further, these pro-apparitionists, while attempting to interpret objective evidence, tend to read in what is not quite there, to offer arbitrary and idiosyncratic explanations, to read the composite picture—half original and half later addition—as if it were either a fifteenth- or sixteenth-century Aztec codex or a nineteenth- or twentieth-century realistic photograph. It is not an ancient codex, nor is it a modern photograph, nor is it realistic. Instead it is consummately *real*—part of the world of religion and therefore of the sacred, the powerful, the life-giving.

The anti-apparitionists, by contrast, a group of late-nineteenth-century persons with noble goals and a possible weakness for devious means, wanted to restrain the Guadalupe devotion. It is currently suspected that in order to keep the Church from rocking

the fragile political boat, they cast doubt on the fundamental authenticity of the apparitions and the tilma by forging documents, including the text of a 1556 sermon attributed to Franciscan Provincial Fray Francisco de Bustamante that identified the Virgin with the goddess Tonantzin and named an Indian artist as the creator of the entire image on the tilma.

With so much confusion surrounding the image as accepted for these four and a half centuries, we must approach the task of interpretation with utmost care. By "the image as accepted" we mean with the mid-sixteenth-century addition of the angel (and six more angels at the edges painted out centuries ago), the lowest swags of the Virgin's gown the remaining angel clings to with each hand, the moon, the clouds, the sunburst body halo (and a gold crown painted out in the mid-1880s), the belt, the black cartoon outlining over the original image, the brooch at the neck, and all the gold *estofado* decoration. In summary, this includes all the black, all the gold, and all parts of the picture except for the face, hands, undecorated gown, and undecorated mantle.[4]

Two of these added attributes of the picture of Our Lady of Guadalupe, the moon upon which she stands and the angel who supports the moon, especially invite our interest. What meanings— probably unconscious on the part of the artist doing the "improvements"—are encoded in these mid-sixteenth-century additions to the original? The moon is mythologically associated with monsters, with bulls (because of their crescent-shaped horns), and with female deities. The moon also has certain associations with snakes: "The serpent, born from itself when sloughing its skin, is symbolic of the lunar principle of eternal return." This relationship suggests Quetzlcoatl, the plumed serpent deity of Aztec religion.[5]

The blackness of the crescent may suggest the death of Quetzlcoatl or Tonantzin or both at the coming of the Christian Madonna. As the Spanish Virgins helped conquer the military-religious foe in Europe and forced Christianity on Moors for whom the crescent was the principal visual symbol, so the Mexican (and New Mexican) Guadalupe helped subdue Indian military and religious power, the forces of any tribes not as Christianized and as obedient as the Spanish thought they ought to be. Thus, al-

though the missionaries may have taught the Christianized Pueblo Indians to call upon the Señora de Guadalupe as their special patron, insofar as they continued to practice their old rituals as well, the Spanish saw them as analogous to Moors and as inviting the displeasure of the Señora de Guadalupe.[6]

The angel initiates a similar train of associations. Angels seem originally to have been connected, as serpents were, with lightning and rain, and to have served as local manifestations of an elemental and primitive sky-god. The angel is also related to the snakelike phallus, particularly in the erotes (winged *putti*) of Roman funerary art and in Eros himself (Amor, Cupid), a personification and deification of masculine erotic drives.[7] The angel's role as messenger (Greek *aggelos*, messenger) suggests comparison with Hermes, the messenger of the Greek gods and personification of masculinity. Since Hermes is a sort of winged serpent himself, the angel in the Guadalupe picture may, along with the moon, symbolize the war god Huitzilipochtli (Hummingbird-on-the-Left), the sun god Nauholin, some other sky god, or even the generally benevolent Quetzlcoatl, not so much supporting the Virgin as being superseded by her, the dangerous and evil masculine being subdued by the powerful feminine.[8]

Let me repeat that these conjectures of mine have been restricted to iconographic details known to have been added to the original. The only "message" of the original can best be phrased "Here I am."

Many people have said that Nuestra Señora de Guadalupe was only a Mexican devotion and was not popular in New Mexico during the last century. In the early 1970s, when I was nearly finished with my census of a thousand santos by subject, I was speaking with a very knowledgeable New Mexican Hispanic who, when told of my project, commented that I would not find very many Guadalupes. I had to reply that I myself had thought so when I began but that I was finding Guadalupe to be the second most numerous title of the Blessed Virgin, trailing Nuestra Señora de los Dolores, despite all her powerful connections to Christ's redeeming passion, by only a few examples.[9]

The early popularity of Our Lady of Guadalupe is further

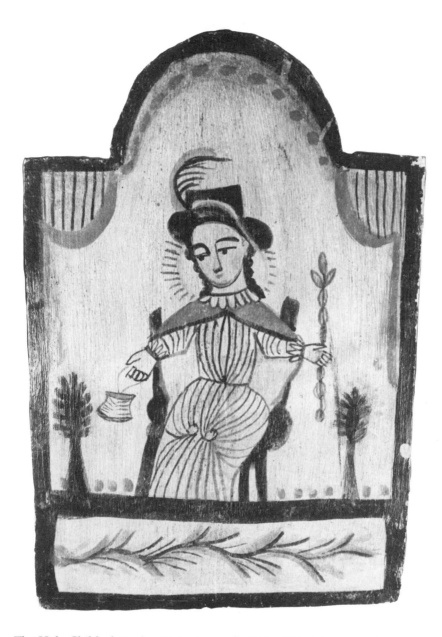

The Holy Child of Atocha (#7 in Appendix B) by Rafael Aragon, who painted many retablos of this charming subject, including the one on the cover of this book. Bequest by Cady Wells to the Museum of New Mexico, Museum of International Folk Art.

substantiated by the research of T.M. Pearce, who notes in his article "Religious Place Names in New Mexico" that "the largest number of place names honoring the Mother of Christ are the eight localities identified as Guadalupe." My own count, using Pearce's *New Mexico Place Names: A Geographical Dictionary,* corroborates his findings on the basis of his own later and fuller evidence.[10] In the eighteenth and nineteenth centuries, despite their other differences in culture, New Mexico shared with the rest of New Spain a single set of religious devotions.

The Spanish population of New Mexico is genetically largely mestizo because the groups that founded the colony in 1598 and refounded it in 1693 contained many Mexican mestizos and Mexican Indians, because the *vecinos* married Pueblo Indians, and because in the eighteenth and nineteenth centuries the Hispanics intermarried with genízaros and genízaras, persons detribalized from Plains and Basin Indian tribes and acculturated into the Hispanic community. Although they were pure-blooded Indians, the genízaros soon lived Spanish-style, giving up nearly all their Indian language, religion, and customs. In New Mexico, there was no way of "living culturally and religiously mestizo." A given family either spoke Spanish as their mother tongue, lived in a Spanish town, and worshiped in the Catholic-Penitente fashion, or they spoke an Indian language as their mother tongue, lived in a pueblo or with a nomadic tribe, and participated in the Pueblo dances (along with being Catholic) or in the Navajo or other Indian rituals.[11]

However much a given New Mexican Hispanic may have been racially an Indo-Hispano mixture or even rarely a pureblooded Indian, he considered himself both culturally Hispanic (he was indeed) and racially Iberian (almost always "yes, to some degree"; almost never "no, not at all"). New Mexican Hispanic ethnic bloodstock is probably a quarter to a third American Indian. The groups who came to settle in northern New Mexico after the Oñate conquest of 1598 and after the De Vargas reconquest of 1693 were mainly *mestizo* and included few *criollos* and even fewer *peninsulares.* Further, the Hispanics resembled the Pueblo Indians a good deal culturally in the way they lived from day to day, as Don Pedro

Bautista Pino suggested in 1812: "Spaniards and pure-blooded Indians (who are hardly different from us) make up the total population of 40,000 inhabitants."[12] Thirdly, the ties to southern New Spain were strong, as is suggested by the great popularity of Nuestra Señora de Guadalupe in earlier years, when all the viceroys and especially Bucareli (1771-79) paid homage to Our Lady of Guadalupe and she served as the chief icon for the total socio-political system.

Guadalupe's Mexican and New Mexican popularity rose immensely after Padre Miguel Hidalgo, taking hints from patriots of the middle of the seventeenth century and from the great eighteenth-century Mexican Jesuit Francisco Javier Clavigero, named her patroness of the 1810 revolution. Since Nuestra Señora de los Remedios (de Socorro) became patroness of the European-born *gachupines* and their upper-class *criollo* allies in putting down Hidalgo's "Rebellion of the Clergy," she earned the nickname *La Gachupina*. New Mexican santos of Remedios are very scarce in comparison with those of Guadalupe, suggesting that the New Mexicans did not identify with Spain and disavow Mexico until about a century later.[13]

The New Mexican self-identification as Spanish and not Mexican dates from the 1910s and 1920s. Nancie González remarks that "it was also in the years immediately following World War I that the term 'Spanish-Colonial' first came into general usage" to differentiate the New Mexicans from the immigrants newly arrived from the Republic of Mexico. And the parallel term "Spanish-American" appeared at the same time. During these years, immigration from Mexico was very high due to continual political unrest. And simultaneously, immigration of Texan Anglos, with their heritage of prejudice against Catholic Mexicans perhaps heightened by a revival of Ku Klux Klan activity, brought the three groups into close and often difficult contact. Partially to avoid being classed by the Texans with the Mexican immigrants, the New Mexico Spanish began to emphasize (and indeed over-emphasize) the real cultural differences between the two Spanish-heritage groups. With statehood (1912), New Mexicans and especially Santa Feans chose to emphasize the Native American and the Spanish American and

deemphasize the Mexican. Consequently, they began to remodel and build in a mix of the Pueblo and hacienda styles, and the 1925 state flag depicts a Zia Pueblo sun symbol in the red and gold color scheme of the Spanish Empire.[14]

THE HOLY CHILD OF ATOCHA

In a very important article, Yvonne Lange tells how the Dominican Fathers brought a statue of Nuestra Señora de Atocha from Spain to Plateros in Zacatecas during the 1780s. The Santo Niño who sat on the Virgin's arm as her attribute became separated in the early nineteenth century and acquired both an identity of his own (partly borrowed from El Niño Cautivo, another Mexican title) and a legend to validate his existence as the Santo Niño de Atocha. The legend went like this:

> In Atocha, a section of Madrid, the Moors imprisoned many Spanish Christians during the later years of the occupation. The conquerors forbade all persons except little children to enter the prison on errands of mercy, not even allowing priests to bring consolation to the dying. The prisoners' relatives, knowing that they lacked food and water and all spiritual consolation, prayed that the Lord would bring the captives some comfort. So one day a child, dressed like the pilgrims of the time, came into the prison carrying a basket of bread and a staff with a gourd full of water tied to the top. To the astonishment of the Moors, the gourd and the basket still were not empty after all of the captives had been served, and each one, as he received nourishment, received also the child's blessing. In answer to his people's prayers, Christ had returned to earth to serve those who needed spiritual and tangible help.[15]

Both because of the legend narrating his original appearance and because of the miracles he worked in New Mexico during the nineteenth century, the Santo Niño de Atocha served as patron against the dangers that had befallen prisoners and that might befall any travelers, who were always in danger in the colony of being taken prisoner by the roving bands of unChristianized Indians as the

Christian Spanish during the middle ages were by the unChristian Moors. There were countless tales of Nuevomejicano children delivered out of captivity by the help of the Santo Niño. In about 1970 a very elderly Hispanic informant told me that a century earlier, when his uncle Gerónimo was a youth, he was captured by *los Pananas*—the Pawnees—in the vicinity of Mora, which lies open to the Great Plains. The Indians confined Gerónimo in a sinkhole of some sort, where he spent the time in fervent prayer for rescue to the Holy Child. Suddenly, the Niño appeared and dropped a string down to him, telling the young man to take hold of it; when he did so, the Niño raised him from the deep hole. The Child then led him to water, gave him some bread, and accompanied him to the safety of the nearest Spanish settlement. Since many New Mexican soldiers were in Bataan at the beginning of World War II and went on the infamous Death March, there was great devotion to the Santo Niño during their captivity. The Holy Child was a late but very popular addition to the pilgrimage site at Potrero de Chimayó, and the Niño has continued to be the focus of devotion even as late as the Vietnam and Persian Gulf wars. All in all, the Holy Child seems in time of war to be a sort of younger-brother figure who saves from perilous enclosure, whereas in times of peace, he serves as a protector against crippling illness and accident, and these protective specializations suggest that his main efficacy is to grant free movement from place to place.[16]

SANTIAGO

The apostle Saint James the Greater—Santiago—is the patron saint of horsemen. Hence he, San Rafael patron of fishermen, and the Magi Kings who empower the Puebloan "Spanish Officials" are the only Christian saints really integrated into the Tewa Pueblo mind, for as Alfonso Ortiz emphasizes in *The Tewa World*, the other needs of the Pueblo people were already covered adequately by their own sacred personages.[17] With the importation of horses into the new world and their acquisition by the Pueblos, Santiago became important to peoples previously unfamiliar with such animals.

Santiago's principal role in the colonial era of Spanish New

Mexico was to oversee the control of the nomadic Indians. He was the heavenly embodiment of the successful Spanish military struggle against the Moors which, as Irving Leonard points out in his *Books of the Brave,*

> engendered a glorification of the warrior even more pronounced than elsewhere in Europe, particularly since the fighting man was a crusader against a pagan faith. In these struggles individual combats were frequent, and in them the successful contestant won fame and was quickly enriched by the booty. Such rewards were far quicker and more satisfying to personal pride than those of the slower and less spectacular ways of agriculture and the handicrafts, and inevitably there emerged the false concept that soldiering was the highest calling and the deeds of war were the duty and almost the sole honorable occupation of manhood
>
> The Spanish reconquest of the Peninsula from the Moorish invaders had associated the more methodical development of agriculture and the manual crafts of [Islam] with a debased paganism and an infidel religion. To the Christian crusader these practical activities and hard labor were suitable for the enemies of God and a befitting badge of servitude.[18]

When the Spaniards tried to make this feudal ethic a reality in seventeenth-century New Mexico by establishing the feudal system that supported it, they finally brought about the inevitable Pueblo reaction, the Rebellion of 1680.

The plan had worked well at first because the Pueblos had a very similar set of relationships that the Spanish preempted,[19] but they did not have the manpower or the firepower to continue to impose their tyranny upon the Pueblos. From early on, the Spanish crown "had forbidden the manufacture of arms in the colonies and had severely limited the importation of them from the homeland." Toward the end of the Spanish era, Pedro Bautista Pino complained that although gunpowder could have been made in New Mexico, it had to be imported from Mexico at great expense. There were at the time only a hundred and twenty-one soldiers in the colony paid

by the crown, so when there was any Indian aggression, the settlers had to volunteer, reporting for duty

> with horses, rifles, pistols, bows, arrows, and shields.
> Likewise, they must pay for their own ammunition and
> the supplies needed during the time they are under
> arms, which is usually a period of forty-five days;
> sometimes, however, there are two or three months of
> continuous and cruel warfare against wild tribes.

And Pino goes on to complain that New Mexicans seldom held positions of command or received suitable promotions.[20] This milieu of citizen-soldiery, armed with bows, arrows, and a few guns shooting with powder the soldiers had to buy themselves, is hardly what the conquistadores had in mind.

But Santiago became the settlers' military patron as surely as he was that of the professional soldier. He had appeared in Spain as early as at the Battle of Clavijo in the ninth century, and he is described at the thirteenth-century Battle of Xerez, fought by King Ferdinand III (San Fernando), as appearing "on a white horse, with a white banner in one hand and a sword in the other, accompanied by a band of cavaliers in white."[21] And he appeared in the New World fourteen times in aid of Spanish military enterprises, including the battle of Acoma in the very first year of the colony's existence. In January of 1599, the Indians of this pueblo were defending their town, built on its hundred-foot-high rock mesa, against a punitive expedition led by Zaldívar; the Indians testified after they had lost the battle that during it they had seen a very brave soldier fighting among the Spanish whom they could not find after the battle was over. According to Gaspar Pérez de Villagrá's recounting of the episode in his versified *History of New Mexico,* they described "a Spaniard who in battle rode always on a great white horse. He has a long thick white beard and a bald head; he is tall, and he wears a terrifying sword, broad and mighty, with which he has cut us all to the ground. He is most valiant." And a source even closer to the event, a letter of one Alonzo Sánchez of 28 February 1599, describes "someone on a white horse, dressed in white, a red emblem on his breast, and a spear in his hand."[22]

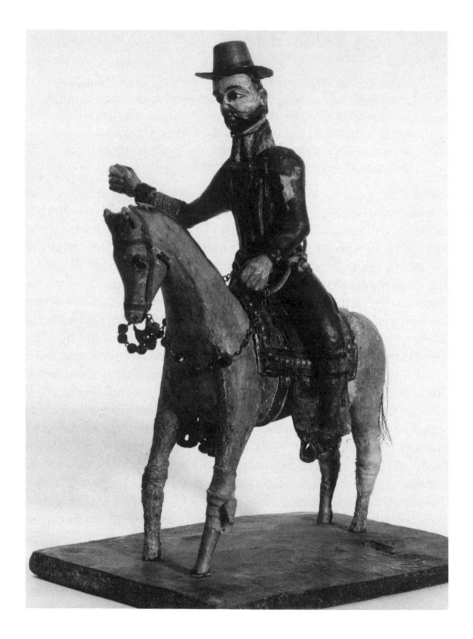

Saint James the Greater (Santiago; #115 in Appendix B) by an anonymous late nineteenth-century santero. Note the fragment of a rosary used as reins, the elaborate bit decoration, the wide skirt on the saddle, and the rider's botas. Laura Gilpin photo; collections of the Spanish Colonial Arts Society, Inc., at the Museum of International Folk Art, Museum of New Mexico.

Furthermore, when the Hispanics moved into southern Colorado soon after the United States takeover, Santiago is said to have appeared in about 1854 to save the San Luis Valley settlement of San Acacio from the Utes.[23] Having begun by protecting the Spaniards from uncooperative Indians during the first months of New Mexico's existence as a Spanish settlement, Santiago quickly became domesticated on the northern frontier, ready to serve the new colony just as he had served the mother country as the patron of soldiers fighting a non-Christian enemy.

In addition to Our Lady of Guadalupe, the Holy Child of Atocha, and Saint James, some other santero subjects serve as protectors against the Indians: the Flight into Egypt, the Christ Child Lost in the Temple, Saint Longinus, and Saint Peter. San Longino joins Santiago as a military man; the Flight into Egypt, San Pedro, and the Niño Perdido join the Niño de Atocha in seeing to the release of those taken prisoner by the Indians; and San Pedro, the keeper of the gate of heaven, becomes a soul-conductor like Hermes-Mercury of classical mythology.

These eight saints taken together account for just over a tenth of the total santo sample of a thousand. Without troubling with the arithmetic, we can say that there was about a fifteen percent drop in the depiction of these protector figures. This reduction may reflect the greater protection from nomadic Indians afforded to the Europeanized area of New Mexico by the United States Army after 1850 and the lessening of a very real cause of unease. But on the other hand, the santos of Nuestra Señora de Guadalupe and the Niño de Atocha comprise the vast majority of the sample of ninety-two, and as the Guadalupe became less popular (for the other reasons we have seen) the Niño de Atocha became more popular. But the fluctuations of popularity for undetermined causes renders the sample dubious and too small to be trusted very far.

Notes

1. Eric R. Wolf, *Sons of the Shaking Earth* (Chicago: University of Chicago Press,

1959), 170. Recent research suggests that there was less religion-mixing than was thought up to the 1960s. Richard J. Parmentier, "The Mythological Triangle: Poseyemu, Montezuma, and Jesus in the Pueblos," 609-22 in Alfonso Ortiz, ed., *Handbook of North American Indians* (Washington: Smithsonian, 1979), notes that occasionally Poseyemu (Po-he-yemu) was enhanced with certain Jesus material and that on rare instances he was even said to be the equal of Jesus. But the fact that he is never *identified as* Jesus makes the difference.

Within the greater Southwest, the Navajos are most often identified as syncretists, for they readily and brilliantly integrated Pueblo elements (and, later, European ones) into their Navajo synthesis.

2. The "Nican Mopohua," the major early documentary source on the apparitions, is thought to have been composed by the Mexican Antonio Valeriano and some of his Náhuatl-speaking associates. The story has been told in a myriad of slightly different ways.

I wish to thank Miguel Leatham for the refinements and improvements in the Guadalupe section.

3. On the survival in New Mexico Spanish folk tales of the European three-part pattern, see George Mills and Richard Grove, *Lucifer and the Crucifer: The Enigma of the Penitentes* (Colorado Springs: Taylor Museum, 1966), 40.

4. Philip Serna Callahan, *The Tilma under Infra-Red Radiation* (Washington: Center for Applied Research in the Apostolate, 1981); Miguel Leatham, "*Indigenista* Hermeneutics and the Historical Meaning of Our Lady of Guadalupe," *Folklore Forum* 22 (1989), 27-39; Leatham, "Image Studies of Our Lady of Guadalupe: An Historical Critique," unpublished paper, 1991.

5. Eric R. Wolf, "The Virgin of Guadalupe: A Mexican National Symbol," in William A. Lessa and Evon Z. Vogt, eds., *Reader in Comparative Religion* (New York: Harper and Row, 1965), 227; Francis Huxley, "The Miraculous Virgin of Guadalupe," *International Journal of Parapsychology* 1 (1959), 22.

Joseph Campbell, *The Masks of God: Oriental Mythology* (London: Secker and Warburg, 1962), 276. In representations of Our Lady of the Immaculate Conception, snake and moon are interchangeable. See also Gilbert Durand, *Les Structures Anthropologiques de l'Imaginaire* (Paris: Presses Universitaires de France, 1960), 340-41.

Donald Demarest and Coley Taylor, *The Dark Virgin* (Freeport, Maine: Coley Taylor, 1956), 28. Regis University has a French print in a 19th century New Mexican soldered-tin-and-glass frame of the Spanish Guadalupe: the crowned Virgin holding the Christ Child and a small handbell. The original statue, one of the chthonic "black virgins" of southern Europe, was supposed to have been carved by Saint Luke.

6. When the question arose of making a chapel out of a kiva (a Pueblo ceremonial chamber), de Vargas argued "that there were a number of churches and cathedrals in Spain which were formerly Moorish mosques"; J. Manuel Espinosa, *Crusaders of the Rio Grande* (Chicago: Institute of Jesuit History, 1942), 153-54. There is a hint in the same direction with regard to the Comanches in

a volume by Espinosa's equally eminent uncle Gilberto Espinosa, *Heroes, Hexes, and Haunted Halls* (Albuquerque: Calvin Horn, 1972), 27.

7. Gunnar Berefelt, *A Study on the Winged Angel* (Stockholm: Almquist and Wiksell, 1968), 57. An interesting set of transvaluations of gender is suggested by the Old Pecos Bull Dance performed at Jémez Pueblo every year on August 2. The day is the feast of Porciúncula, a title of Our Lady of the Angels, which was the name of the church at Pecos Pueblo (the people from there joined the Jémez Pueblo in 1838). In being associated with angels in a positive fashion, Our Lady assumes a sort of masculine aspect; the bull involved in the dance is a seriocomic monster figure which, through it is masculine, gains a feminine configuration by means of its crescent-shaped horns.

8. In this speculation, I do not want to suggest that overt sexuality consciously recognized by the people involved was part of the Guadalupe cult. Instead, my position is just that of Erich Neumann's disclaimer in *The Origins and History of Consciousness* (Princeton: Princeton University Press, 1970), 150-151: "Our retrospective psychological interpretation corresponds to no point of view consciously maintained in earlier times; it is the conscious elaboration of contents that were once extrapolated in mythological projections, unconsciously and symbolically." What I have tried to do is to make explicit and thematic what I guess to be present in the Guadalupe picture (as doctored up some time after 1531) but only implicitly and prethematically.

I would like to bolster the case I have tried to make by referring to the immense ambiguity of the image of the serpent throughout world cultures. The serpent first appears in the Judaeo-Christian tradition on the tree of life—as "the guardian, the thief, or the keeper of the Herb of Life in Semitic legend" (Durand, *Les Structures*, 341, my translation); it next appears as the brazen serpent, also on a tree, saving the people from the bites of the saraphs, the burning serpents who are etymologically and symbolically related to the seraphs, the burning angels. In the same part of the world, the serpent is an attribute of the Magna Mater, as Neumann points out (pp. 48-49); the equivalent figure in Chinese myth, the dragon, is also benevolent (Mircea Eliade, *From Primitives to Zen* [New York: Harper and Row, 1966], 243).

But just as the serpent can have a double aspect, so the feminine may, as Ari Kiev explains in his book on Texas-Mexican folk medicine, *Curanderismo: Mexican-American Folk Psychiatry* (New York: Free Press, 1968), 164. Speaking of overly indulged youngest children feeling abandoned when the next sibling arrives, Kiev says: "It is no doubt partly because of such experiences that mother figures remain in fantasy as both dangerous *brujas* [witches] and all-loving Virgins, representing both the repressed hostilities toward the rejecting mother and the unsatisfied longings for the pleasant, bygone dependency. If a child cannot turn to an all-accepting mother, he may turn to the Virgin for acceptance and favors." No wonder Durand calls the serpent, which is both masculine and feminine, both good and evil, both death and life, "the living correlative of the labyrinth" (p. 344); he might have said "of the desert."

Jungian and Freudean interpretation of artistic, religious, and literary sym-

bols is suitable activity for all children from nine to ninety, and any number may play.

9. The statistics are: N.S. Dolores—53 = 10, 34, 7, 2 (if the final figure were statistically absorbed by the others, it would give 46 prior to 1850); N. S. Guadalupe—50 = 16, 24, 2, 8 (which would revise to a total of 48 before 1850). For an independent assertion of Guadalupe's presence and power in nineteenth-century New Mexico, see the anonymous *Historia de la Aparición* (Mexico: La Europa de Fernando Camacho, 1897), II:293-94 (by Esteban Antícoli, S.J.), as summarized in Miguel C. Leatham, "The Santuario de Guadalupe in Santa Fe and the Observations of Fr. Esteban Antícoli, S.J.," *New Mexico Studies in the Fine Arts* 10 (1985), 12-16.

10. T.M. Pearce, "Religious Place Names in New Mexico," *Names* 9 (1961) 3; *New Mexico Place Names: A Geographical Dictionary* (Albuquerque: University of New Mexico Press, 1965).

11. When Father Gabriel Ussel had been in Taos for fifteen years (fall 1858-early 1874), long enought to learn something about the Catholicism of the pueblo in his charge, he wrote:

> It is untrue, if not a gross ignorance, to say as it has been published here and copied in the States newspapers, that the Indian Pueblos in New Mexico under the cover of some Catholic practice, are but superstitious, idolaters, believers in [the] future coming of Montezuma. Indian[s] believe in [the] true God, believe all that the Church teaches them, are baptized according to the Catholic Church rites, [and are] firmly attached to her. [A] little over a year [ago], when Agent J.M. Cole tried by every means to bring them to his point, to receive J.M. Roberts, Presbyterian minister, for their teacher, how was he disabused? Is he not another witness that our Indians of Taos are Catholics, and determined to raise their families in the [Catholic] faith?

Nancy Nell Hanks, "Not of This Earth: An Historical Geography of French Secular Clergy in the Archdiocese of Santa Fe, 1850-1912," dissertation, University of Oklahoma, 1993, 171-72, quoting a letter to Lamy, Archives of the Archdiocese of Santa Fe, loose document 1874 # 1.

12. H. Bailey Carroll and J. Villasana Haggard, trans. and eds., *Three New Mexico Chronicles* (Albuquerque: The Quivira Society, 1942), 9. See for instance Clevy Lloyd Strout, "The Resettlement of Santa Fe, 1695: The Newly Found Muster Roll," *NMHR* 53 (1978), 260-70. Ramón Gutiérrez, *When Jesus Came, the Corn Mothers Went Away* (Stanford: Stanford University Press, 1991), 171, 174-75, estimates that by the late eighteenth century a third of culturally Hispanic New Mexico was genízaro; he cites Donald Cutter and Albert H. Schroeder. Government officials and army officers who came to New Mexico were probably mostly *peninsulares*, while enlisted men were probably mostly *mestizo*.

At the San Felipe Neri de Albuquerque fiesta of late May 1888, Major José Desiderio Sena of Santa Fe praised "la raza Hispano-Mejicana"; see Thomas J.

Steele, S.J., *Works and Days: The History of San Felipe Neri Church* (Albuquerque: Albuquerque Museum, 1983), 51.

13. Hugh M. Hamill, *The Hidalgo Revolt* (Gainesville: University of Florida Press, 1966), 161, 178-79. Miguel Sánchez' 1648 oration and Francisco Javier Clavigero's *Historia antigua de México* are major works in forming Mexican consciousness. The viceroys typically went to the Guadalupe shrine en route to the City of Mexico; Bucareli went out to pray practically every single day of his tenure.

14. Nancie L. González, *The Spanish-Americans of New Mexico* (Albuquerque: University of New Mexico Press, 1969), 80; see also 203-04, where González cites Erna Fergusson and Mary Austin on the appearance of the term "Spanish-American" in the same decade. See also Matt S. Meier and Feliciano Rivera, *The Chicanos: A History of Mexican Americans* (New York: Hill and Wang, 1972), 113-14. If Mary Austin and Frank Applegate did not create the term "Spanish Colonial," they certainly gave it currency in 1920s New Mexico.

Robert J. Torrez, "State Seal Receives Eagle-Eyed Scrutiny," *New Mexico Magazine* 71, 12 (December 1993), 80-87, describes the official 1887 Territorial Seal, which features a Mexican eagle grasping a rattlesnake and guarded by an American golden eagle—quite a different message from the 1925 state flag.

15. Yvonne Lange, "Santo Niño de Atocha: A Mexican Cult Is Transplanted to Spain," *El Palacio* 84 # 4 (Winter 1978), 2-7. I have rewritten the legend from E. Boyd, *Saints and Saint Makers of New Mexico* (Santa Fe: Laboratory of Anthropology, 1946), 126-27, quoted verbatim in previous editions of *Santos and Saints*, 109-10.

See also Charles M. Carrillo, "Santo Niño de Atocha," unpublished paper, 1984, and Cecile Turrietta, "Santo Niño de Atocha in New Mexico," unpublished paper, 1992.

In the Madrid faubourg of Atocha there is a Dominican church of Nuestra Señora de Atocha.

16. If the Niño is a younger-brother figure, then San Miguel and Santiago, both to be treated later, would be elder-brother figures. For comparable oral-phase material, see my "Oral Patterning of the Cyclops Episode, *Odyssey IX*," *The Classical Bulletin* 48 (1972), 54-56. This last motif will be treated in Chapter VI in connection with monsters.

17. Alfonso Ortiz, *The Tewa World: Space, Time, Being, and Becoming in a Pueblo Society* (Chicago: University of Chicago Press, 1969), 156; Leslie A. White, *The Pueblo of Santa Ana, New Mexico* (American Anthropology Association Memoir # 60, 1942), 256-67, 350-51. The Pueblos provided large numbers of excellent auxiliaries to the Spanish during the eighteenth century; see Oakah L. Jones, *Pueblo Warriors and Spanish Conquest* (Norman: University of Oklahoma Press, 1966).

18. Irving A. Leonard, *Books of the Brave* (Cambridge: Harvard University Press, 1949), 5-6.

19. Gutiérrez, *When Jesus Came*, 122.

20. Leonard, *Books*, 242; Pino in Carroll and Haggard, *Three New Mexico Chronicles*, 68-69.

21. Washington Irving, *Spanish Papers* (New York: G.P. Putnam's Sons, n.d.),

468; Rafael Heliodoro Valle, *Santiago en América* (Mexico: Editorial Santiago, 1946), 19-20, 33; Marc Simmons, *Santiago: Saint of Two Worlds* (Albuquerque: University of New Mexico Press, 1991), 8-9.

22. Gilberto Espinosa, transl., F.W. Hodge, ed., *History of New Mexico* (Los Angeles: Quivira Society, 1933), 264; see especially Miguel Encinias *et al.*, eds., trs., *Historia de la Nueva México* (Albuquerque: University of New Mexico Press, 1992), 298-99. Incidentally, Villagrá was bald.

George P. Hammond and Agapito Rey, *Don Juan de Oñate, Colonizer of New Mexico* (Albuquerque: University of New Mexico Press, 1953), 427. See also Benjamin W. Read, *Illustrated History of New Mexico* (Santa Fe: New Mexican Printing Company, 1912), 229; Mrs. William T. Sedgwick, *Ácoma, the Sky City* (Cambridge: Harvard University Press, 1926), 84; and Simmons, *Santiago*, 17-19, 25.

23. Luther Bean, *Land of the Sky Blue People* (Alamosa: The Olde Print Shoppe, 1964), 97-98; *San Luis Valley Historian* 4 # 4 (1972), 2; Marianne L. Stoller et al., *Diary of the Jesuit Residence of Our Lady of Guadalupe Parish, Conejos, Colorado, December 1871-December 1875* (Colorado Springs: Colorado College, 1982), 70n112; Simmons, *Santiago*, 27-28. Whenever Christianity expands into an area previously non-Christian, apparitions and other miracles are likely to be reported.

See also Joseph Winter, "¡Santiago!" *New Mexico Magazine* 64 # 3 (March 1986), 53-57; Robert J. Torrez, "Santiago: Observation of an Ancient Tradition in a Northern New Mexico Village," *El Palacio* 95 # 2 (Spring/Summer 1990), 46-55.

V

The Mirrors
of the Holy Persons

T raditional New Mexican santos were holy because they came
into being within a strong religious-art context composed of
their relationship to their makers, their materials, their models, and
their intended uses. The proximate objects of imitation in the New
Mexico santero tradition were artistic: the previous representations
of the subject done by the santero himself and the available repre-
sentations of the subject by other santeros in the traditions of New
Spain and New Mexico. The ultimate imitated object of each santero
painting or statue is the saint or other holy person. The relation
between the santero image and the holy person from whom it
derives its special quality of power will focus the little "armchair
ethnotheology" that follows. For present purposes, there are two
kinds of santos: those that represent the saints and the angels and
those that represent the adult Christ in his Passion.

In New Mexico, art was religious in purpose and not aesthetic,
so the santero's goal was to create an instrument of holiness and
power rather than an artifact for detached contemplation. Conse-
quently, the connection between the image and the actual saint was
a matter of utmost importance. The artifact is extrinsically holy both

because of what may be done with it (prayer) and because it was made by a holy santero working within a holy tradition. The santo's intrinsic sanctity results from the way the santo imitates the saint. As a general principle, a ritual article or action is more powerful (first) the more authentically it imitates its prototype and (second) the more holy and powerful that prototype is.

The mentality this rule of thumb reflects might be termed "folk Platonism." In this way of thinking, an individual cult object—holy picture or statue—is validated by a holy person who lives in heaven, and an individual cultic action—a religious ritual—is validated by an action performed by a "culture hero" during the special time when all the patterns for religious ritualism were permanently set.[1] Because this "folk Platonism" relates the artifact rather to the eternal reality it represents than to contemporary human awareness, it runs the risk of letting the religious artifact or the religious ritual deteriorate into unimaginative, mechanical, dead imitation.[2] Since aesthetic considerations were de-emphasized in the New Mexican art world, where the tradition was far more important than anything the self-effacing artist added to it, it may be wondered how the artistic quality of the santos stayed as high as it did for so long. But the couple of dozen santeros who produced the bulk of New Mexico santos apparently exercised their craft with the earnestness and honesty that came from deep devotion to the santos they made, to the saints that the santos represented, and to the tradition that linked them into a unity.

There are two modes in which New Mexico cult objects are validated. The first is the simpler; it has to do with the relationship of pictures and statues depicting the ordinary human saints, the angels, the Virgin, and the divine Persons to those holy persons themselves. The principle stated above, that the power of a cult object or action is gauged by the norms of fidelity to the original and power of the original, applies quite readily. The question of fidelity was cared for by the tradition of santero art, for the santero can assume that he is making his santo right if he is making it "the way it's always been done," the way the tradition indicates. The question of power insures that the santo will imitate not the saint as he or she was formerly active during an earthly lifetime but the

saint presently living in heaven and hence active at the peak of power and holiness.

For it is not the saint in this world, having the slight power of a holy human being, but the saint established in heaven, in the timeless "now" of eternity, who is able to give the maximum power to the bulto or retablo which imitates him or her. Before death, New Mexican piety maintained, holy persons have only a very limited power, but God has assigned some of them after death certain responsibilities in definite earthly matters, and he has granted them the authority to fulfill their duties throughout the world for the rest of time. Hence the saints of New Mexican art are shown not in moments from their earthly lives but in the eternal now of heaven, not in the earthly geography of their weak mortality but in the empowering habitat of paradise.

In eternity, the saints have retrieved and summed up timelessly all the moments of their earthly histories and (more important) all the power and responsibilities for earthly affairs God has given them to exercise in all places for all subsequent history. For the New Mexicans, then, the saints are mainly sources neither of aesthetic beauty nor of ethical example but of help. The various items they hold—skulls, rocks, crosses, books, pennants, and so forth—are not implements for performing the particular pious actions of their earthly lives; these items are instead iconographic attributes which serve to establish each saint's eternal self-identity, and very often the saint's attributes are signs too of the responsibilities he or she is currently fulfilling on behalf of people on earth.

European religious art of the Renaissance era suggests that if San So-and-So, pictured in a moment from his earthly history, was once a mere mortal like us, we can attain his eminence by imitating him. This presupposition leads toward Pelagianism, that constantly recurring Christian heresy which holds that a man saves his own soul by living a good life in imitation of Christ and other holy persons. The New Mexico santero art seems on the other hand to say, Santa Such-and-Such is now in heaven, and God has assigned her to aid me; this holy retablo is of itself and by its own sanctity both my powerful claim on her and her potent presence at the spot of need. Since a ritual or ritualistic object is holy and powerful to the

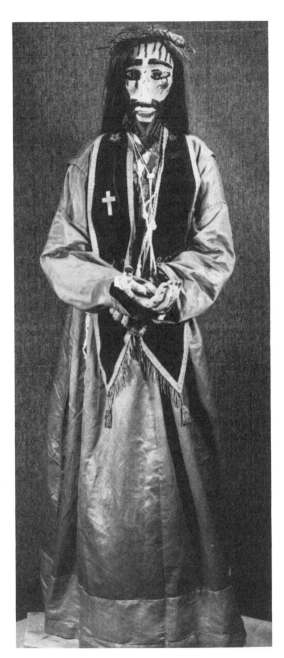

Our Father Jesus the
Nazarene (#13 in Ap-
pendix B) by an
anonymous santero,
from a morada (chapter
house of the peniten-
tial Brotherhood of Our
Father Jesus the
Nazarene) west of
Taos. The arms can
move, and the wig is
real human hair. Be-
quest of Cady Wells to
the Museum of New
Mexico, Museum of In-
ternational Folk Art.

degree that it represents, participates in, and hence *becomes* the ritual-founding action or the sacred being from the pattern-setting time or place, the New Mexico santero links his image to what is most real and most holy: the saint in heaven. The santo is very much like a mirror, for if you see a man's reflection in a mirror, that image shares so thoroughly in his motion and his very life that you do not see the reflection only, you see in a very true way the person himself—and he can see you. So the santo makes possible a two-way visual communication between earth and heaven, between heaven and earth, and the communication by sight can initiate a communication of voice and of ear.

Not only ordinary saints but most other holy personages thus validated the santos that mirrored them. The Blessed Virgin, like the rest of the human saints, is more powerful now than she was on earth. And the angels, God the Father, and God the Holy Spirit never had other than a heavenly existence.

The second mode of validation is that associated with any santero statue or painting of the adult Christ, for example, with a retablo or (especially) bulto of Jesús Nazareno (Jesus the Nazarene) or of the Man of Sorrows, a crucifix, or a Santo Entierro (Holy Buried Body of Christ). For all their traits of iconic stylization, these figures have a dimension of living and dynamic presence rarely encountered even in other New Mexican religious art. Their powerful interaction with the sensitive viewer elicits an interpersonal—a spiritual—experience. The Jesús Nazareno and Santo Entierro figures derive their forceful presence largely from a lavishness of very carefully wrought detail, from their size (they are nearly as large as an adult, far bigger than other santos), and from their articulation (they are hinged with leather or cloth at the shoulder like huge puppets so they can be carried through the various stages of capture, scourging, way of the cross, crucifixion, deposition, and burial).

The validation of these Christ-figures stems not, as in the case of the other holy personages, from any heavenly existence but from a particular set of earthly, historical actions, the Passion. Christ in

his eternal pre-existence or in his present glorification does not guarantee these santos; the earthly Christ does so by having performed the only complex of actions that is recognized by Christians as a truly pattern-setting and sanctifying event: the Passion and Death.[3] In the Jesús Nazareno bultos, the hinging of the shoulders suggest that it is not so much the person Christ who is imitated by the bulto as it is the action-sequence of Christ's Passion, Crucifixion, Deposition, and Burial. This complex action (in a fuller theology, with Resurrection and Ascension added) is the validating basis of Christian salvation and Catholic sacramentalism, and consequently it stands in Catholic Christianity as the equivalent of the action-complex of the culture hero of a tribal culture.

The pattern-setting action of any culture-hero always occurs in a special kind of time, the sort of special period that Mircea Eliade calls *in illo tempore*—"in *that* time, in the beginning, in the once-and-for-all time" that establishes the eternal archetype and sets the pattern for all other times. The *illud tempus* readily absorbs portions of our "clock and calendar" time into itself, and so we can have access to the sacred time whenever we wish: mere *now* can become sacred *then*. This kind of time-identity baffles Aristotelian logic, but ritual is the key: the devout believer knows that "the beginning," the *illud tempus*, starts again whenever the original deed of the culture hero is repeated in ritual, and because the santo is intrinsically sacred, heavily freighted with power for life, it tends to engender ritual.[4]

Within his special kind of time, then, the culture-hero has performed an action central to the sacred story that later narrates it and the rite that later re-presents it. The narrative generally contains an authorization, in the form of a command, a request, or a grant of permission for the subsequent performances of the ritual: "And this day shall be unto you for a memorial: and ye shall keep it a feast to the Lord throughout your generations: ye shall keep it a feast by an ordinance for ever" (Exodus 12:14); "do this in remembrance of me" (I Corinthians 11:24). And so devout Jews celebrate the Seder year after year, and all Christian denominations —Oriental, Protestant, and Roman—enact a memorial of the Passion of Christ.

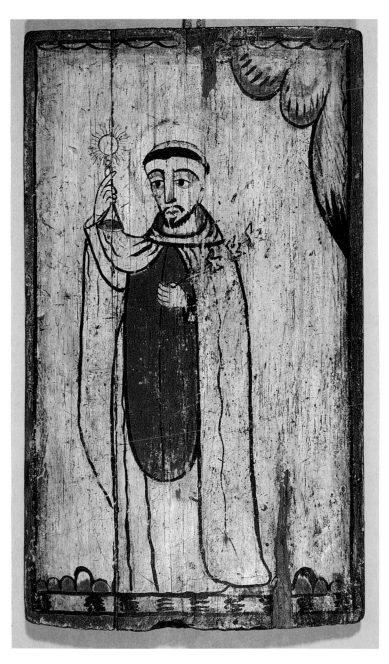

Saint Raymond the Unborn (#113 in Appendix B) by José Aragon (active 1820-35). A great painter of the classical period of santero art is at the height of his powers here. The draftsmanship santero art is especially stunning. Regis University Collection.

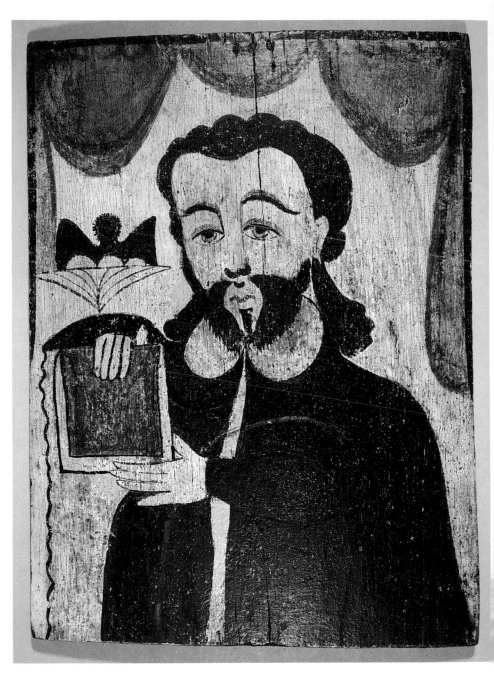

Saint Ignatius Loyola (#87 in Appendix B) by Rafael Aragon (active 1820-62). Badly wounded in battle, Iñigo López de Loyola convalesced into the great mystic who founded the Jesuits. The artist has endowed him with a self-possession appropriate to a man united with God. The strange object on the shelf at the left is a biretta, a medieval student's hat that became part of clerical gear. Regis University Collection.

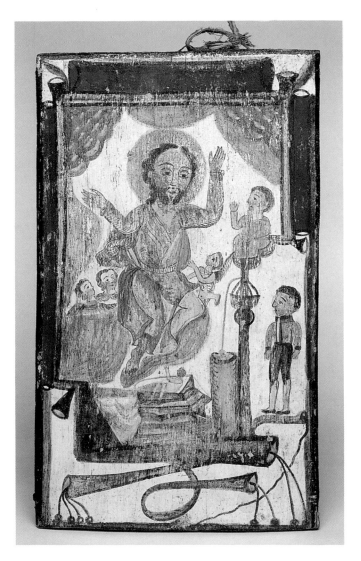

Resurrection (#22 in Appendix A) by Rafael Aragon (active 1820-62). A large Christ rises in the center of the panel, a very tiny figure at his feet holds up a hand from a grave in the rock, and a small figure at the viewer's right might represent Christ enthroned. From a private collection, with permission.

Our Lady of Sorrows (Dolores, #31 in Appendix A) by a follower of Molleno. Up to the waist, this bulto is hollow, merely a thin wooden base, a framework of slats, and a covering of cloth covered with gesso and painted. The tin halo and sword are modern additions, fitting into original holes. Regis University Collection.

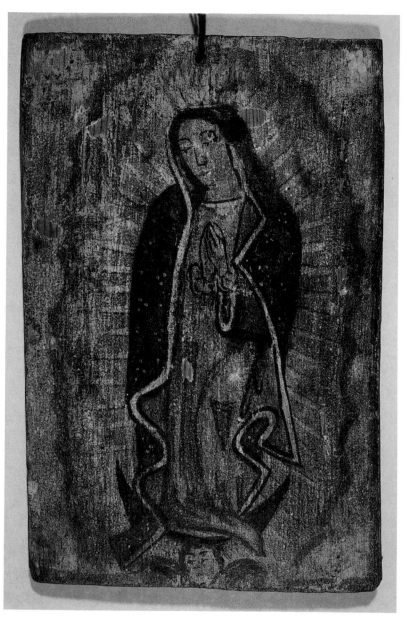

Our Lady of Guadalupe (#33 in Appendix B) by Antonio Molleno (active 1800-40). Little flakes of mica in the yellow ocher seem to give an extra sparkle to the body halo (sunburst) in which the patron of the Americas stands. Regis University Collection.

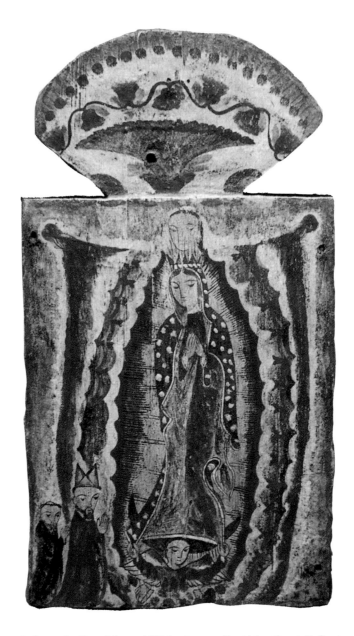

Nuestra Señora de Guadalupe (#33 in Appendix A) by the A.J. Santero (c. 1822). This powerful retablo depicts the moment when Bishop Zumárraga and a Franciscan friar first saw the image of Our Lady on Juan Diego's tilma and knelt in adoration. From a private collection, with permission.

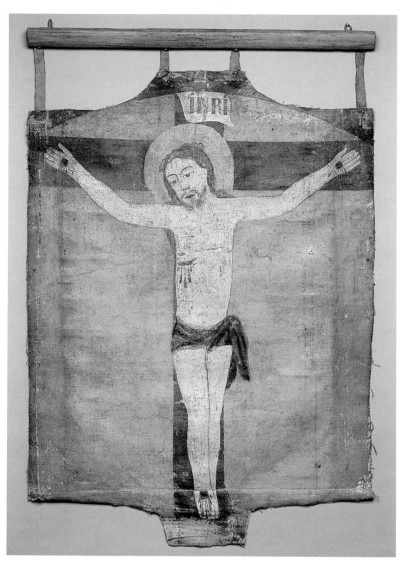

Crucifixion (#16 in Appendix B) by Mexican-born José de Gracia Gonzales (active in New Mexico and southern Colorado 1860-1900). At one time stretched and framed, perhaps as part of an altarscreen, this oil on canvas was later taken loose, hung from a wooden rod, and carried on a pole as a processional banner by the penitential Brothers of the chapter at Tecolote, in San Miguel County. Regis University Collection.

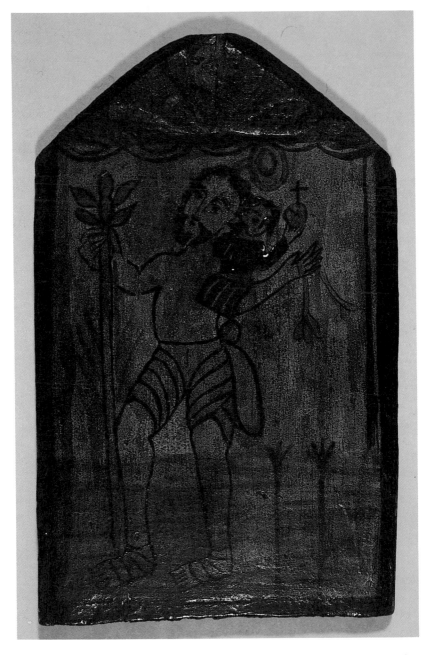

Saint Christopher (Cristóbal, #68 in Appendix A) by Frank Applegate, who presented this little panel to Mary Austin on 9 September 1928, her sixtieth birthday. Real trendsetters, Austin and Applegate initiated the revival of the santero tradition in the 1920s. Regis University Collection.

Indeed, from the earliest days Christians have adopted all possible strategies for preserving and communicating the Passion and Death of Christ, for assuring that this event would never be forgotten and become inaccessible from later history. First, the Calvary event took the form of the Eucharistic meal. Secondly, it took artistic form in icons in the Eastern churches and paintings and statues in the Western. And thirdly, it took multiple narrative forms: the original preaching (kerygma), the Passion narratives in each of the four gospels, the chanting of the passion during the Holy Week liturgy, the Five Sorrowful Mysteries of the Rosary, four of the Seven Sorrows of Mary, innumerable vernacular ballads telling the story of the Lord's sufferings, and the Stations of the Cross (a set of fourteen moments from Pilate's sentencing to Jesus' burial).

These different forms of Christ's Passion and Death helped solve a problem in the New Mexican church toward the end of the eighteenth century. The problem was the lack of pastoral care due to the rapid growth and spread of Hispanic population and the relative scarcity of priests. As the Hispanic population continued to grow, the people had to move away to find new land for farming and ranching, while at the same time the supply of priests remained small. More and more of the Hispanics found themselves too far from any parish for regular priestly care. The Mass and the other essential rituals were conspicuous in the Hispanic villages only by their absence, especially during Holy Week, the most holy time of the year.

The first step toward a solution resulted indirectly from the Franciscan devotion to the Passion of Christ. This central feature of traditional Franciscan spirituality led to an early-eighteenth-century revival of the Stations of the Cross. The powerful preaching and writing of the Italian Franciscan Leonardo di Porto Maurizio (d. 1751) brought them back into high favor during the first half of the eighteenth century, his Franciscan brethren promoted the Stations in the American Southwest, and so the devotion of the Way or Stations of the Cross was the last great Franciscan gift to the Hispanic people of New Mexico as they moved out of the over-

crowded towns into the mountain valleys in search of vacant land. With the Stations providing their plot-line, the people dramatized what the Mass would have ritualized. As the penitential season of Lent concluded with Holy Week, the most sacred time of the year, more and more Spanish towns engaged their entire populations in transforming the private devotion of the Stations into a great public religious drama, a complex and wonderful multimedia enactment involving in some degree all the forms of Christ's Passion and Death.

In New Mexico, the people performed the passion play only on Holy Wednesday, Holy Thursday, and Good Friday, never at any other time of the year. The play was always based on the Stations of the Cross as supplemented by the Five Sorrowful Mysteries and reinforced by the last four of the Seven Sorrows of Mary. *Alabados*— passiontide hymns, especially those that adhered to the Stations— provided most of the text. By singing the alabados and responding to the prayers, even a person who did not take a role such as Pilate, Simon of Cyrene, a Pharisee, a Roman soldier, or a Holy Woman of Jerusalem could become totally involved in the ritual and thus totally present to the central event of salvation history.[5]

After the New Mexican passion play got started, it rapidly became widespread, turning up in the Spanish towns of Santa Fe, Santa Cruz, Albuquerque, and Tomé. The Yankee merchant Josiah Gregg witnessed it in Santa Fe during the 1830s:

> An image of Christ large as life, nailed to a huge wooden cross, is paraded through the streets, in the midst of an immense procession, accompanied by a glittering array of carved images, representing the Virgin Mary, Mary Magdalene, and several others; while the most notorious personages of antiquity, who figured at that great era of the World's history,—the centurion with a band of guards, armed with lances, and apparelled in the costume supposed to have been worn in those days,—may be seen bestriding splendidly caparisoned horses, in the breathing reality of flesh and blood.[6]

The most renowned passion play has been the one performed in

the village of Tomé, about thirty miles south of Albuquerque on the east bank of the Rio Grande. In 1776, Fray Francisco Atanasio Domínguez referred to "the settlers, who sometimes hold their Holy Week function in the chapel," and the citizens of Tomé performed the play at the church on the plaza every Holy Week until the 1950s.[7]

The play's main "characters" were two great bultos of Christ, the Jesús Nazareno that took the part of the Lord up to the crucifixion and the Santo Entierro with its articulated shoulders and neck which "hung upon the cross, the nails thrust through holes provided in hands and feet. Later, after the scene of the crucifixion, He was taken down from the cross, replaced in the coffin, and returned to the church."[8] Other statues took the parts of Our Lady of Sorrows, Our Lady of Solitude, and Saint John the Evangelist, and townspeople acted the remaining parts.

On Holy Thursday evening, the people enacted Judas' betrayal of Jesus to the Pharisees and Romans, then the priest carried the story forward in a sermon. The Nazareno bulto spent the night in a latticework prison-cell in the church, guarded by Roman soldiers but ministered to by angels. On Good Friday morning, the townsman portraying Pilate released Barabbas and condemned the bulto of Christ, whom he declared innocent, to the cross. A centurion on horseback led the entourage around the Tomé plaza for the first nine of the Stations of the Cross; then the priest delivered a brief sermon. In the afternoon, the Santo Entierro was hung upon the cross, flanked by the two thieves (youths tied to smaller crosses and standing comfortably on ample ledges). The three "bodies" were lowered, and the Santo Entierro was borne around the plaza in a coffin and returned to the church in a great funeral procession.

When Josiah Gregg witnessed this "Holy Week function" in the 1830s and became one of the first persons to describe it, it contained another component besides the Stations of the Cross:

> I once chanced to be in the town of Tomé on Good Friday, when my attention was arrested by a man almost naked, bearing, in imitation of Simon, a huge cross upon his shoulders, which, though constructed of the lightest wood, must have weighed over a hundred

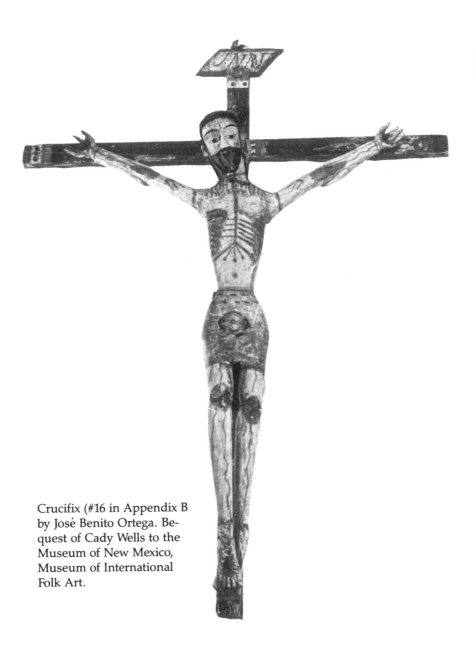

Crucifix (#16 in Appendix B by José Benito Ortega. Bequest of Cady Wells to the Museum of New Mexico, Museum of International Folk Art.

pounds. The long end dragged upon the ground, as we have seen it represented in sacred pictures, and about the middle swung a stone of immense dimensions, appended there for the purpose of making the task more laborious.[9]

The bearer of the cross in likeness to Jesus must have been a member of La Cofradía de Nuestro Padre Jesús Nazareno—the Brotherhood of Our Father Jesus the Nazarene, an organization of Spanish Catholic laymen which seems to have arisen in the colony a bit later than the passion play, perhaps in the 1780-1810 period.[10] During the earlier weeks of Lent, the men of the Brotherhood used their Jesús Nazareno and Santo Entierro bultos to enact the stages of the Christ's passion, but the focal moment of the Penitente ritual cycle was the re-enactment of Christ's crucifixion on Good Friday, when one of the Brothers might be tied to the full-size cross he had carried to the Calvario, raised upon it, and left for a short time.

Although it is known outside the villages principally for its corporal penances, the Brotherhood existed and still exists mainly for deeds of charity and mutual help within the local community. The two things worth noting are probably these, that the Brothers' obedience to their immediate superior, the Hermano Mayor (Elder Brother) is of more value than their penance, and that "individual innocent suffering is connected with the healing of the wider community."[11] The Brothers' religious exercises developed for the most part from standard devotions and penances of the Catholic Church; for instance, their Tinieblas is a powerful, wonderful development of the standard Catholic Tenebrae, a ritualizing of the darkening of the sun and moon, the earthquake, the tearing of the temple veil, and the rising of the dead — the expression of Nature's dismay and return to chaos when Christ died.[12]

The characteristic hymns of the Brotherhood, the *alabados*, derive their Spanish name for the opening words of a song in praise of the Eucharist, "Alabado sea—Praised be." These songs serve as the liturgical texts of many of the Penitente rituals; their ballad-like stanzas narrate the events being commemorated, guiding the mind

and moods of the devout and the actions of the human performers
through the sequence of holy history. For example, here are the stan-
zas of "Pues Padiciste Por Amor Nuestro" that narrate the fourth,
sixth, and eighth stations:

> Su amante Madre
> lo encuentra tierno,
> y queda herido
> de ambos el pecho.
>
> Mujer piadosa
> le ofrece un lienzo
> y el rostro santo
> recibe en premio.
>
> A las que lloran
> por sus tormentos
> que lloren manda
> por si y sus deudos.
>
> ———
>
> His loving Mother
> tenderly meets him,
> leaving wounded
> the heart of them both.
>
> The pious woman
> offers him her veil
> and receives as reward
> the holy countenance.
>
> Those who weep
> for his sufferings
> he tells to weep
> for themselves and their children.

The penitent Brothers engaged in a variety of penitential
practices—scratching their backs to start the flow of penitential
blood, scourging themselves, and applying cactus to their bodies—
in addition to carrying heavy crosses and reenacting the Crucifix-
ion of Christ mentioned above. These five penances are, I believe,

ritualizations of the Five Sorrowful Mysteries of the Rosary. It should be added that in all of these penances, the wounds "are not deep and the muscle structure is not damaged."[13]

In general, the Brothers were the most significant nineteenth-century patrons and practitioners of the arts. Their *moradas*—chapter houses—are prime examples of vernacular communal architecture, and the composition of *alabados*—passiontide hymns—and the santos would never have ben so numerous or become so excellent without the Brothers' inspiration and patronage. In these concrete ways, the Brothers typified the New Mexican Hispanic modes of inserting their human lives into the divine life, with all its authenticity, permanence, and sacred power.

Bishops Zubiría and Lamy from 1833 to 1875, Archbishops Lamy and Salpointe and their successors from 1875 to the 1930s, and the Jesuits of *Revista Católica* from 1875 to the 1930s could not cope with the mentality at the root of Penitente activities and the other principal ingredients of New Mexican Spanish Catholicism. There is good reason to suspect that—however much they usually kept it to themselves—the Mexican and Spanish-educated priests in the colony prior to 1851 had reacted negatively to the activities of their parishioners.[14] To men educated in seminaries dominated by Counterreformation neo-Aristotelianism, educated in a world dominated by the rationalistic Enlightenment, the penitential rites of the men of New Mexico must have looked like the worst sort of medieval superstition, and because the santos of Christ typical of the Brotherhood reveal their full meaning only in the context of the "folk Platonism" mentioned above, the priests from outside the colony must be excused for failing to comprehend them.[15]

William Wroth quotes some comments on a bulto of Jesucristo made by Miguel Herrera. The santo had a head and lower jaw that could be moved by wires: "On Good Friday, Christ raises his head and tries to talk to us."[16] A bulto or an actor in a passion play or a Brother in penitential earnest might substitute for Christ in enacting the events of his passion, and in the same way the bulto of

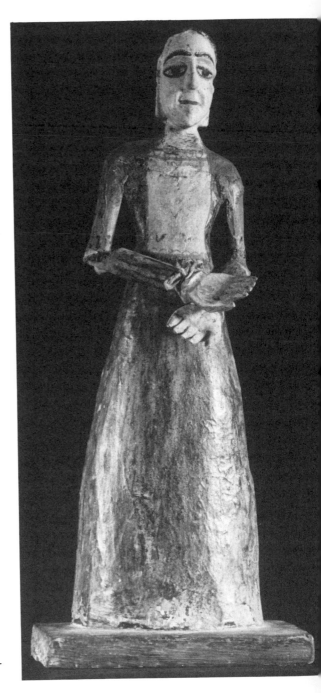

Our Lady of Solitude (#48 in Appendix B) by José Benito Ortega. Held up by some means, her arms with their large, powerful hands received the implements of the passion—the crown of thorns, nails, and so forth—when her son's body was removed from the Cross. Bequest of Cady Wells to the Museum of New Mexico, Museum of International Folk Art.

Jesús Nazareno or the Santo Entierro served in many a priestless village as a substitute for the reserved Eucharist. The people carried it about the fields to bless them on the feast of Corpus Christi, the day when a priest, had one been available, would have carried the consecrated host itself in procession.

Sacramental theology on the "folk-Platonic" model enhances our understanding of New Mexican enactments of Christ's Passion and Death, whether they come about as drama, penance, or art. The sanguinary "Penitente" crucifixes, the Jesús Nazareno and Santo Entierro bultos, the passion plays, and the Brothers' ceremonies are all best evaluated together, as parallel manifestations of the same religious dynamic. In the New Mexican tradition, as we have seen, most saints are represented in repose, so that even San Acacio and Santa Librada are not depicted in the moment of their "painful" crucifixions so much as shown possessing their crosses as attributes; but the Brothers' crucifixes and especially their Nazarenos and Santo Entierros are definitely action-oriented. They show a highly dramatic Christ, often made with hinged limbs so they can go through the various torturous stages of capture, flagellation, crowning with thorns, mocking, carrying the cross, crucifixion, deposition, and burial.

The events of Christ's Passion and Death compose a pattern that surpasses the earthly deeds of any other holy person, indeed, of all of them combined. Hence, when the men of the village move the Jesús Nazareno bulto through the various moments of Christ's earthly passion, death, and entombment, the activity is almost certainly to be understood as a folk substitution for the inaccessible Catholic Mass. The action, no less than the articulated statue itself, is validated by the primal Christian event in such a manner that the action is the ritual sign in which that primal event is really present. This kind of activity originally took place in New Mexico without authorization by the official Church, and there is no provision in any official Catholic theology of the sacraments for it; but the people were undoubtedly performing rituals along the lines of the sacraments. They made present in their own day, in their own

villages, in their own bodies the identical action upon which the Christian religion is based.[17]

What they did was not a Pelagian effort to gain their salvation by doing for themselves what Christ had already done for all. Just as in traditional Catholic theology a particular Mass is not distinguishable in its fundamental being from Christ's sacrifice of himself on Calvary, so the penitential crucifixion ritualizes and hence becomes (to a limited degree, in a limited place, and for a limited time) the unique once-for-all Calvary. The person tied to the cross may be 'Mano Espiridion Miera of our village, but really and truly (if temporarily and to a limited degree) he has become, he is, Jesus Christ.[18]

The Hispanic people of the latter part of the eighteenth century and the first part of the nineteenth, brought up in a strongly sacramental religion and then abandoned by their priests, needed to find a satisfying and available substitute for confession, the Mass, and the Eucharist. Reasserting the inherent priestly character of every Christian community, they turned especially to the key event of their faith, the Passion and Death of Christ, to gain some measure of expiation of their sins and to secure strength to live authentic lives. Hence the santos, the Christmas and Holy Week dramas, the penitential practices of the Brothers of Our Father Jesus the Nazarene, and other analogous popular devotions actually form a quasi-sacramental system. What the sacraments and the Mass were to a village with a priest, the santos, penances, wakes, and enactments of the death of Jesus were to a village without one. A sacramental sociocultural tradition in which "village membership, not kinship affiliation or extraterritorial membership, is the basis of identification" needed to relate not just the separate individuals but the village as a living community to the system of holiness and power composed of God, Christ, the Virgin, the angels, and the saints. And to do so without a priest naturally demanded a strategy both communal and sacramental.[19]

In this interesting age, Post-Modern if not yet Post-Absurd, Hispanic New Mexicans' self-validation through santos and

ceremonies might instruct us that what we men and women need above all is our own validation. The various churches offered this validation in times past throughout Christendom; whenever and wherever it was present in New Mexico, the Roman Church offered it in its official and usual manner, and where the official Church was absent, the penitential Brotherhood of Our Father Jesus offered that great gift. Like the validation of a santo or that of a ceremony, the authentication of a person adds little or nothing to his understanding of himself, but it adds enormously to the assurance that, like the statue and the devotion, he himself makes sense far beyond his limited ability to comprehend such things. As the Brothers sing in one of their alabados:

> There is no one now
> Who is not worth something;
> Christ is already dead.[20]

Notes

1. These sacred persons and pattern-setting actions take the place of the Platonic ideas, for this is not a Platonism of knowledge but of being. The important thing is not a flow of knowledge or explanation—from the more intelligible to the less intelligible—but a validating participation of the power–holiness of the greater (saint or saving event) by the lesser (santo or cultic ritual).

In Platonism, ideas exist independently of human thought and guarantee the things of which they are ideas; thus a horse participates in (without exhausting) the idea "horse" and is intelligible and indeed real because of its sharing in the validating power of the idea. In Aristotelianism, by contrast, things exist independently of thought and guarantee the ideas derived from them; thus the idea of horse is valid and true because it springs in human thinking from some real horse or horses. In Platonism, consequently, everything is a symbol reifying its idea, and due to its participation in the idea it renders the idea as concretely present as it can be; a thing is hence a natural symbol, its very being is dependent on this fact, and it cannot be adequately separated from the being of the idea. In Aristotelianism, symbols are all artificial and—within limits—arbitrary, and are hence always adequately and really distinct from that which they symbolize.

To quote Karl Rahner on this point: "We call attention only in passing to the theology of the *sacred image* in Christianity. An exact investigation into the history of this theology would no doubt have to call attention to a two-fold concept of

image which is presented by tradition. One, more Aristotelian, treats the image as an outward sign of a reality distinct from the image, a merely pedagogical indication provided for man as a being who knows through the senses. The other is more Platonic, and in this conception the image participates in the reality of the exemplar—brings about the real presence of the exemplar which dwells in the image." *Theological Investigations IV* (Baltimore: Helicon Press, 1966), 243.

2. The archetypes that the primal religions projected backwards into *"illud tempus*—beginning time" Plato rendered static and essentialist and projected into the world of ideas. Subsequently, Augustine asserted them to be in the mind of God (especially in the memory of the Father), and Jung put them in the collective unconscious; "folk Platonism" sets them in heaven. Mircea Eliade, *The Myth of the Eternal Return* (Princeton: Princeton University Press, 1965), 6-7, 34-35; Margaret Finch, *Style in Art History* (Metuchen: Scarecrow Press, 1974), 85. Putting Jacques Maritain, Carl Jung, and Erich Neumann together, we might say that the creative idea emerges from the collective unconscious where it previously lurked as an archetypal exemplar begging to be expressed outwardly, and that during the Renaissance it became a dominant conscious motive in an increasingly-reflective individual consciousness.

3. Christianity goes radically beyond and even contrary to the Platonic scheme of static essences ("ideas") by placing the all-important redemptive paradigm, Christ dying crucified, squarely in clock-and-calendar time. As Paul accurately saw, to the gentiles this was foolishness and absurdity (1 Cor. 1: 23), since the Hellenized gentiles could not imagine that anything eternally valid could arise in time and space and matter and be narrative and existential.

As for the santos: the normal and appropriate setting of most retablos and bultos is on the wall, on the shelf, or in the nicho, receiving prayers and transmitting them to the holy person who is in heaven as well as present in a limited manner in the santo. The big bultos of Christ in his passion were made for dramatic rituals, performing the sacred action. See George Mills, *The People of the Saints* (Colorado Springs: Taylor Museum, 1967), 61.

4. "Always and everywhere men have had the conviction that in gestures and rites and figurative representations, what is signified and pointed to is in fact present precisely because it is 'represented'; and this conviction should not be rejected off-hand as 'analogy-magic'"; Karl Rahner, *The Church and the Sacraments* (New York: Herder and Herder, 1963), 36.

All interaction with a santo tends to evoke a ritual context, and we may suspect that many a piece of myth or folklore originated from ritual, not the other way around. A prime example is the Santo Niño de Atocha origin tale as Yvonne Lange has researched it (see Chapter IV).

5. Thomas J. Steele, S.J., "The Spanish Passion Play in New Mexico and Colorado," *New Mexico Historical Review* 53 (1978), 239-59. Another source of the passion plays may be found in the priests' Good Friday sermons such as the one treated in William Wroth, *Images of Penance, Images of Mercy: Southwestern Santos in the Late Nineteenth Century* (Norman: University of Oklahoma Press, 1991), 21-23, and one preached in Santa Fe in 1821.

6. Josiah Gregg, *Commerce of the Prairies* in Reuben Gold Thwaites, ed., *Diary of Early Western Travels* (Cleveland: Arthur H. Clark, 1905), vol. 20, 48. See also W.W.H. Davis's descriptions of Santa Fe's Holy Thursday and Good Friday processions in *El Gringo, or, New Mexico and Her People* (New York: Harper and Brothers, 1857), 345-46.

7. "[D]el vecindario, el que algunas veces hace en esta capilla su funcion de Semana Santa"—Biblioteca Nacional, México, legajo 10, numero 43; photostat pages 4279-80, Coronado Room, University of New Mexico Libraries; Domínguez, *The Missions of New Mexico, 1776*, trs, eds., Eleanor B. Adams and Fray Angélico Chávez (Albuquerque: University of New Mexico Press, 1956), 154.

8. Florence Hawley Ellis, "Passion Play in New Mexico," *New Mexico Quarterly* 22 (1952), 203. See also John E. Englekirk, "The Passion Play in New Mexico," *Western Folklore* 25 (1966), 17-33, 105-21; Steele, *Holy Week in Tomé: A New Mexico Passion Play* (Santa Fe: Sunstone Press, 1976), for Spanish and English texts with some commentary; Steele, "The Spanish Passion Play," 243-46.

9. F. Stanley, *The Tomé New Mexico Story* (Pep, Texas: F. Stanley, 1966), 8; Gregg, Commerce, 181.

10. The best single book on the Brotherhood of Our Father Jesus is Marta Weigle, *Brothers of Light, Brothers of Blood: The Penitentes of the Southwest* (1976; rpt., Santa Fe: Ancient City Press, 1989); her compilation, *Penitente Bibliography* (Albuquerque: University of New Mexico Press, 1976), is the companion. See also Thomas J. Steele, S.J., and Rowena A. Rivera, *Penitente Self-Government* (Santa Fe: Ancient City Press, 1985), on district and regional government among the various village chapters. Wroth, 40-52, studies the early documentation of the Brotherhood and the subsequent historiography.

Good older accounts are: Fray Angélico Chávez, "The Penitentes of New Mexico," *New Mexico Historical Review* 29 (1954), 97-123; George Mills and Richard Grove, *Lucifer and the Crucifer: The Enigma of the Penitentes* (Colorado Springs: The Taylor Museum, 1966); Bill Tate, *The Penitentes of the Sangre de Cristos* (Truchas: The Tate Gallery, 1966); Marta Weigle, *The Penitentes of the Southwest* (Santa Fe: Ancient City Press, 1970); and Lorenzo de Córdova, *Echoes of the Flute* (Santa Fe: Ancient City Press, 1972).

Most scholars seem to agree that the New Mexican Brotherhood arose in the Santa Cruz Valley, and in 1840 when Gregg saw the penitential cross-bearer, Tomé would have been near the southern rim of its geographical spread.

11. Weigle, *Brothers of Light*, 151-53; C. Gilbert Romero, *Hispanic Devotional Piety: Tracing the Biblical Roots* (Maryknoll: Orbis Books, 1991), 104.

The Brotherhood seems to me to follow many organizational models. Fray Angélico Chávez suggested the Seville Confraternity as a likely source outside the colony, for they too used the extraordinary title *Nuestro Padre*—Our Father—to refer to Jesus Christ. William Wroth has identified various specifically penitential organizations in New Spain (Mexico), principally La Santa Escuela de Cristo—The Holy School of Christ—as analogues and sources of the New Mexican "Fraternidad Piadosa de Sangre de Cristo" or later "de Nuestro Padre Jesús Nazareno." Even within the northern colony there were many confraternities and

pious parish societies, including the Franciscan Third Order of men and women, but no one of them had an exclusive influence on the Brotherhood as organization. For a variety of interpretations, see Fray Angélico Chávez, "Penitentes of New Mexico," 97-123; Weigle, *Brothers of Light*, 26-51; Steele and Rivera, *Penitente Self-Government*, 7-8, 10-11; William Wroth, *Images of Penance*, 35-42; J. Manuel Espinosa, "The Origin of the Penitentes of New Mexico: Separating Fact from Fiction," *Catholic Historical Review* 79 (1993), 454-77.

12. See Steele and Rivera, *Penitente Self-Government*, 196-97.

13. Juan Hernández, "Cactus Whips and Wooden Crosses," *Journal of American Folklore*, 76 (1963), 221; he agrees with Margaret Mead, *Cultural Patterns and Technical Change* (New York: New American Library, 1955), 167, who notes that for traditional New Mexican Hispanics surgery and accidents "are the source of considerable anxiety, for to be [deeply] cut or broken in some way damages the whole person."

14. Wroth, *Images of Penance*, 40, 44-46, 51, 172-73.

15. In the Reformation and Counterreformation era, the older Platonic sacramental theology had been replaced by a neo-Aristotelian theory of conjoined instruments, a Rube-Goldberg system based on creationist, materialist models and confined almost totally to efficient causality. Such a theology can make no sense of New Mexican religious activities, for it cannot satisfactorily connect the mythic pattern-setting deed to the ritual. In the order of efficient causality, the cause must always be *other* than the effect, but by contrast in the order of ritual causality, the sacred ceremony must be *identical* with the paradigmatic event (the Last-Supper-to-Pentecost event performed by Christ in and at the edge of historical time).

Catholic sacramentalism demands to be understood in parallel with tribal, archaic religions, where differences of time, place, format, minister, and beneficiary are erased so that the rite is identically the same event, for it occurs in the *illud tempus*. The Christian rite performed today is valid because the rite is Christ's eternal act of redemption as it concretely affects a particular person or group and because Christ remains the true celebrant; Louis Bouyer *Rite and Man* (Notre Dame: University of Notre Dame Press, 1963), 66; on page 57 he stated that "What man does in the ritual is a divine action."

16. Wroth, *Images of Penance*, 130 and 185n20, where he cites especially Cleofas Jaramillo, *Shadows of the Past* (1941; rpt. Santa Fe: Ancient City Press, 1972), 61.

17. Weigle, *Brothers of Light*, 190, 273n5, 275n29; Steele and Rivera, *Penitente Self-Government*, 191-95.

18. Córdova, *Echoes*, 9, maintains that it was considered a signal honor to be named to enact Cristo—not at all a punishment but indeed a reward for having been an outstanding *hermano*. Richard Gardner, *Grito! Reies Tijerina and the New Mexico Land Grant War of 1967* (New York: Bobbs-Merrill, 1970), 75-74, passes along this John Wayne episode: "One little old lady of Rio Arriba recalls standing as a young child in the placita of San Pedro on the Sangre de Cristo grant during Good Friday celebrations and receiving the shock of her life when the

call to colors sounded and the United States cavalry thundered in to 'save' a highly indignant penitent from the cross."

19. Edward P. Dozier, "Peasant Culture and Urbanization: Mexican Americans in the Southwest," in Philip K. Bock, ed., *Peasants in the Modern World* (Albuquerque: University of New Mexico Press, 1969), 144-45. I would like to register my caveat about Dozier's reference to the *compadrazgo* (godfather) relationship as "fictional" and "ritual or fictitious" (151, 153). The sponsors or witnesses, who represent the Church as community in the conferral of various sacraments, are made very much of in the Catholic system, most especially as the Hispanics understand it. Cf. John L. McKenzie, *The Roman Catholic Church* (Garden City: Doubleday, 1971), 164-65.

In this context, we might see a solution to George Mills' question in *People of the Saints*, 60, why the Hispanic men of New Mexico feel compelled to become Brothers of Our Father Jesus and do penance: as male authority over others is sanctioned communally, so is male responsibility for others.

20. Laurence F. Lee, "Los Hermanos Penitentes, *El Palacio* 8 (1920), 11; I have never found the Spanish version of the text. Alexander Darley, *The Passionists of the Southwest* (Pueblo: author, 1893), 36, evidently translated the same lines as "There's none unworthy / Since Jesus died," and S. Omar Barker, "Los Penitentes," *Overland Magazine and Out West Magazine* 82 (1924), 153, offers "Christ is now dead / And all are worth saving, / Now give him your soul / For which he is calling."

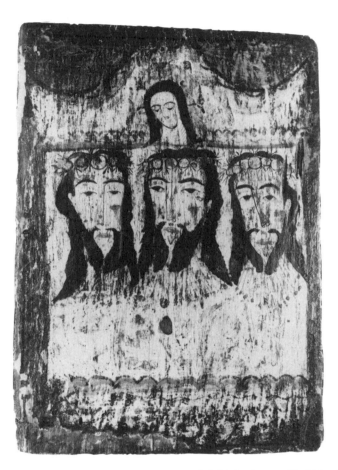

Veronica Holding the Triple Rostro (#15a and #139 in Appendix B) by Pedro Fresquis. In Taos Valley enactments of the passion play, the young woman who played Veronica held her veil not once but three times to Christ's face. Courtesy of the Denver Art Museum, Anne Evans Collection, 1936.3.

VI

Saints and Prayer

T he majority of the saints venerated in New Mexico and
southern Colorado were patrons for certain particular hopes
and protectors against certain fears. In the early 1970s, I did a small
amount of questionnaire work in the region, testing the possibili-
ty of recovering knowledge of this subject. Catholic pastors put me
in touch with a few dozen elderly Hispanics, and I asked them,
in regard to a list of saints, why was each of them prayed to: For
what benefit was this saint asked? For protection from what evil
was that saint petitioned? In this way I learned the hopes and fears
the Hispanics traditionally associated with many of the saints.

By 1970, a great deal of the original information had undoubted-
ly been lost forever, but even that late I was able to recover enough
remnants, both from the questionnaires and from published and
archival sources, to realize that the saint-related system of patrons
and protectors fed more information into a generalized motivational
system drawn up for an agrarian peasant society and gave a far more
complete and accurate picture of New Mexican motivation than did
several standard books on the New Mexico Hispanics taken
together. This descriptive definition applies best of all to Hispanic

New Mexicans of the first three quarters of the nineteenth century—before the arrival of the railroad in 1879-80—though it probably applied to the people of smaller out-of-the-way villages down to the Second World War.[1]

The eighteenth and nineteenth-century New Mexican lived in a peasant society quite isolated from its "great tradition," the metropolitan tradition of king and archbishop realized fully in Madrid and fairly completely in Mexico City. By contrast, a peasant society is a small agricultural village which is not quite independent of the capital city, not quite complete in itself. Peasants form the broad and strong foundation of the entire composite traditional society, and consequently they must be defined within that larger context. By means of their agricultural surpluses the peasants indeed support the non-agricultural specialist workers and rulers, and in past ages the peasant was arguably the origin of all economic values.

The farming villages in New Mexico were unusually isolated from their market towns and even from one another.[2] In the few market towns that existed, people did their business more by barter than by cash, just as in the villages themselves transactions were carried on by gift-exchange and work-sharing more often than by barter. The people of the farming villages needed only a few things from the market towns and the even greater world that those towns mediated: some necessary tools, particularly those of metal like saws and axes, and metal itself to be worked up locally. European-style weapons came from the larger society by way of the towns: guns, swords, and the "business end" of halberds and lances. Some dyes were imported into the colony for the woolen cloth made by the Hispanics and Pueblos; these dyes often turned up, as already noted, among the santero's materials. And any truly fine clothing for special occasions, like weddings and feast days, came into the colony from outside.

From the local region the villagers obtained a few more things, especially salt, pottery, and santos made by the specialist santeros. Specialists within the home village included the *curandera* (a woman skilled in herbal folk medicine), the *partera* (midwife), the blacksmith, the carpenter, and (as the population outgrew the land

base in the early nineteenth century) the Hispanic potter. But each extended family provided from its own labor and talents the vast majority of what it needed to live. Their animals—sheep and goats, cattle and pigs, burros and horses—provided work, meat, hides and wool for clothing, and grease for candles. The people cut timber for fuel, for their few items of furniture, for vigas and lintels. And finally, the earth itself provided the adobe and rock for the house, multiple crops for food and other uses, and the remainder of the pigments.

During its years of isolation, New Mexico experienced a significant decline in effective energy-use due to a decline in its weapon and tool technology, especially farming implements. The people spent more manpower and more manhours performing the same tasks of defense and cultivation than they had at the beginning of the colonial period. In the colony's earliest years, the settlers had been relatively well supplied with weapons with which to subdue the Pueblo Indians and coerce work from them which the Spanish later had to do themselves. When weapons and armor of the European sort broke or wore out, makeshift bows and arrows, buffalo-hide shields and jackets, and lances with fire-hardened wooden tips replaced them. And when the well-made farm tools they had brought from New Spain broke, they had to fashion homemade plows, pitchforks, scythes, sickles, shovels, hoes, and so forth, tools that took more work to use when they were homemade than did those made in commercial workshops by specialized craftsmen.[3]

The New Mexican world, by contrast to the urban life of the "great tradition" of its own day, was made up of numerous semi-isolated extended-family peasant village communities, each of which had to provide most of what it consumed. As Karl Marx wrote of the nineteenth-century French peasantry: "Each individual peasant family is almost self-sufficient; it itself directly produces the major part of its consumption and it acquires its means of life more through exchange with nature than in intercourse with society.[4]

Peasant religion has always been utilitarian and moralistic— that is to say, practical, pragmatic, and directed to the concrete social roles and duties each member must perform faithfully if the social

order is to survive, remain stable, and perhaps even flourish. Hence it will curb aggressiveness, competitiveness, and individualism, socialize the members of the peasant society by spotlighting their dependence upon the group, and sanction the unquestioning fulfillment of routine tasks. As Robert Redfield has summed it up, the peasant's values center around "an intense attachment to native soil; a reverent disposition toward habitat and ancestral ways; a restraint on individual self-seeking in favor of family and community; a certain suspiciousness, mixed with appreciation, of town life; a sober and earthy ethic.[5]

Because they founded their Catholic religious practice on values like these, New Mexicans were resourceful enough to survive in the face of a practically total abandonment by the "great tradition" of Spain, New Spain, and the Mexican Republic. By the nineteenth century, this "great tradition" existed for the most part as a psychological awareness on the farthest horizon of consciousness as the fundamental guaranteeing and validating factor of their community life as citizens of the Spanish Empire and as Catholics. Political validation began with the royal court in far-off Madrid, passed through the viceroy in Mexico City and the governor in Santa Fe, and finally attained the alcalde in the nearest town. Religious validation began with the papal court and the Franciscan superior-general in Rome, passed through the Franciscan provincial in Zacatecas, the bishop of Durango, and the custos in Santo Domingo, and eventually trickled down to the priest in the nearest parish church. There was little impact left when these affirmations of their existence finally reached the people of some outlying village in manual contact with their land.

Close to the land as they were, nineteenth-century New Mexico peasants lived lives marked by a large number of customs surviving from, reverting to, or at least reminiscent of the Middle Ages. Moreover, New Mexico repeated the original medieval synthesis of classical (or Renaissance) survivals; Christianity; and retribalization, detribalization, and acculturation (of Germanic tribesmen in Europe, of Native Americans in the new world). Two further factors especially reinforced this New Mexican medievalism: the *Recopilacíon de las leyes de las Indias,* The compilation of royal

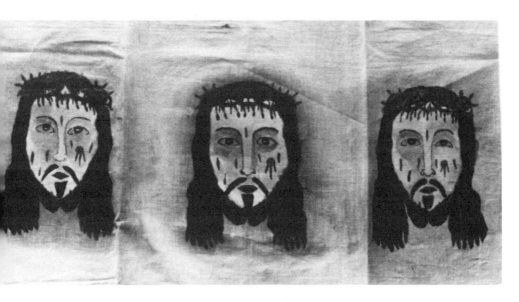

The Triple Rostro (#15a in Appendix B) by an unknown artist, probably about 1935. In Taos Valley enactments of the passion play, the young woman who represented Veronica held her veil not once but three times to Christ's face. From a private collection, with permission.

decrees that mandated for the colonies a lifestyle based on a generic medieval Iberian townlife, and the Franciscan friars' mainstream medieval Catholic spirituality. Taken together, all of these factors gave rise to a believing community that prayed and worshipped in common, doing rituals together that implicitly but very effectively committed the faithful to live out in their daily lives what they acted out in their rituals, to walk in the footsteps of Jesus not only during Holy Week but all the days of the year.

Totally devoid of Renaissance or Romantic hunger for novelties, the New Mexican peasant, like any other peasant, had instead a desire for what Eric Wolf refers to as "that sense of continuity which renders life predictable and hence meaningful."[6] New Mexican santos enhanced this predictable and meaningful dimension of village life, for they make up a set of visual "commonplaces" where the verbal epithets of rhetorical commonplaces are replaced by the santos' visual attributes, their significant iconographic traits. The santos are a central component of system which is both visual (because pictorial) and oral (because of the legends, prayers, and associations passed down by word of mouth about the vast majority of the saints the santeros represented). The santo subjects tally with the people's hopes and fears in such a way as to provide a key component in a motivational system that enables the believer to prevail upon God and the saints to control the world for the benefit and protection of mankind.

Not every single saint was patron of some special hope or fear, and some saints were petitioned for as many as ten needs. Conversely, certain needs cannot be shown to correspond to any of the saints, other needs were submitted to several saints, and some other "felt needs" were probably not submitted to any saint since they were felt to be beneath the dignity of sainthood. Nevertheless, the considerable correlation between saints and needs meant that the New Mexican Christian had a way to interpret nearly every major opportunity or major problem, a way to hope for heavenly aid when mere human means seemed vain.

Some comments on particular hopes and fears offer a more concrete sense of the motivational system:

- With regard to protection against sickness (1.113), Margaret

Mead offers a helpful remark: "There is a sort of persistent hypochondria. . . . not characterized by general complaints of feeling bad 'all over.' . . . By projecting the trouble onto a specific body-part, totality is protected."[7] The list of sicknesses submitted to the care of individual specialist saints—trouble with teeth, eyes, skin, plague (usually smallpox or bubonic plague), and burns—suggests that ordinary saints were felt to have less power than they would need in order to penetrate to the "innards" where more serious and mysterious ailments reside, and that such troubles would need to be submitted to the Holy Child of Atocha, the Sacred Heart, Nuestra Señora del Socorro—even to Santa Rita de Casia as the patroness of hopeless cases. The wounds that a man receives while performing corporal penance, as has been noted above, fall into the superficial class, never involving the amputation even of a finger (a practice in some Native American tribes), penetration into the body cavity, or nailing of the hands or feet. If people suspected that someone's insanity was a result of witchcraft, they would have submitted it to the care of San Ignacio de Loyola, but otherwise they would simply have left it in God's care. There was an Iberian tradition that the insane were especially touched by God, and some Native Americans had a like attitude, but Ari Kiev's study of Texas folk medicine points out that Texas Mexicans viewed madness as often "punishment from God."[8]

• All the saints prayed to with regard to intemperance (1.114) seem also to have been invoked against sexual misbehavior but not against drunkenness or drug-use, which were apparently not significant problems in the period before the American incursion.[9]

• Several persons who responded to the questionnaire made a point of saying that Doña Sebastiana, the allegorical personification of Death, was not invoked as a saint would be, that she served instead merely as a reminder of the possibility of death (1.115); only one respondent mentioned persons invoking her. This information casts doubt on the caption in Mills and Grove's study of the Brotherhood which says that Doña Sebastiana "is appealed to for long life" and on Ely Leyba's remark that persons "would pray to the image of Sebastiana that their lives would be prolonged."[10] By contrast, *una buena muerte* (a good death in the state of grace

resulting in admission into heaven) was a favor fervently to be prayed for—though it need not hurry.

• Granted that childbirth (1.121) was not considered pathological, still its very real dangers were taken to San Ramon Nonato ("Nonnatus" means "not born"; he was a Caesarean delivery after his mother had died), the patron of midwives, women in pregnancy and childbirth, and the unborn.[11]

• The supplicant prayed to San Cayetano, patron of gamblers (1.1252), by saying, "I'll bet you a rosary in your honor you *don't* do this favor for me." There is nothing about gambling in the biography of San Cayetano, just as there is nothing about dancing in the life of San Luis Gonzaga.

• The Renaissance norms and values that continued to influence church architecture in New Mexico did not translate very effectively into domestic architecture or into religious painting. Exact symmetry (1.127) was only very rarely—and then probably accidentally—a property of santos; retablos are more often than not noticeably non-rectangular, and many of them hung for upwards of a hundred years crooked on the walls of New Mexico homes and chapels.

• The old opinion about New Mexican deemphasis on learning (1.211, 1.221) might need modification. Santo Tomás de Aquino, a patron of scholarly activities, appeared only once in the sample of a thousand santos, but Santa Gertrudis, who appeared fifteen times in all, was associated with youth and school twice in six answers, while her official status as Patron of the Spanish Americas got no mention. The New Mexican villagers were aware, as noted, that there was a "great tradition"; and even though they may have had no practical use for it for their own immediate purposes, they respected it, felt that it validated their existences from a distance, and hoped their children or grandchildren might by some lucky stroke come to participate in it. When the railroad arrived in 1879-80, created "New Towns" in Las Vegas and Albuquerque, and seemed to bring a North-American "great tradition" into New Mexico, the Hispanics evidenced a great hunger for the sort of education that would suit their children for that new life.[12]

• The only three saints who appear in the category "Achievement" (1.3)—Juan Bautista, Pascual Baylon, and Antonio de Padua—

were associated with strayed animals and lost things. That nothing
was said about animals or things stolen was probably due to the
situation in the old extended family villages, where apart from war-
time incursions by wild Indians, there was little likelihood of theft,
burglary, or robbery. There was instead a tendency toward com-
munal usage of many things privately owned—tools to be bor-
rowed, and so forth—with the whole village to some degree at least
co-responsible for everything in the village.

• All the saints that had to do with ridding oneself of general-
ized sin (1.311, 1.312, 2.111, 2.112) seem to have been connected
with the penitential Brotherhood, and all these saints and all other
saints who had to do with getting rid of particular sinfulness (e.g.,
sexual; see 1.114) were prayed to on behalf of others. There was,
in other words, a group dimension to New Mexican sin-
consciousness, whether it was one's own or another's, which points
to a communal honor-and-shame culture rather than to a mere in-
dividualistic guilt culture. An interpersonal reaction to one's own
wrongdoing (shame) called for a communal cleansing (penance
done in a group); and hence we should see the "death" of the
Brother chosen to be the Cristo as not merely an individual but
clearly a village expiation: the Brother who dies *as* Christ dies, *like*
Christ, "for the sins of the whole people" (John 12:50).

• A happy death was a standard object of prayer, but this is the
only benefit belonging to a distant and vague future (1.324), one
which does not answer a present need, that the people asked of
the saints. Perhaps the people did not worry overly much about
the remote future, sensibly taking of matters at hand as well as they
could and letting the year after next take care of itself.

• The statistics relating to the two patrons of Brotherhood
anonymity (2.1233), San Juan Nepomuceno and San Ramón
Nonato, suggest that the Brothers of Our Father Jesus the Nazarene
adopted them quite early, though Brotherhood circumspection
doubtless increased during the nineteenth century. The Mexico-
trained diocesan clergy had imbibed some of the values of the ra-
tionalistic Enlightenment and took a dim view of the Brothers' public
penances, which appeared (and were) quite medieval. In 1833,
when Bishop Zubiría had announced his intended visitation of New

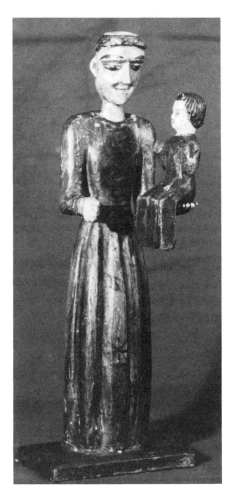

Saint Anthony of Padua (#59 in
Appendix B) with the body by
José Rafael Aragon or the Santo
Niño Santero, the head by José
Benito Ortega, and the Christ
Child by José de Gracia Gon-
zales. This is not so much a
connoisseur's *objet d'art* as a
teacher's illustration, since it
shows clearly how in earlier
times holy fragments were not
discarded but recycled. Regis
University Collection.

Mexico (the first bishop to travel there since 1760), Padre Antonio José Martínez wrote him a very circumstantial and negative description of the Brothers' public rituals, thereby contributing to the Bishop's order to the Brothers to cease and desist. The Anglo-Americans were a parallel factor. Marta Weigle notes that "When the Anglos began to move into the region after 1821, they reported rituals of a nonsecret religion practiced by much of the population," but she adds that penances performed during the day in a village were always done in a *venda* (hood) "more to insure humility than to hide from authorities." Mary Austin had suggested much the same about the origins of the Brothers' anonymity, that the original motive was "the moral necessity of protecting [the] penitents from spiritual pride by concealing their identity under the black bag which is still worn by flagelantes in all public processions."[13] Hence it seems that anonymity predated the entrance of Bishop Zubiría, the Anglo Protestants, and the French Catholic clergy, and the relocation of the ceremonies to places outside the villages.

• The section on the family (2.1235) includes at least two patrons for each of the main subdivisions, and many of the saints, such as San Francisco de Asís, Santa Gertrudis, San José Patriarca, Santa Rita de Casia, and San Antonio de Padua, were very popular and very frequently represented by the older santeros. It is worth note that a girl's need for help in finding a husband was the object of a devotion, but not a boy's in finding a wife.

• There was no saint for the very important New Mexican institutions of godfather, godmother, godchild, compadre, or comadre, so perhaps these relationships were subsumed under the basic familial positions of status: father, mother, child, brother, or sister (2.3113). But in practice the baptismal relationships actually outweighed the natural, so that for instance if a man served as godfather for his blood brother's child, he and his brother would address each other for the rest of their lives as "compadre."[14]

• The problems of travelers (2.3114 in Appendix E) and of captives (2.3115) seem to have been quite important in New Mexico during the last century. Granted a lot of duplication of statistics between saints associated with the two dangers, traveling is connected

with 6.8% of the sample of a thousand santos (Appendix B), imprisonment with 3.6%.

This motivational study of the New Mexico Spanish of the nineteenth century portrays a people with a special relationship both to the deity and the saints who are portrayed in santero art. The saints, as they are aligned with the needs—the hopes and fears— associated with them, constitute a particular motivational economy which, while it is not complete in all respects, is a necessary supplement to all other accounts of the New Mexico Hispanics of a century ago: "The People of the Saints," as George Mills well named them in the title of his book, cannot be known accurately apart from their saints. The santos—the wooden saints, retablos and bultos— were components of a power-system which reached from earth to heaven and controlled hell, and in so doing protected the culture (including the power-system itself) from that worst of all disasters, a people's loss of confidence in their way of life. The New Mexicans of the last century could not physically control their world through technology, but whenever they needed help from the distant past or from another world altogether, they found that help through means at hand. They knelt before their santos and prayed to the saints, and they have endured.

Notes

1. The whole generalized motivational chart appears as Appendix E. Fromm and Maccoby have defined a people's social character as "a character structure common to most members of groups or classes within a given society . . . a 'character matrix,' a syndrome of character traits which has developed as an adaption to the economic, social, and cultural conditions common to that group." Erich Fromm and Michael Maccoby, *Social Character in a Mexican Village* (Englewood Cliffs: Prentice-Hall, 1970), 16.

2. There was a story told of a little mountain village in the northern part of the colony which was neither attacked nor overcome during the Pueblo Rebellion of 1680, that was not even aware that anything at all had happened until the Spanish settlers returned a dozen years later; the village was used to being left alone. The story was absolutely not true, but the fact that it could be told with a straight face suggests the vastness of isolation in the furthest

backwaters of the New Mexican past.

3. The settled population of New Mexico, counting both the Spanish and the Pueblo Indians, appears to have declined in the first century and a half of the colony's history. Disease not associated with malnutrition probably played the major role in this decline, but the food and energy crisis fostered by the tool-and-weapon decline probably caused an appreciable part of the major population decrease.

See especially D.W. Meinig, *Southwest* (New York: Oxford University Press, 1971), 13. Eric R. Wolf, *Sons of the Shaking Earth* (Chicago: University of Chicago Press, 1959), states that "Between 1519 and 1650, six-sevenths of the Indian population of Middle America was wiped out" (195); he gives a cogent argument in terms of energy-use (198-211). For other particulars, Wolf, 160, notes that "Only one plow, of the many [types of] Spanish plows, was transmitted to the New World," and Irving A. Leonard, *The Books of the Brave* (Cambridge: Harvard University Press, 1949), 242, notes that the Spanish Crown "had forbidden the manufacture of arms in the colonies and had severely limited the importation of them from the homeland." The weapons shortage appeared in Chapter IV in connection with Santiago.

4. Karl Marx, *The Eighteenth Brumaire of Louis Napoleon* in Karl Marx and Frederick Engels, *Selected Works* (New York: International Publishers, 1968), 172. Marx means that the French peasants did not interact with the national economic society; they had, of course, constant interaction with the social fabric of the village.

5. Robert Redfield, *Peasant Society and Culture* (Chicago: University of Chicago Press, 1960), 78; see also Rodolfo Stavenhagen, *Social Classes in Agrarian Societies* (1970; rpt., Garden City: Doubleday, 1975), 66-67. Frances Swadesh, "The Social and Philosophical Context of Creativity in New Mexico," *Rocky Mountain Social Science Journal* 9 (1972), 15, comments that "In New Mexico, the most admired personality configuration centers on reserve, coupled with sensitive perceptions of the feelings of others, frequently communicated by nonverbal means."

Michael Candelaria, *Popular Religion and Liberation* (Albany: SUNY Press, 1990), 30-33, cites Gilberto Giménez as attributing the following traits (to which I have added a few annotations) to popular religion as contrasted to the religion of the ruling classes: popular religion belongs to a subordinate, rural, local culture; it is a religion of salvation, of the poor, and of the laity; it is unsystematized-prethematic, mythical-lyric and folkloric-narrative, vernacular-oral, practical and useful (rather than commodified); and it relies on traditional authority (rather than on hierarchical-bureaucratic authoritarianism).

6. Eric R. Wolf, *Peasants* (Englewood Cliffs: Prentice-Hall, 1966), 98. As Father Ong points out, "Romanticism appears as a result of man's noetic control over nature, a counterpart of technology, which matures in the same regions in the West as romanticism and at about the same time, and which likewise derives from control over nature made possible by writing and even more by print as means of knowledge storage and retrieval"; Walter J. Ong, S.J., *Rhetoric,*

Romance, and Technology (Ithaca: Cornell University Press, 1971), 20.

Preconditions for Romanticism, in other words, are to be found in Newton's mathematicizing of the universe (*Principia*, 1687) and James Watt's invention of the steam engine (1769). Then for the first time in his multimillion year career, man could comfortably confront nature, which hitherto has been overwhelmingly threatening, knowing that he could always fall back upon the comparatively safe world promised him by science and technology.

Swadesh, "Social and Philosophical Context," 16, adds, "New Mexican perceptions of the relationship between Man and Nature do not apparently lead to the celebration of Nature for its own sake, which is characteristic, for example, of the poetry of Wordsworth."

7. Margaret Mead, *Cultural Patterns and Technical Change* (New York: New American Library, 1955), 184.

8. Ari Kiev, *Curanderismo: Mexican-American Folk Psychiatry* (New York Free Press, 1968), xi.

9. Erna Fergusson, *Albuquerque* (Albuquerque: Merle Armitage, 1947), 29.

10. George Mills and Richard Grove, *Lucifer and the Crucifer: The Enigma of the Penitentes* (Colorado Springs: Taylor Museum, 1966), 14; Ely Leyba, "The Church of the Twelve Apostles," *New Mexico Magazine* 11 (1933), 49.

11. Mead, ed., *Cultural Patterns and Technical Change*, 172.

12. Thomas J. Steele, S.J., *Works and Days: A History of San Felipe Neri Church* (Albuquerque: Albuquerque Museum, 1983), 101: "Many boys—not only Protestants but Catholics as well—attended [a school sponsored by a Protestant church] out of what I would call a sheer necessity of learning English, for in these parts its use is so necessary for trade with the Americans of the United States that the Spanish people make great and protracted sacrifices to send their boys to schools where it is taught."

13. William Wroth, *Images of Penance, Images of Mercy* (Norman: University of Oklahoma Press, 1991), 40, 44-47, 50-51, 167, and especially 172-73.

Marta Weigle, *The Penitentes of the Southwest* (Santa Fe: Ancient City Press, 1970), 32, 35-36. In her notes to Lorenzo de Córdova's *Echoes of the Flute* (Santa Fe: Ancient City Press, 1972), 51, Weigle says that secrecy increased after the Civil War; Weigle, *Brothers of Light, Brothers of Blood* (Albuquerque: University of New Mexico Press, 1976), 75, 90-93, 102, 141-42, 149; Weigle, "Ghostly Flagellants and Doña Sebastiana: Two Legends of the Penitente Brotherhood," *Western Folklore* 36 (1977), 135-47; Mary Austin, *Land of Journeys' Ending* (New York: The Century Company, 1924), 353.

14. Lorin W. Brown, "'Compadres' and 'Comadres,'" W.P.A. Writers' Project, New Mexico, History Library, Museum of New Mexico, 5-5-2 # 1, p. 3: "The new compadres treat each other by that title from then on and by no other, even though they be brothers. This new bond is more sacred and supercedes all others. The new ritual of courtesy takes place in all their contacts, both social and in a business way"; also Brown, *Hispano Folklife in New Mexico*, ed. Charles L. Briggs and Marta Weigle (Albuquerque: University of New Mexico Press, 1978), 119. See also Swadesh, "Social and Philosophical Context," 12.

APPENDICES

Appendix A

A CHRONOLOGICAL LIST OF SANTEROS

In each instance, the dates given are the dates the santero may be guessed to have worked. Supplementary information is added, as well as a bibliographical reference of the shortest effective sort, using these abbreviations:

CI: William Wroth, *Christian Images in Hispanic New Mexico.* Colorado Springs: Taylor Musuem, 1982.

Cross and Sword: Jean Stern, ed., *The Cross and the Sword.* San Diego: Fine Arts Gallery of San Diego, 1976.

IPIM: William Wroth, *Images of Penance, Images of Mercy.* Norman: University of Oklahoma Press, 1991.

NKS: Larry Frank, *New Kingdom of the Saints.* Santa Fe: Red Crane Books, 1992.

NMMag: New Mexico Magazine.

PAC: E. Boyd, *Popular Arts of Colonial New Mexico.* Santa Fe: Museum of New Mexico Press, 1959.

PASNM: E. Boyd, *Popular Arts of Spanish New Mexico.* Santa
· Fe: Museum of New Mexico Press, 1974.

Saints: José E. Espinosa, *Saints in the Valleys.* Albuquerque: University of New Mexico Press, 1960, 1967.

"Santero." E. Boyd, "The New Mexico Santero," *El Palacio* 76, 1 (1969), 1-24; also published as a booklet.

Wallrich: William Wallrich, "The Santero Tradition in the San Luis Valley," *Western Folklore* 10 (1951), 153-61.

Wood Carvers: Charles L. Briggs, *The Wood Carvers of Córdova, New Mexico.* Knoxville: University of Tennessee Press, 1980; Albuquerque: University of New Mexico Press, 1989.

APOCRYPHAL

1587 José Manuel Montolla and Montolla de Pacheco—supposed painters of the Trampas altarscreens; *NMMag* 11 (1933), 52. See instead 1756 Miera, 1785 Fresquís, and 1865 Gonzales.

FOLK TRADITIONAL

Immigrants into the colony started this tradition from the Mexican Renaissance styles then current in New Spain. By the end of the eighteenth century it had become a vernacular ("folk") tradition carried on by Hispanics born in the villages of New Mexico.

I. 1695-1750

The santeros of the earliest period were mainly if not entirely located in Santa Fe or Santa Cruz or in the conventos (rectories) of pueblo missions.

1695-1720 "Franciscan F" was a painter of hide paintings more renaissance than baroque in spirit, who did not make use of "architectural" borders. "Santero," 3-5; *Popular Arts of Spanish New Mexico,* 121.

1705-1730 Francisco Xavier Romero, born in Mexico City, resident of Santa Cruz de la Cañada, shoemaker, surgeon, scamp, and likely santero of the hidepainting style-group Boyd attributed to the anonymous "Franciscan B." He was a more baroque stylist of hide paintings than "Franciscan F." "Santero," 5; *PASNM,* 122; Steele in Thomas E. Chavez, ed., *Segesser Anthology* (Santa Fe: Museum of New Mexico Press, forthcoming.

1745-1749 (Anonymous) Painter of an oil painting of San Miguel in the Church of San Miguel in Santa Fe, given by the commander Don Miguel Saenz de Garvisu. *PAC,* 24.

II. 1750-1810

Again, these later artists mainly if not entirely resided in Santa Fe, in Santa Cruz, or in conventos.

1750-1778 Fray Andrés García decorated many pueblo churches as well as the Hispanic parish churches at Albuquerque, Santa Fe, and Santa Cruz. He tended to paint faces very red. "Santero," 6-7; *Saints,* 23-24; *PASNM,* 96-98; *CI,* 59-68; *NKS* 29, 69.

1753-1755 Fray Juan José Toledo made some statues. *PAC,* 24.

1759-60 The artists of the Castrense (Cristo Rey) altarscreen.

1756-1789 Don Bernardo Miera y Pacheco, a Spanish-born military cartographer. Artist of Castrense altarscreen; Mirabal and Carrillo. Made images for the pueblo churches at Nambé,

Santo Domingo, San Felipe, Acoma, and Zuni, for San Miguel in Santa Fe, and the chapel in Trampas. Imitators. Mentioned by Pino in Carroll, ed., *Three New Mexican Chronicles,* 99; "Santero," 7; *PASNM,* 98-110; *CI,* 51-54; *NKS,* 69-71.

1765-1815 Manuel Miera, son of Bernardo. A soldier in Santa Fe and a family man in Santa Cruz, listed as a painter in a 1779 soldiers' roster.

1775-1810 (Anonymous) makers of gesso-relief panels, possibly including a priest from Mexico. "Santero," 7; *PASNM,* 145-49; *CI,* 83-91.

1780-1800? (Anonymous) "Eighteenth-Century Novice" was a copyist of oil paintings who often used red underpainting. "Santero," 7-8; *PASNM,* 109-10; *CI,* 55-59; *NKS,* 68-69.

III. 1785-1850
The santeros of the classical period lived, so far as we know, in villages in the central region, not in Santa Fe.

1785-1831 Pedro Antonio Fresquis of Las Truchas, probably the first native-born santero, did work in Trampas, Truchas, Chamita, Santa Cruz, and Nambé and in the Rosario Chapel in Santa Fe. He tended toward space-filling designs, dark backgrounds, and sgraffito. "Santero," 8-10; *PASNM,* 327-40; *CI,* 170-84; Love, *Santa Fean* 12 #11 (December 1984), 20-22; *NKS,* 36-65.

1795-1830 The Santero of the Delicate Crucifixes, very similar to Fresquis. *NKS,* 63-65.

1790-1809 (Anonymous) "Laguna Santero" decorated the churches at Acoma, Laguna, Zia, Santa Ana, San Felipe, and Pojoaque. He appears to have had more contact with European and Mexican art than did Fresquis. Imitators, especially Molleno. "Santero," 10; *PASNM* 155, 166-69; Marsha Bol, "The Anonymous Artist of Laguna and the New Mexican Colonial Altar Screen," M.A. thesis, UNM, 1980; *CI,* 69-82, 92-93; *NKS,* 66-81.

c. 1800-1850 Antonio Molleno, formerly known as the "Chili Painter," painter of progressively more stylized retablos, carver of bultos, very occasional painter of hides. Imitators. "Santero," 10-12; *PASNM,* 349-65; *CI,* 93-99; *NKS,* 82-107.

1810-30 Master of the Lattice-Work Cross. *NKS,* 146, 150-53.

1810-30 Santero of the Mountain Village Crucifixes. *NKS,* 146-48, 152.

1810-1840? Antonio Silva of Adelino, identified as the carver of the
 crucifix and Nuestra Señora of Tomé church. *Saints*, 38, 50;
 NMMag 51 # 7-8 (July-August 1973), 21; Albuquerque *Journal*
 "Metro" (9 April 1993), 1, 4.
 1810-50? Juan Flores, San Miguel-Las Vegas area. *PASNM*, 430.
 1818 Juan Gutiérrez of Alburquerque. In Archives of the Ar-
 chdiocese of Santa Fe, loose document 1816, # 18, p. 16r
 (53:666r), may refer either to Juan Antonio, b. 1795 at Ber-
 nalillo, son of Lt. don Juan Miguel, m. 19 July 1818 at Albur-
 querque to María Rosalía Anaya, or to Juan José Pascual
 Domingo, b. 1793 at Sandía, m. 20 January 1818 at Albur-
 querque to María Manuela Gallegos, d. 22 May 1839 in
 Alburquerque.
 1820-1835 José Aragon of Chamisal, Spanish-born but perfectly ac-
 culturated to New Mexico's santero tradition, was a painter
 and carver of works that are, along with Rafael Aragon's,
 among the easiest to like of the New Mexican tradition. Im-
 itators. "Santero," 13-14; *PASNM*, 366-75; *CI*, 105-14; *NKS*,
 108-43.
 1820-1870 Arroyo Hondo School, a style-group of works attributed by
 various experts to various artists under various names, in-
 cluding José Aragon, the Dot-and-Dash Santero, the Arroyo
 Hondo Painter, one of the Quill-Pen Followers a.k.a. the Ar-
 royo Hondo Carver, the Taos County Santero a.k.a. the
 Master of the Penitente Crucifixes, and Juan Miguel Her-
 rera. *PASNM*, 374-75; *CI*, 115-22, 185-91; *IPIM*, 116-19,
 122-24, 128, 130-32; *NKS*, 111, 242-47, 264-77; conversation
 with Charles Carrillo, 19 January 1993, who noted the style-
 traits that unify the Arroyo Hondo Carver's bultos with the
 Quill-Pen Follower's retablos.
 1820-1862 José Rafael Aragon of Córdova, painter of altarscreens at
 Talpa, Llano Quemado, Vadito, Picurís, Córdova, Chimayó,
 Santa Cruz, and Chama, who uses firm outlines and col-
 ors. School and imitators. "Santero," 14-15; Ahlborn, *Am-
 éricas* 22 #9 (September 1970), 9; *PASNM*, 391-407; *Wood
 Carvers*, 26-29; Donna Pierce, "José Rafael Aragon,"
 American Folk Painters of Three Centuries (1980), 47-51; *CI*,
 129-59; *NKS*, 198-241.
 c. 1822 The A. J. Santero is named from initials appearing on one
 of his retablos. Boyd notes his "thick, gritty gesso ground

and acid coloring." "Santero," 13, *PASNM*, 366; *CI*, 192; *NKS*, 162-69.

1830s-1840s The Santo Niño Santero was aptly named from his large number of charming Santo Niños. "Santero," 15-16; *PASNM*, 376-77; *CI*, 160-69; *NKS*, 178-97.

1830s-1840s The Quill-Pen Santero or Santeros, apparently influenced by Molleno, was or were named for the apparent use of a pen instead of a brush to make fine lines. Imitators. "Santero," 16; *PASNM*, 388, 392; *CI*, 99-103; *NKS*, 170-77.

1830-60 Benito Bustos, likely either identical with or a follower of the Quill-Pen Santero, possibly made an altarscreen and one known retablo which might better be ascribed to Miguel Herrera. *CI*, 193-94; *NKS*, 267 and 276.

c. 1835 José Manuel Benavides of Santa Cruz; *PASNM*, 384-85; *Cross and Sword*, 21.

1840-50 The Carver of the Muscular-Torso Crosses. *NKS*, 265, 274.

1845-60 Leandro Martín, born in Spain, moved to New Mexico. *NKS*, 311n91.

c. 1860-1872 José Miguel Aragon of Córdova, Rafael's son. *Wood Carvers*, 26-29.

c. 1860 Nasario Guadalupe López of Córdova (1821-91), father of José Dolores López, reputedly the creator of the death-cart (Doña Sebastiana). Miller, *Bulletin of the Museum of Modern Art* 10 #5-6 (May-June 1943), 5; "Santero," 22; Steele, "The Death Cart," *Colorado Magazine* 55 (1978), 1-14; *PASNM*, 468-71; *Wood Carvers*, 29-30; *IPIM*, 150-54.

c. 1860? Eusebio Córdova of Córdova was identified as possibly the sculptor of the San Isidro shown in plate 45 of Espinosa, *Saints*, 38, 50, 79; E. Boyd, *Saints and Saint Makers of New Mexico*, 64.

IV. 1850-1930

As tin-and-glass work took hold in Santa Fe and spread out from there in all directions, the surviving santeros were to be found in more and more peripheral areas until the folk tradition died out altogether.

1850s Rafael Silva of Mesilla, Doña Ana County. *PASNM*, 432.

1865-1902 José de Gracia Gonzales, born in Guaymas, Sonora, Mexico, lived in Peñasco and Trinidad, was oil-painter of the Trampas altarscreens and of many other altarscreens in the Peñasco area, painter and sculptor of numerous individual

pieces. Boyd, Supplement to "Santero," 5, #343; *PASNM*, 343-49; especially Wroth's fine detective work in *IPIM*, 101-15; *NKS*, 248.

1860s? Tomás Salazar of Taos, a name without works attached. *Saints*, 80.

1860s? José Miguel Rodríguez and Patricio Atencio of the Taos and Arroyo Hondo region. *PASNM*, 434.

1860s-1880s Juan Miguel de Herrera (1835-1905) of Arroyo Hondo, maker of bultos with shell-shaped ears. Jaramillo, *Shadows of the Past* (1941, 1981), 61; Jarmillo, *Romance of a Little Village Girl* (1955), 187-88; "Santero," 16-17; *PASNM*, 408; *IPIM*, 118-19, 130-32; *NKS*, 264-66, 275-77.

1860s-1890s Juan Ramón Velásquez of Canjilón, maker of very large and striking bultos, employed housepaint when available. José Edmundo Espinosa, "The Discovery," *El Palacio* 61 (1954), 185-90; "Santero," 17-18; *PASNM*, 408-16; *NKS*, 266-67, 278-79.

1870s-1890s Antonio Herrera of Capulin, Colorado, a San Luis Valley santero. Wallrich, 154-58.

1875-1885 Quill-Pen Follower. *IPIM*, 65, 94-97; *NKS*, 170-77.

1875-1920 Higinio V. Gonzales of San Ildefonso, Las Vegas, Canjilon, and the Santa Cruz area (1844-c.1922). He was a real Renaissance man: schoolteacher, tinworker (Lane Coulter and Maurice Dixon, *New Mexico Tinwork* [1990], 128-31), songwriter (John Donald Robb, Robb Archive, UNM; "H.V. Gonzales," *New Mexico Folklore Record* 13 [1973-74], 1-6); *Hispanic Folk Music of New Mexico and the Southwest*, 6, 322, 328, 400, 409; photo on page 530), and poet (Anselmo Arellano, *Los Pobladores Nuevo-Mexicanos y su Poesía*, 57-74), as well as a santero.

1880s? Sánchez, apprenticed to a santero in Ojo Caliente, quit to become a farmer. He was the father of Joe Sánchez, an informant of Wallrich, 158-59.

1880s-1907 José Benito Ortega of La Cueva near Mora, who endowed some of his saints with dotted eyebrows and eyelashes and with stylish Yankee-made pegged boots. School. "Santero," 18-20; *PASNM*, 416-25; *IPIM*, 63-86; *NKS*, 280-95.

1880s-1920s Francisco Vigil (1855-1928) of Arroyo Seco, San Pedro, Fort Garland, and El Valle near San Luis, Costilla County, Colorado. Wallrich, 160; *IPIM*, 137, 143; Fred Birner, personal communication; census records.

c. 1890-1910 "Abiquiú Morada Santero," perhaps Mónico Villalpando
 or Mónico Benavídez, whose works appear as plates 24-25
 of Wilder-Breitenbach, *Santos: The Religious Folk Art of New
 Mexico* (1943) and figures 42, 52, and 53 of Ahlborn, *The
 Penitente Moradas of Abiquiú* (1968). School. *PASNM*, 436;
 IPIM, 116-17, 126-27, 129; *NKS*, 265, 272-73.

1890s-1910s José Inés Herrera, active in the area of El Rito, the sculptor
 of the Death Cart of the Denver Art Museum collection;
 Shalkop, *Wooden Saints* (1967), 46; Robert Stroessner, *San-
 tos of the Southwest* (n.d.), 52-53; *IPIM*, 157.

 c. 1895 Retablo Styles I (staring eyes), II (Las Vegas area), III, and
 IV (oil paintings on flour sacks). *IPIM*, 65, 85-93.

 1898 José L. Morris of Buena Vista (La Cueva), a nephew of José
 Benito Ortega. *PASNM*, 416, 428.

 1900-1920 Dionisio Guerra of the El Paso area, Santa Fe, and Old Town
 Albuquerque, molder and painter of plaster statues. Tom-
 ás Atencio, "Social Change and Community Conflict in Old
 Albuquerque," UNM dissertation (1985), 203-04.

 c. 1900 Southern Colorado Styles: San Luis Valley Style I (very
 much like Velásquez) and II; Front Range Styles I (Aguilar
 area) and II. *IPIM*, 137-38, 140-42, 144-48.

 1930s Juan Ascedro Maes of the San Luis Valley, who quit when
 he left the Catholic Church about 1941. Wallrich, 160.

ROMANTIC REVIVAL

The Taos and Santa Fe art and literary colonies introduced into Hispanic
New Mexico a reflective awareness of the santero tradition—history as
such, a deep past which is not the living tradition—and they created a
market for twentieth-century versions of the older santos. Hence the re-
mainder of this list is made up of romantic revival santeros (who are
distinct from real folk santeros as primitivists are from primitives).

Six tests for romanticism-revivialism can be named, *any one of which*
could be grounds for identifying the artist in question as a participant
in the romantic revival:

Religious Test

1a. The traditional santero and the community he worked for felt that
 the santo was sacred in itself because its efficient, exemplary, for-
 mal, and final causes were holy. The efficient cause, the santero
 himself, was necessarily a practicing Roman Catholic.

1b. The romantic-revival santero tends to say that the santo becomes ho-ly only when the priest blesses it.[1] This assertion rationalizes the commodification of santos: selling them, selling them away from the in-group, selling them to non-Hispanics, to non-Catholics, or even to non-believers. The romantic-revival santero need not even be a Roman Catholic.

Economic Test

2a. Ownership of a santo was normally transferred only within the in-group (village, *raza*, or at least Catholic religion) and only by gift, gift-exchange, or barter.

2b. Participants in the cash-economy have entered the world of craft specialization that signals the end or near-end of the land-based farming and ranching economy.[2]

Option Test

3a. The true folk santero knows only the one tradition his father or father-surrogates handed on to him. He must gather for himself most of materials he uses.

3b. A revival santero knows of other artistic traditions besides his ancestral one. He often knows his ancestral art precisely as historical (for him and his in-group it is not present as a living tradition), and if he chooses it, he does so much the same as he might choose any alien tradition from the past or the present. Such a condition marks his transcendence of the medieval cultural mode and his arrival at the renaissance or romantic mode (knowing two or more cultures well enough to distingush between or among them and to choose one while rejecting another). A corollary of such historical knowledge is that non-Hispanics will begin to make santos; they have equal access to this historical knowledge of the tradition and are equally free to choose it.[3] The revival santero has access to manufactured materials such as gesso, paints, brushes, and sawmill lumber.

Style, Technique, and Subject-Matter Test

4a. The folk santero learned what he learned from others while he was working with some older man.

4b. The revival santero comes under the influence of advisor-patrons, usually Anglos, who help create the market for him. These persons often recruit artists who have no living-family background of santero work; they often supply models from the historical (non-living) past; and they often interpret the market they have helped create so as to foster certain subjects and techniques and curtail others (the birds-

and-bunnies St. Francis rather than the skull-and-stigmata St. Francis, San Pascual the Kitchen Patron rather than Our Lady of Sorrows; bultos rather than retablos, unpainted bultos rather than polychromed).[4]

Gender Test

5a. In a traditional folk society, almost no woman is ever publicly known as a religious functionary. This stricture may have begun to dissolve with the arrival of Loretto Sisters and Sisters of Charity in the 1850s.
5b. The revival creator of santos is likely to be a santera.

Attribution Test

6a. The traditional santero remains anonymous because he feels that his work expresses the tradition and derives wholly from it and only minimally from his own individual talent.
6b. The revival artist signs his or her works, at least when asked to do so.

V. 1920-1950

The romantic revival of santero art began in Santa Fe and spread from there (by way of Lorin W. Brown's connections) to Córdova and (by way of the art colony) to Taos.

1910s-1943 Celso Gallegos, devout sacristan of the Agua Fria chapel, carved pine, leaving it without the previously-standard santero finish of gesso and paint and introducing non-religious subjects.

1922-1931 Frank Applegate, author, collector, dealer, and the first known Anglo santero.

1930-1938 José Dolores López of Córdova, also working in unfinished wood, specialized in such subjects as Adam and Eve, the Flight into Egypt, and the Tree of Life. *PASNM*, 467-71; *Wood Carvers*, passim, for all the Córdova artists.

1930s-1980s George (José Dolores' third son, died 1993) and Silvianita López (died 1992) of Córdova.

1930s-1935 Ricardo López (fourth son).

1930s-1960s María Liria López de Martínez of Córdova (daughter).

1930s-1940s E. Boyd (Elizabeth Boyd Hall), Santa Fe artist and scholar.

1930s-38, 1960s Nicudemos López, eldest son of José Dolores.

1931-1964 Patrocinio Barela of Taos, a near-surrealist in comparison to his predecessors on this list. *NMMag* 14 #11 (November 1936), 25, 33; Crews et al., *Patrocinio Barela*; Crews, *Américas* 21 #4 (April 1969), 35-37.

1930s Santiago Mata of Santa Fe, who worked in the W.P.A. Federal Art

Project. E. Boyd, Supplement to "Santero," 6.

1930s Juan Sánchez of Mexico and Ratón, active with the W.P.A.; *Wood-Carvers*, 98.

1930s Henry Brito, Robert Brito, Pedro Cervantes, Elidio Gonzales, Henry Gonzales, Lorenzo López, Elias Romero, Ben Sandoval, Fred Sandoval, all of Santa Fe.

1930s-1980s Eliseo Rodríguez of Santa Fe. LeViness, *Liturgical Arts* 27 #4 (August 1959), 82-83, 88-89.

1930s-1980s Elmore William "Elmer" Shupe, "on the highway" south of Taos, a collector, dealer, and frequent santero. *Cross and Sword*, 74, pl. 77.

1930s-1960s "Carson Group" of Shupe workers, mainly women in the Mormon town of Carson, Taos County, who made small colcha embroideries of saints for sale to Taos tourists: Frances Varos Graves and others.

1935-1989 Efren Martínez of Santa Fe.

1940s Santiago Gallegos from near Hernández

1940s-1950s Don Gallegos of Santa Fe, an academic Öberammergau-type carver

1940s-1950s Cipriano Melisendro Rodríguez of Santa Fe.

VI. 1950s
(The decade in which the artist began work)

Luis Aragon of Shoemaker and Albuquerque

Will Barrett of Albuquerque

Frank Brito of Santa Fe

Richard Chavez (E. Boyd, "Catalogue/Mumey," 19 Apr 1968, #218)

Alfonso Córdova of Aguilar, Colorado

Samuel (Sammy) Córdova of Córdova

Gilberto Espinosa of Albuquerque

Benita Reino de (Ricardo) López of Córdova

Juan Clímaco Lovato of Costilla and Denver

Joe A. Lucero of Albuquerque

Frank E. McCulloch, Jr., of Albuquerque

José and Alice Mondragon of Córdova and Chimayó

Nolie Mumey of Denver

Sabinita López de Ortiz and Cristóbal "Junior" Ortiz of Córdova

Marco Oviedo of Chimayó

Paula Rodríguez of Santa Fe

Max Roybal of Albuquerque

Pete V. Sena of Pecos and Greeley

Howard Shupe of Taos and Sedona, Arizona

Teodocio Váldez of Denver

Frederico Vigil of Santa Fe

Malcolm Withers of Denver and Santa Fe

VII. 1960s
(The decade in which the artist began work)

Tomás Burch, Tim Burch, and Emily Burch Hughes of Raton
Ruth Campbell of Albuquerque
Gloria López de Córdova and Herminio Córdova of Córdova
Rafael López Córdova of Córdova
John C. Dorman of Santa Fe
Victor Emert of Albuquerque
Cándido García of Albuquerque
José Marcos García of Albuquerque
José Griego of Embudo
Adelina Ortiz Hill of Santa Fe
Andrew Johnson; *PASNM*, 363.
Jolaroque of Utah
Robert Lentz of Pecos and Albuquerque
Eurgencio and Orlinda López of Córdova
Precídez Romero de López and Rafael López of Córdova
Apolonio A. Martínez of Chimayó
Eluid Levi Martínez of Córdova and Santa Fe
Jo Martínez of Chimayó
Luz Martínez of Taos
Olivar Martínez of La Villita and Española
Ben Miller of Santa Fe
Abenicio Montoya of Santa Fe
Edmund Navrot of Santa Fe
Jackie Nelson of Santa Fe and Abiquiú
Earl Noell of Tesuque
Ben Ortega of Tesuque
Henry Quintana of Santa Fe
Lenor Rueda of Taos
Leo and Del Salazar of Taos (nephews of Patrocinio Barela)
Jorge Sánchez of Albuquerque
J. Ben Sandoval of Santa Fe
Luis Sandoval of Santa Fe
Eleanor Sewell (Eleanora) of Albuquerque
Rosina López de Short of Albuquerque, Santa Fe, and Pojoaque
Amarante O. Trujillo of Taos
R.R. Ulibarrí of La Ciénega
Horacio Valdéz of Dixon
Bill Tate of Truchas and Santa Fe

VIII. 1970s
(The decade in which the artist began work.)

Estevan Arellano of Embudo
Federico Armijo of Albuquerque
Luis Avila of Chimayó
José Alberto Baros of Las Vegas
B. Brabec of Albuquerque
Simeon Carmona of Albuquerque
Charles Carrillo of Albuquerque and Santa Fe
Marie Romero Cash of Santa Fe
Evelyn, Gary, and Rafaelito Córdova of Córdova
Lina Ortiz de Córdova and Federico Córdova of Córdova

Catherine Ferguson of Santa Fe
and Galisteo
Carlos Frésquez of Denver
Clorinda García of Santa Fe
David Gonzales of Santa Fe
Roberto Gonzales of
Albuquerque
Mónica Sosaya Halford of
Santa Fe
Don Headlee of Denver
Juan (John Fred) Jiménez of
Tesuque and Santa Fe
Anita Romero Jones of Santa Fe
Cidelia López of Córdova
Félix A. López of Mesilla, Rio
Arriba County
José Benjamin López of Española
Leroy López of Santa Cruz
Manuel López of Santa Cruz,
Hernández, and Chilí
Manuel R. López of
Albuquerque
Marcos López of Taos
Ramón José López of Santa Fe
Ricardo and Nora López of
Española
Victoria López of Canjilón
Abad Lucero of Albuquerque
Luisito Lujan of Nambé
Olivar Martínez of Española
Ida Montoya of Pojoaque
Juan Navarrete of Taos
Bob O'Rourke of Fort Collins
Eulogio and Zoraida Ortega of
Velarde
Alex, Lawrence, Elvis, Orlene,
and Amy Ortiz of Córdova

Guadalupita "Pita" Ortiz of
Albuquerque
Helen R. Ortiz of Santa Fe
Linda Martínez de Pedro of
Chimayó
Rose Griego Polaco of Mora
Viviana Duran Prelo of Tularosa
Enrique Rendon of Monero and
Velarde
Olivar Rivera of Nambé
Isaac, Eleanor, and Isaac, Jr.,
Romero of Santa Fe
Juan and Georgina Romero of
Vadito
Manuel Romero of Llano
Quemado
Orlando Romero of Nambé and
Santa Fe
Rosario of Santa Fe
Claudio (Clyde) Salazar of
Española
Ernesto, Michael, Leonardo, and
David Salazar (sons of Leo) of
Taos
Joseph Sánchez of Torreon
Alejandro ("Alex") Sandoval of
Santa Fe
Juan Sandoval of Albuquerque
Carlos Santistevan of Denver
Thomas L. Sena of Glorieta
Juan María Suazo of Albu-
querque
Luis Tapia of Santa Fe
Luis Trujillo from north of
Santa Fe
Timothy A. Váldez of Santa Fe
Irene Martínez Yates of
Albuquerque and Grants

IX. 1980s or 1990s
(The period in which the artist began work)

A pattern that dimly emerged in the 1970s became strong and crystal-clear in the 1980s: the revival of santero art began more to generate and sustain itself from within, less to be generated from outside. Anglo money continues to provide most of the fuel, of course, and so the santeros prudently remain quite aware of their patrons' preferences. But family mentoring spanning two, three, or even four generations, a large number of master-apprentice relationships, widespread networking among santeros and santeras, and a fair number of peer-groups like La Escuelita of Española have drawn the initiative away from the Anglos and into *la raza*. There is a widespread sense of a Nuevomejicano culture alive in the present and ready for the future. The earliest signs of the shift were the lessening number and percentages of new Anglo artists together with the increasing number and percentage of new Hispanic santeras and santeros, until in the last quarter-century there have been almost no new Anglos—and those few appear mainly on the geographical edge (like northern Colorado) or on the age-group periphery (seniors and school-children).

Filimón P. Aguilar of Bernalillo
Genevieve Aguilar of Taos
Frank "Pancho" Alarid of
 Santa Fe
Genevieve Alcon of Mora
Adán Alire of El Rito
Adam Archuleta of El Rito
Glenn J. Archuleta of El Rito
Louis Jerry Atencio of Dixon
Billy Babcock of Santa Fe
Donald Baca of Santa Fe
Luisa Baca of Albuquerque
Abel and Carlos Baros of Las
 Vegas
Darlene Baros of Las Vegas
Daniel Blea of Albuquerque
Bernardo C de Baca of Santa Fe
William Cabrera of Grants and
 Santa Fe
Rosa María Calles of Las Vegas

Estrellita de Atocha and Roan
 Miguel Carrillo of Santa Fe
Anthony Romero Cash of
 Santa Fe
Frank Cervantes of
 Albuquerque
Eladio Chávez of Albuquerque
Joseph A. Chávez of
 Albuquerque
James M. Córdova of Santa Fe
Rafael López Córdova of
 Córdova
Sam Córdova of Albuquerque
Rhonda Crespín-Bertholf of
 Tijeras
Jessica Delgado of Las Vegas
Macario Durán of Santa Fe
Esteban Edwards of El Paso,
 Texas
Leroy Encinias of Albuquerque

David P. Escudero of Las Vegas
Belarmino Esquibel of Santa Fe
José Raul Esquibel of Littleton,
 Colorado
Corine Mora Fernández of
 Santa Fe
Troy Fernández of Chimayó
Cruz Flores of Las Vegas
Benjamin A. Gabaldon of
 Santa Fe
José Gabaldon of Albuquerque
Chris and John Gallegos of Rio
 Rancho
Jason and Ann Gallegos
R.A. Gallegos of Santa Fe
Rubén M. Gallegos of Rio
 Rancho
Clorinda García of Santa Fe
Lydia Vigil García of Ranchos de
 Taos
M.J. García of Santa Fe
Richard García of El Rito
Gustavo Victor Goler of Santa Fe
 and Taos
Willie Gómez of Albuquerque
Andy Gonzales of Santa Fe
David F. Gonzales of Santa Fe
Eric Gonzales of Taos
Jeff Gonzales of Santa Fe
María Fernández Graves of
 Ranchos de Taos
Manuel Gurule of Santa Fe
Richard and Raquel Halford of
 Santa Fe
Dion Hattrup of Santa Fe
Elaine Miera Herrera and Janel
 Herrera of Rio Rancho and
 Corrales
Faustino Herrera of Santa Fe
Nicholas Herrera of El Rito
Carmelita Valdés de Houtman

of Santa Fe
Robert (Urban) Jaramillo of
 Questa
Rubel U. Jaramillo of Antonito,
 Colorado
José V. Jaurequi of Silver City
Eugen Johe of Ojitos Frios
Frank, Patricia, and Mark
 Johnson of Albuquerque
Juanito of Trinidad
Roberto Lavadie of Taos
Ellen Chávez de Leitner and
 Maria, Johanna, Franz, Cecilia
 and Genevieve Leitner of
 Chimayó
Diego López of Española
Glen and Cindy López of
 Córdova
Joseph López of Española
Leon, Lily, Bo, and Miller López
 of Santa Fe
Peter López of Montezuma
Raymond López of Santa Fe
René López of Hernández
David Nabor Lucero of Santa Fe
John Lucero of Albuquerque
José Floyd Lucero of Santa Fe
Juan M. Lucero of Las Cruces
Denna Trujillo Luciani of Taos
Ernie, Anthony, and Melissa Lu-
 jan of Santa Fe
Jerome Lujan of Nambé and
 Santa Fe
Dolores Marie Maes of Peralta
José U. Maes of San Juan Pueblo
Leonard Manzanares of
 Medenales
Louie Mares of Santa Fe
Antonio Martínez of Ranchos de
 Taos
Mary Jo and George Martínez of
 Chimayó

Miguel S. Martínez of Hobbs
Solomon Martínez of Córdova
Fr. Tim Martínez of Mora
Tommy Martínez of Córdova
Trina and Pamela Martínez of
Santa Fe and Córdova
Irene Medina of Córdova
Christina, Celina, and Cynthia
Miera of Corrales
Rudy Miera of Bernalillo and
Corrales
Clarence Mondragon of Taos
Jerry Mondragón of
Albuquerque
Gilbert J. Montoya, Jr., of Santa
Fe (grandson of Frank Brito)
Joseph Montoya of Albuquerque
Richard H., Teresa, Melissa, and
Daniel Montoya of Santa Cruz
Ruben O. Montoya of Santa Fe
Matilda Mora of Santa Fe
Benito Murphy de Sosaya of
Santa Fe
Tony Navarro of Bernalillo
Arturo Olivas of Los Angeles,
California
Gerónimo Olivas of Alamosa,
Colorado
John Olivas of Thornton,
Colorado
Lorenzo Ortega of Santa Fe
Michael B. and Anthony Ortega
of Tesuque and Santa Fe
Adam Ortiz of Albuquerque
Charlene Ortiz of Santa Fe
Jeremy, Andrew, Camille, and
Lena Rae Ortiz of Córdova
Alcario "Carrie" Otero of Tomé
Patricia, Gacobo, Oliver, Daisy,
J.J., and Tony Oviedo of
Chimayó

Adonio "Nono" Pacheco and
Adonio "Don-Chris" Pacheco,
Jr., of Taos
Frances Perea of Santa Fe
Rick Pfeufer y Armijo of
Albuquerque
Nico Preciado of Santa Fe
Max Pruneda of Albuquerque
Gilbert, Pamela, and Regina
Quintana of Santa Fe
Rubel Rael of Vaughn
Lloyd Rivera of Ranchos de Taos
Alfred L. Rodríguez of San
Antonio, Texas
Arturo Rodríguez of Thornton,
Colorado
Jacobo "Jake" Rodríguez of
Santa Fe
José Rodríguez of Española
Meggan Rodríguez of Taos and
Denver
Miguel Rodríguez of Santa Fe
Tomasita J. Rodríguez of
Santa Fe
Adam M. Romero of Santa Clara
Pueblo
Dawn Romero of Santa Fe
Donna Wright de Romero of
Santa Fe
Jody Romero of Truchas
Lee Romero of Truchas
Tim Roybal of Medanales
Tranquilino Roybal of Santa Fe
Ernesto A. Salazar of
Albuquerque
Ricardo P. Salazar of El Prado
Eduardo Sánchez of Santa Fe
Joseph T. Sánchez of Tijeras
Angela and Cordilia Sandoval of
Córdova and Chimayó

Henry Sandoval of Córdova and
 Chimayó
Jerry P. Sandoval of Córdova
Randy Sandoval of Córdova
Vanessa and Teresita Sandoval of
 Chimayó
Carlos Jr. and Brígida
 Santistevan of Denver
Arlene Cisneros Sena of
 Santa Fe
Benito Sena of Albuquerque
Florence Serna of Española
Jacobo de la Serna of Los
 Luceros
Bill Struck of Denver
Pete Tafoya of Ranchos de Taos
Frank Tollardo of Taos
John R. Tollardo of Albuquerque

Jimmy E., Debbie, Jaime, and
 Cordilia Trujillo of
 Albuquerque
Julian Trujillo of Albuquerque
Michelle Trujillo of Taos
Zachary Trujillo of Albuquerque
Isidro and Una Urtiaga of Belén
Carmelita Laura Valdés of
 Santa Fe
Daniel, Amanda, and Marisa
 Valenzuela of Santa Fe
Carmen Romero Velarde of
 Ranchos de Taos
Trini David Velarde of Ranchos
 de Taos
Gabriel Vigil of Santa Fe
Michael M. Vigil of Questa
Paul and Sean Younis of Santa Fe

*For help in assembling the more contemporary names, I would especially like
to thank* José Aguayo of Museo de las Américas, Denver; Fred Birner of
Denver; Charles Carrillo, Santa Fe santero; Roberto Gonzales of de Col-
ores Gallery, Old Town Albuquerque, a santero; Rick Manzanares of
CHAC, Denver; Gabriel Meléndez formerly of the Hispanic Culture
Foundation and now of UNM, Albuquerque; Felipe Mirabal of Las
Golondrinas in La Ciénega; Ray Móntez of Móntez Gallery, Sena Plaza,
Santa Fe; Bud Redding of the Spanish Colonial Arts Society, Santa Fe;
Daniel Salazar of Denver; and Carlos Santistevan, Denver santero. If the
list has omitted anyone, it is my fault and I apologize.

Notes

1. George López made this assertion to just about everyone who came into his livingroom shop. Charles Briggs, "To Sell a Saint," *Papers in Anthropology* 17 (1976), 209-11; Briggs, *Wood Carvers*, xv, 192-98, quoting both J.D. López and George López; Laurie Kalb, *Santos, Statues, and Sculpture* (1988), 13, quoting Enrique Rendon; Gayle Boss et al., *Santo Making in New Mexico: Way of Sorrow, Way of Light* (1991), 32, quoting Luis Tapia.

2. The santero revival is one example of craft specialization on the occasion of loss of land-base, later than but very similar to the turn to pottery-making treated in Charles Carrillo, "Hispanic Pottery As Evidence of Craft Specialization in New Mexico, 1790-1890." Charles L. Briggs is the leading and only authority in regard to making santos as craft specialization. See his "To Talk in Different Tongues" in William Wroth, ed., *Hispanic Crafts* (1977), 42-47; *Hispano Folklife in New Mexico* (1978), 13, 254n17; *Wood Carvers*, 45-53; "Remembering the Past" in Wroth, ed., *Russell Lee's F.S.A. Photographs* (1985), 5-7, 14n2; *Land, Water, and Culture* (1987), 230-32; and *Competence in Performance* (1988), 36-39, 92, 378nn5-6.

In 1892-93, the people of Córdova lost legal control of the Córdova Grant; in 1915, they lost the de facto use of their outlying lands; in 1917-18, José Dolores López began carving; in 1921-22, he began selling to Anglos.

3. Celso Gallegos was inspired by, and imitated in his own way, a late-baroque bulto attributed to one of his great-great-grandfathers. Since he lived in a plaza just south of Santa Fe, the artists of the city discovered and advised him from early in his career. See Helen Cramp, *NMMag* 9 # 11 (November 1931), 20 and 46; Helen Cramp McCrossen, *School Arts Magazine* 30 (1931), 456-58; "Santero," 22; Clifford Stevens, *Santa Fe New Mexican* "Viva," (13 January 1974), 6; *PASNM*, 431, 433, 435; *Wood Carvers*, 64.

4. *Wood Carvers*, 64. In 1922, Frank Applegate started interpreting the market to José Dolores López, and in 1930 he induced him to imitate Celso Gallegos' unpainted wooden bultos.

5. At the beginning of the santero tradition, Bernardo Miera y Pacheco, definitely born in Spain, signed a few of his pieces; José Aragon, who tradition says was born in Spain, signed a fair number of his retablos; and Rafael Aragon signed a few retablos and a few altarscreens. In later days, Marcus Jiron of Ojo Caliente, about 1900, signed a *tenebrario*—candlestick for tinieblas.

Appendix B

A LIST OF SAINTS

All the saints represented by New Mexico santeros from the eighteenth century until the end of the nineteenth are listed below. They are divided into six categories: divine subjects, titles of Mary, angels, male saints, female saints, and other.

Each listing gives pertinent biographical and devotional information about the saint or holy person, his or her iconographic properties, any information about patronage. The final line gives the ratio of occurrence in a random sample of exactly one thousand santos which I enumerated in 1974. This sample renders each particular santo precisely a tenth of a percent of the whole. The grand totals are 1000 = 203, 567, 168, 62; omitting the last figure—santos that cannot be assigned to a time period —gives 21.6% of santos in the first period, 60.4% in the 1815-50 era, and 17.9% in the last period. The figures will be given as five numbers—for instance 13 = 8, 5, 0, 0—meaning that there are 13 occurrences of the subject in that thousand (hence 1.3% of all santos show this subject); of these, 8 date from 1785 to 1815, 5 from 1815 to 1850, none from 1850 to 1900, and none are unable to be assigned chronologically. There are many subjects that did not occur in that sample of a thousand but that occur elsewhere.

With help especially from Yvonne Lange and Charles Carrillo, I have become aware since the first version of this book in 1974 both of totally new subjects and of new subdivisions of subjects. New subjects carry a decimalized number (e.g., 5.5) and have no occurrences-in-the-thousand numbers. New subdivisions carry a letter (e.g., 13a) and share in the number of the previously known subject.

DIVINE SUBJECTS

1 a-d. La Santísima Trinidad (The Holy Trinity)
 Biblical *The Sunday after Pentecost*
 These three divine persons in numerically one nature constitute the deepest mystery of the Christian faith. The Father is the first person, the Word-become-man is Jesus of Nazareth, the Holy Spirit dwells in the Church and in each Christian.

 1a. The Father as an old man sits at the viewer's right, the Son as

a young man sits at the Father's right hand, and the Holy Spirit as a dove hovers between and above them. This is the mode of representation preferred by the Roman Catholic Church.

1b. The "Pietà" Trinity with the Father holding the dead Christ while the Spirit as dove hovers overhead. The Church tolerates this depiction but does not foster it.

1c. Three equal or even identical men. When shown as three identical men, the emblem of the sun marks the Father, the lamb the Son, a dove or a tongue of fire the Spirit; thcy often hold a bar, chain, or lightning bolt. Until 1928, the Church did not foster but tolerated this depiction because of the Orthodox analogues (cf. Andrey Rublev's masterpiece of the 16th century) and because of the biblical source in Genesis 18; in 1928, the Church forbade it, no reason given.

1d. Three chests and heads growing from a single lower torso. Saint Antoninus of Florence (d. 1449) described this depiction as "a monstrosity by the very nature of things," and on 11 August 1628 Pope Urban VIII issued a condemnation which was repeated by Benedict XIV on 1 October 1745. See Chapter III, note 2; Donna Pierce, *New Mexico Studies in the Fine Arts* 3 (1978), 29-33.

Enlightenment; favors of immediate need; thanksgiving; faith, harmony, and peace; protection against all enemies and temptations; deliverance from locusts, earthquakes, and famine.

13 = 8, 5, 0, 0.

2. Nuestro Padre Dios (God the Father)
Biblical-celestial *No special feast day*
See the previous entry.

A single man, bearded, often with a pointed crown, often with a triangular halo, holding his right hand in blessing, often with a book or power symbol in his left hand—a lightning-bolt or an arrow. Occasionally he holds a heart.

Enlightenment, aid, and fortitude; paternity.

3 = 0, 3, 0, 0.

3. El Espíritu Santo (The Holy Spirit)
Biblical-celestial *Pentecost Sunday*
See the entries on the Trinity above; the Church fosters only the scriptural images of dove and tongue of fire as depictions of the third Person of God.

Shown as a dove, especially within a lunette which is supposed to be attached to a reredos; in association with Santos Felipe Neri, José Patriarca, and others, the Spirit becomes an attribute.

Enlightenment, perhaps.

2 = 0, 2, 0, 0.

3.3. Los Desposorios de la Virgen (Betrothal of Mary and Joseph).
Biblical (Mt. 1:18) *January 23 or November 26*

The legend was that the high priest assembled various eligible men to become the spouse of Mary and chose Joseph when his walking staff burst into blossom.

Joseph at Mary's right holds his flowering walking staff, the sign by which the high priest chose him from among the group of eligible suitors; the Holy Spirit as a dove hovers above as they join hands.

Of the family.

3.5. La Aunuciación (The Annunciation)
Biblical (Luke 1:26-38) *March 25*

The Archangel Gabriel approaches Mary with God's request that she bear the Son of God by the overshadowing of the Holy Spirit.

Mary, usually kneeling in prayer, the angel, often the Holy Spirit in the form of a dove.

(?)

3.7. La Visitación (The Visitation)
Biblical (Luke 1:39-56) *May 31*

Having learned from the Angel Gabriel that Elizabeth is with child, Mary goes to help her.

An "A.J. Santero" panel, Frank, *New Kingdom of the Saints* (1992), pl. 137, shows Elizabeth and Mary embracing in the center and Zachary and Joseph (with his flowering staff) on either side.

(?)

3.9 Nacimiento de Jesucristo (Birth of Jesus Christ)
Biblical (Matthew and Luke) *December 25*

The birth of Jesus at Bethlehem of Judea.

Mary and Joseph stand or kneel at either side of a manger in which the infant lies. The "reliquary" in the Córdova chapel is probably a Nacimiento; the moon presently attached to it belongs to a Guadalupe.

(?)

4. La Huida a Egipto (The Flight into Egypt)
Biblical (Mt. 2:13-23, modeled on Genesis 47) *17 February*

An episode in Matthew's infancy narrative where a dream instructs Joseph to take Mary and Jesus and escape into Egypt to keep Herod from killing the child.

Joseph leads the donkey, Mary rides sideways on it and carries the

child, and an angel sometimes accompanies them. A Rafael Aragon retablo adds at the bottom the massacre of the Holy Innocents as well as a great deal of obscure allegorical commentary; see E. Boyd in Hougland, *American Primitive Art* (1946), 24-25, 36-37.

For travelers.

2 = 1, 1, 0, 0.

5. La Sagrada Familia (The Holy Family)

Biblical *First or Third Sunday after 6 January*

Jesus, Mary, and Joseph; Jesus is shown as a child.

The Child Jesus stands in the center, usually holding hands with each of his parents. Sometimes in a retablo, the dove appears above the group. Rafael Aragon did a crib-scene "reliquary" for the Córdova Chapel.

Of the family.

13 = 1, 9, 3, 0.

5.5 La Santa Parentela (The Holy Extended Family)

Biblical implication *No Feast Day as such*

Mary, Joseph, and Mary's parents, traditionally named Ana and Joachim; the cousins Elizabeth (Isabel) and Zechariah (Zachary) are not included here. Following Bernard of Clairvaux and Francis of Assisi, medieval spirituality had a great concern for and curiosity about the humanity of Christ. *Golden Legend*; Yvonne Lange, conversation of 11 January 1993; the main Santa Cruz altarscreen includes an eighteenth-century oil painting of the Santa Parentela.

At the top of the panel, Mary and Joseph flank the Niño; at the bottom, Ann and Joachim flank a cross; the five are connected by vines originating with the grandparents.

For family.

1 = 1, 0, 0, 0 (these figures formerly belonged to # 22).

6. El Santo Niño (The Christ Child)

Biblical *No Feast Day*

Christ as an infant or as a young boy.

6a. A young boy kneeling in a long robe, with hands together in prayer.

6b, 6c. The Christ Child of the Passion, the Christ Child of the Resurrection: a pair of bultos in the Córdova Chapel recently identified by Donna Pierce; see Frank, *New Kingdom of the Saints* (1992), plates 219-20.

Protection for children, probably.

0 = 0, 0, 0, 0.

7. El Santo Niño de Atocha (The Holy Child of Atocha)
 Legendary *No Feast Day*
 Yvonne Lange, "El Santo Niño de Atocha: A Mexican Cult Is Transplanted to Spain," *El Palacio* 84 # 4 (Winter 1978), 2-7, tells the historically accurate story of this devotion, which arose in Zacatecas about 1800 when the Niño was removed from the arms of a statue of Nuestra Señora de Atocha and placed in a chair. Frankfurter, *El Palacio* 94 # 1 (Summer-Fall 1988), 30-39, makes a case for influence from the Niño Cautivo legend. The legend told in Boyd, *Saints and Saint-Makers of New Mexico* (1946), 126-27, and retold in earlier editions of *Santos and Saints* (1974, 1982) on 109 was developed to rationalize this new advocation of the Holy Child. In Mexico, the devotion has also acquired the local name "El Santo Niño Manuelito de San Pedro [de las Colonias]." New Mexico possesses at least five Santo Niño de Atocha alabanzas.
 A child, always seated, in pilgrim's garb (broad-brimmed hat, staff with gourd, shoes), with a basket which generally contains roses. The staff is often decorated with ribbons; the ankles are occasionally shackled together. For a standing figure, especially bearded, see Santiago (# 115 a or b).
 For travelers, for delivery of prisoners; more recently, against illnesses, especially those that cripple.
 26 = 1, 14, 9, 2.

8. El Niño Perdido (The Lost Child)
 Biblical (Lk. 2:41-50) *No Feast Day*
 Christ remained behind in the Temple at age twelve when his parents left, and they had to return to seek him; it is the fifth joyful mystery of the rosary.
 A child, usually standing, in short trousers and no shirt or in a long robe, holding nothing.
 For lost and kidnaped children; for travelers, especially pilgrims in danger.
 4 = 0, 4, 0, 0.

9. El Niño de Praga (The Infant Jesus of Prague)
 A devotion associated with a 17th-century *No Feast Day*
 statue in the Carmelite church of Our Lady
 of Victory in Prague
 A celebration of the childhood and kingship of Jesus.
 A child dressed in a full robe, usually red, wearing a crown and holding a globe with a cross on top and often a sceptre.
 (?)
 13 = 1, 10, 1, 1

10. Cristo el Divino Pastor (Christ the Good Shepherd)
Biblical (John 10:11) *No Feast Day*
Christ referred to himself as "the good shepherd" in relation to his "flock," since he was willing to die to save them.

Standing, wearing a hat, carrying a lamb on his shoulders, with another by his feet, marked with the stigmata.

For shepherds.

1 = 0, 1, 0, 0.

11. La Entrada a Jerusalem (The Entry into Jerusalem)
Biblical (all gospels) *Palm Sunday*
The brief triumph of Christ shortly before his death, when he entered Jerusalem surrounded by an admiring crowd.

Christ on a donkey, often with persons bearing palm branches.

(?)

1 = 1, 0, 0, 0.

11.5 Cristo Atado a la Columna (Christ at the Column)
Biblical *Good Friday*
The second of the Sorrowful Mysteries of the Rosary, when the Roman soldiers scourged Christ.

Christ with his hands tied, wearing a royal crown (not of thorns), stands before a column that often resembles a chalice and that catches his blood. See Wroth, *Christian Images* (1982), 56; Frank, *New Kingdom of the Saints* (1992), 257, 299; Taylor Museum 3892. A beardless Christ might represent Christ's soul; see *Christian Images*, 149. Artists sometimes mix the historical (the event of scourging) and the transhistorical (Man of Sorrows; see 13a) by showing the nail-wounds and the spear-wound.

(?)

12. La Coronación de Espinas (The Crowning with Thorns)
Biblical (Mt. 27, Mk. 15, Jn. 19) *Good Friday*
This is part of the passion of Christ, when the Roman soldiers mocked his claim to kingship; it is the second Sorrowful Mystery of the Rosary.

Christ sitting or standing, clad in a purple robe, with a crown of thorns newly placed around his head. Can be a pose of a Jesús Nazareno hinged bulto (# 13).

12a. Cristo Sedente durante de su Pasion (Christ Seated during his Passion)
Gertrud Schiller, *Iconography of Christian Art* (1972), 2:73-74, 85-86, describes "Christ in Distress" and "Christ in Repose" images from the

European middle ages, the former more common in the north, the latter in the south. Both seem to find a distant echo in these rare images.

Christ sits, almost enthroned, marked with the wounds of the early part of the passion from the scourging and the crown of thorns; he may have a rope around his neck or his wrists, and he may hold the reed "scepter" of the soldiers' mocking. If the rope or the crown of thorns is lacking, it could be a santo of Job (# 90.5).

Penitential associations.

0 = 0, 0, 0, 0.

13. Nuestro Padre Jesús Nazareno (or, de Nazareno)
(Our Father Jesus the Nazarene or Nazarite; or of Nazareth; the Ecce Homo)

Biblical (Mt. 27, Mk. 15; esp. John 19:5) *Good Friday*

The presentation of the scourged, thorn-crowned, purple-robed Jesus to the crowd; also, the bulto which can be put through most of the phases of the passion (see Chapter V).

Usually a bulto, nearly life-size, of Christ standing; it is hinged at the shoulders (and sometimes neck and knees), not bearing the marks of the nails or spear.

13a. El Varón de Dolores (The Man of Sorrows)

Non-Biblical *Good Friday*

Under this title, Jesus stands (sometimes in his tomb, often with a rope around his neck) displaying all the marks of his passion, including the wounds of the nails and the spear (the last received after his death— John 19:33-34). But neither is he dead (his eyes are open and fixed on the viewer), nor is he risen (he shows by his expression that he is in pain); instead, the figure presents a timeless, non-historical allegory of all the suffering Jesus endured in his passion and death. As Schiller (*Iconography of Christian Art* 2:198) puts it, "The image of the Man of Sorrows is unambiguously a devotional image; it does not depict any event." It nicely exemplifies the late medieval spirituality of Western Europe as it flowed from Bernard of Clairvaux and Francis of Assisi.

Penitential associations.

Forgiveness of mortal sins, against evil and enemies; penitence, the daily cross; faith, hope, and charity; for a good death (in the state of grace).

21 = 1, 12, 8, 0.

14. Jesús es Cargado con la Cruz (Jesus Carries his Cross)

Biblical (John 19:17) *Good Friday*

Roman custom made condemned prisoners carry their own crosses.

Matthew and Mark neglect the issue, Luke is a bit vague, only John explicitly states that Jesus did so. It is commemorated by the second to ninth stations of the Way of the Cross and the fourth Sorrowful Mystery. Imitation of this event of the passion is of course a key practice of the penitential Brothers of Our Father Jesus the Nazarene, for several Brothers often carried crosses in the procession to the Calvario.

The examples in the sample are all retablos, though this subject could be a phase of the Jesus Nazareno bultos. The retablos show Christ in a long robe bearing the cross; he often has a rope around his neck.

For repentance and bearing suffering; this last would especially be suggested by Mt. 10:38 and 16:24, Mk. 8:34, and Lk. 9:23 and 14:27.

5 = 1, 2, 2, 0.

15. El Divino Rostro (Veronica's Veil)

Legendary (the sixth station of the Cross) *Good Friday*

According to a pious legend, a woman wiped the face of Christ as he carried the cross, and he left an imprint of his face indelibly on the cloth. A Latin-Greek phrase, *vera icon*, was metathesized into "veronica," which soon came to he understood as the name of the kind helper. See Ewa Kuryluk, *Veronica and Her Cloth* (1991).

The veil is occasionally shown by itself, but usually Santa Verónica is shown holding it. I counted both types as one unit.

15a. El Velo de Tres Rostros (The Triple Rostro)

Legendary (The Sixth Station of the Cross) *Good Friday*

This is a Taos-region variant of Veronica's Veil, derived from the local custom that Santa Verónica in the passion play touches her veil *three* times to Christ's face. See Steele, Denver *Post* "Empire" (8 April 1979), 23-25. Variants of the alabado "Venir Pecadores" describe Santa Verónica touching her veil to Christ's face "y en tres partes pinta / Cristo su hermosura—and Christ paints his beauty in three places."

Imprint of Jesus on our hearts, miracles, converts, sexual purity. Also, through association of Santa Verónica with the woman in Mt. 9:20-22 and Mk. 5:25-34, for healing hemorrhages.

8 = 4, 3, 1, 0.

16. Cristo Crucificado, Crucifijo (Crucifix)

Biblical (all gospels) *Good Friday*

The death of Christ, dealt with most especially in Chapter V above.

Christ nailed to the cross, clad in a loincloth, with a crown of thorns about his head. A great decorative pouf often stands out from the loincloth to the viewer's left. A skull at the base of the cross is Adam's; see Schiller (*Iconography of Christian Art* 2:130-33); see also E. Boyd, *El Palacio*

58 (1951), 225, 234-36. The crosses for several Rafael Aragon crucifixes are composed of three swords, one serving as the upright and two smaller ones making the crossbar.

16a. Nuestro Señor de Esquípulas (Our Lord of Esquípulas)

The cross to which the Lord of Esquípulas is nailed is a Tree of Life —tinged with green, sprouting three branches from the upright and four from the crossbar; see Schiller (*Iconography of Christian Art* 2:133-34). —The black Christ of Esquipulas in Guatemala (see Stephen de Borhegyi, *El Santuario de Chimayó* [Santa Fe: Spanish Colonial Arts Society, 1956], 2-4) is like any black Christ the male correlative of the earth mother (Cybele, Demeter, Black Virgin) as goddess-personification of the rich black fields; this part of the iconography got lost on the way to New Mexico.

16b. Nuestro Señor de Mapimí (Our Lord of Mapimí)

There is no iconographic difference between this and the regular crucifix, but the Brothers of Our Father Jesus identify certain crucifixes as Mapimí. There are three alabados to the Lord of Mapimí in Rael, *The New Mexican Alabado* (1951), 71-77, and an account of the history of the devotion.

The iconography should logically—but does not—include an arrow wound in one leg just below the knee.

16c. Nuestro Señor de Zacatecas (Our Lord of Zacatecas)

Just above the crown of thorns, the crucified Christ seems to wear a halo with three sets of rays; his loincloth is large and very decorative. The background is a pattern of rectangles.

Salvation of the world, pardon from sins, bearing of sufferings; faith, piety, peaceful death; all needs.

81 = 21, 26, 26, 8.

17. La Santa Cruz (The Holy Cross)

Biblical *Good Friday; 3 May*

The cross shown without the body of Christ. It is often decorated with designs (sometimes made of straw). The designs often show the *Arma Christi*, the "weapons of Christ" which taken together as a set make up his coat of arms; by these weapons Christ won his victory over sin and death—not by using them but by allowing them to be used against him. As few as four or five items may be shown—cross, INRI, nails, hammer, crown of thorns, spear—or as many as several dozen.

17a. La Cruz Cubrida or Vestida (The Draped Cross)

Sometimes the cross is shown with the cloth used in lowering the

body draped over both arms.

Presumably the cross would have the same patronage as the crucifix.

15 = 1, 5, 9, 0.

18. El Santo Entierro (Christ in the Tomb)
Biblical (all gospels) *Holy Saturday*
The dead body of Christ in a latticework casket.
(?)
2 = 0, 1, 1, 0.

19. El Sagrado Corazón (The Sacred Heart)
Biblical—Mt. 11:29 ("Learn of me *Friday after the third*
for I am meek and humble of heart") *Sunday after Pentecost*
and John 19:34 ("One of the soldiers stuck a spear into his side, and immediately blood and water came forth").

The medieval devotion to the five wounds spun off a devotion to the spear-wounded heart of Christ as the object or medium of mystical union. The better-known later devotion, promoted particularly by the Jesuits after it originated in seventeenth-century France, emphasized reparation.

The heart is often shown by itself, often encircled by a wreath of thorns, usually with a cross above it. It is occasionally shown at the center of the chest of Christ, who may have a triangular halo.

Forgiveness of sins; all petitions; protection of family and home; health; against avarice, jealousy, and hatred.

9 = 0, 5, 1, 3.

20. El Gran Poder de Dios (The Great Power of God)
Allegorical *No Feast Day*
A representation of the divine power operating in the world.

This is a unique piece in the Museum of New Mexico's Charles D. Carroll Collection (N.M./4 CDC) showing Christ enthroned among angels, with the Blessed Virgin above him, and a priest, flanked by a deacon and subdeacon, elevating the host. It appears as an illustration in Boyd, *Popular Arts of Colonial New Mexico* (1959), 49.

1 = 0, 0, 1, 0.

21. Alegoría de la Redención (Allegory of the Redemption)
Since about 1985 this allegorical title has seemed a false identification of subject # 5.5, the tableau of La Santa Parentela—the Holy Extended Family including Joachim and Anna.

[1 = 1, 0, 0, 0—these figures from the sample of a thousand santos are transferred to subject # 5.5]

22. La Resurrección (The Resurrection)
 Biblical (all gospels) *Easter Sunday*
 The rising of Christ to a new life after his death and burial.

 An elaborate Rafael Aragon retablo in a private collection shows a
very small figure (Christ dead?) poised at the edge of a very Byzantine-
looking rock tomb, a large rising Christ in the center of the panel, and
a middle-size figure seated at one side (Christ enthroned?). There are
also three angels and a Roman soldier for a total of seven figures. A
simpler Rafael Aragon panel shows only the main figure (Museum of
New Mexico, International Folk Art).

 Promise of reward for fidelity to God's will; perhaps for acceptance
of suffering.
 2 = 0, 2, 0, 0.

ADVOCATIONS (TITLES) of the BLESSED VIRGIN

22.5 Nuestra Señora de los Afligidos (Our Lady of the Troubled)
 A title of Mary *perhaps 19 August*
 A unique New Mexican representation of a devotion that appears
in Mexico and Brazil.

 Mary sits on a heavenly throne surrounded by angels, two of whom
wear Franciscan robes and flank a globe of the universe which supports
a black lunar crescent in which a child (Christ?) sits. Mary is crowned,
the dove hovers before her breast, and she raises her hand in blessing;
Out West 21 # 3 (September 1904), 220-26; Christine Mather, *From Bar-
oque to Folk* (1980), 54-55.

 For the afflicted.

23. Nuestra Señora de los Angeles (Our Lady of the Angels);
also Porciúncula or Persíngula
 A title of Mary *August 2*
 As mother of Christ and perfect disciple, Mary ranks higher than
the angels.

 Mary is dressed in a blue mantle, holding the Niño or a sword and
cross or a dove; she stands on a serpent and is surrounded by angels.

 Director of the angels who are guardians of humans; control of
monsters.
 3 = 0, 3, 0, 0.

24. Nuestra Señora de la Anunciación (Our Lady of the Annunciation)
 A title of Mary *March 25*
 This is Mary at the moment when the Angel Gabriel approached her
and asked her to become the mother of Jesus. There is only a slight dif-

ference between this title and Immaculate Conception. Note # 41a, La Alma de la Virgen.

Mary is shown standing; a budding tree and a monstrance are in the background (these can be attributes of the Immaculate Conception).

(?)

0 = 0, 0, 0, 0.

25. Nuestra Señora de la Asunción (Our Lady of the Assumption)

A title of Mary *August 15*

A teaching of the Roman Catholic Church holds that Mary was taken body and soul into heaven, and is like Christ already in the resurrected state. La Conquistadora (Our Lady of Peace) of the Santa Fe Cathedral was originally an Assumption.

A painting of Mary with no special attributes was thus identified for me by the mayordomo of a small chapel.

(?)

1 = 0, 1, 0, 0.

26. Nuestra Señora de Atocha (Our Lady of Atocha)

A title of Mary *No Feast Day*

This is the source of the Santo Niño de Atocha (#7) as Yvonne Lange pointed out in her *El Palacio* article; there is a church in a neighborhood of Madrid, Spain, where this title of Mary began. The story is told that as the statue of Our Lady of Atocha neared Zacatecas, some robbers attacked the caravan and tried to open the packing case containing the image, but such a great noise issued from it that they ran away.

Mary holds the Niño (who later escaped from her grasp); she wears a brocaded hoop skirt and a crown. She is sometimes shown seated.

(?)

0 = 0, 0, 0, 0.

27. Nuestra Señora de Begoña (Our Lady of Begoña)

A title of Mary *October 8 or second Sunday of October*

Our Lady of Begoña is patroness of the Basque city of Bilbao. A vested eighth-century statue found in an oak tree is venerated in a Gothic chapel on a hilltop.

Crowned, seated in an armless chair, holding the crowned Child and a rose, surrounded by oak branches.

(?)

0 = 0, 0, 0, 0.

28. Nuestra Señora del Camino (Our Lady of the Way)

A title of Mary *No Feast Day*

Probably the Spanish version of the Señora del Camino venerated at Pamplona.

Mary stands in a rich red gown holding the crowned Niño and a palm branch or a palmer's staff—the symbol of a pilgrim—while two angels place a crown on her head. See Wilder and Breitenbach, *Santos* (1943), 47 and pl. 55; Sánchez Pérez, *El Culto Mariano en España* (1943), 103-04; Wroth, *Christian Images* (1982), 109.

Protection of pilgrims and travelers.

0 = 0, 0, 0, 0.

29. Nuestra Señora de las Candelarias (Our Lady of the Candlesticks)
A title of Mary *February 2*

This is a confused title in New Mexico. The real Candelarias, a Canary Island apparition, became confused with Nuestra Señora de San Juan de Los Lagos so that the name of the former became widely applied to images of the latter (# 45 below).

The real Candelarias sits and holds the Niño and a small bouquet; there is either no candle or a single extremely large candle. By contrast, N.S. de San Juan de los Lagos is flanked by a pair of candles in candlesticks. See Lange, *Santos de Palo* (1991), 7.

(?)

1 = 0, 0, 1, 0.

30. Nuestra Señora del Carmen (Our Lady of Mount Carmel)
A title of Mary *July 18*

The orders of Carmelites, both monks and nuns, spread devotion to the brown scapular; Carmelite Father Lynch writes of "Our Lady's triple promise to assist us in life and death and to bring us as soon as possible to the gate of Heaven" (*Your Brown Scapular* [1950], 40).

Mary, dressed in a brown scapular without a shield at the breast and a yellow gown, holds a brown scapular with a cross on it and the Niño; he is usually dressed in red and often holds a scapular. Mary often wears a crown, Christ sometimes does. There are often souls in purgatory at the bottom.

Against all dangers, especially hell; in the hour of death (in New Mexico a brick of adobe was often brought to a dying member of the Carmelite Third Order and placed on his or her chest to ease [!] the final agony); for the souls in purgatory.

24 = 6, 11, 5, 2.

30.5 Nuestra Señora de la Cueva Santa (Our Lady of the Holy Cave)
A title of Mary *First Sunday of September*

This advocation allegorizes Song of Solomon (Canticle of Canticles) 2:14, "My dove in the clefts of the rock," a text sometimes written in Latin on the retablo. The devotion originated with the Carthusians of Valle de Cristo near Segorbe, Spain.

Since that erotic book was usually interpreted presenting the relationship between God and his chosen people (Jews, Church), Mary as type of the church sits in a church-bell-shaped cave; the bell image is often enhanced by being topped with a crown that looks like the bell-staple.

Perhaps Mary as type of the Church as our protectress.

31. Nuestra Señora de los Dolores (Our Lady of Sorrows)
A title of Mary *Friday before Palm Sunday and September 16*
This is Mary enduring the sorrows predicted in Luke 2:35, especially that of the crucifixion of Jesus. The advocation arose about 1390, perhaps when the mourning figure of Mary was separated from a "Calvario" (crucifix with Mary and John) and made a distinct object of veneration; see Wroth, *Images of Penance, Images of Mercy* (1991), 75.

Mary standing with her hands folded, a sword or seven swords piercing her heart, wearing a red gown and a cowl; very infrequently she is crowned.

Strength in suffering; compassion for others in sorrow; help with children, help in childbirth; for sinners. There is a definite penitential interest, as Chapter V stated, since it is usually the Dolores bulto that engages in the Encuentro enactment as the Jesús Nazareno bulto moves in procession toward Calvary.

53 = 10, 34, 7, 2.

32. El Corazón de Nuestra Señora de los Dolores
(The Heart of the Sorrowful Mother)
A version of the above title of Mary *Friday before Palm Sunday and September 16*
This is merely a disembodying of the heart of Dolores on the model of presentations of the Sacred Heart of Jesus or the Immaculate Heart of Mary that show only a heart.

A disembodied heart with a sword or seven swords piercing it.

For the same needs as Nuestra Señora de los Dolores.

0 = 0, 0, 0, 0.

33. Nuestra Señora de Guadalupe (Our Lady of Guadalupe)
A title of Mary *December 12*
The account of this apparition is examined at length in Chapter IV.
Mary, sometimes with identifiably Indian features, standing in a

body halo, supported upon a dark upturned crescent and a winged angel. She often wears a crown (an early addition to the original removed in the 1880s).

For general favors in sickness; against all evil, particularly war; patroness of the Mexican and Indian peoples.

50 = 16, 24, 2, 8.

33.5. Nuestra Señora de Loreto (Our Lady of Loretto)
A title of Mary *March 1*

Legend declares that the Holy Family's house at Nazareth flew to several places in Italy before coming to a final landing at Loretto, on the Adriatic coast of the old Papal States.

Our Lady of Loretto is crowned with a papal crown, wears a brocaded gown which completely hides her arms; the crowned Niño who holds a globe is tucked into her bodice. There is often a cross on her dress. See Espinosa, *Saints in the Valleys* (1960, 1967), pl. 4.

(?)

34. Nuestra Señora de la Luz (Our Lady of Light)
A title of Mary *May 21*

This presentation of Mary as a savior from enclosure in a monster who symbolises Hell (or perhaps Purgatory) dates well back into the middle ages, but it became a Jesuit devotion later, especially in Sicily.

Mary holding the Niño, drawing a "soul" out of the mouth of a monster; she is crowned or an angel holds a crown over her head, and sometimes an angel offers her a basket of roses.

Rescue from Hell or Purgatory; illumination of the mind by her wisdom; return of those who have left the church or of a husband who has abandoned his wife.

0 = 0, 0, 0, 0.

35. Nuestra Señora de la Manga (Our Lady of the Sleeve)
A title of Mary *No Feast Day*

This is a variation of Nuestra Señora de los Dolores with a sleeve-like fold of her cloak; it may be connected with the Italian Madonna de Partos.

Rare retablo, exactly like the Dolores, except titled at the bottom "Nuestra Señora de la Manga, advocate of births, and of plagues and of those who suffer," in the Charles D. Carroll Collection of the Museum of New Mexico (SR/300 CDC). It is by Pedro Fresquis.

Helper at births; protection from plague; advocate of those who suffer.

1 = 1, 0, 0, 0.

35.5. Nuestra Señora de la Merced (Our Lady of Mercy)
 A title of Mary *24 September*
 The crowned Virgin holds a rose or a scepter in her right hand and
the crowned Niño on her left arm, and both of them hold small scapu-
lars. She wears the full white scapular of the Mercedarian Order with
its characteristic shield at her breast.
 For captives; for anyone in need of divine mercy.

36. Nuestra Señora como una Muchacha (Our Lady as a Girl)
 A title of Mary *No Feast Day*
 This might be meant to depict Mary at her presentation in the Tem-
ple as a girl of twelve or so; if so, the feast day would be November 21.
 A young girl holding a lily.
 Perhaps purity.
 1 = 0, 1, 0, 0.

37. Nuestra Señora como una Pastora (Our Lady as a Shepherdess)
 A title of Mary *No Feast Day*
 The Capuchin Franciscans fostered this devotion, a Marian echo of
Christ as the Good Shepherd (#10).
 Mary in a shepherdess's hat, surrounded with sheep in a pastoral
landscape.
 Probably patron of shepherds, possibly also for care of souls.
 0 = 0, 0, 0, 0.

38. Nuestra Señora del Patrocinio (Our Lady of Protection)
 A title of Mary *Third Sunday of November or the day before or November 11*
 The devotion dates to the middle ages. Mary holds the Niño; both
hold scepters and are crowned. Mary's robe is red; she stands on an
angel-supported moon.
 Protection, presumably mainly from the usual preternatural dangers.
 1 = 0, 1, 0, 0.

39. Nuestra Señora de la Piedad (The Pieta; Our Lady of the Deposition)
 A title of Mary *Good Friday*
 The bereaved mother holds the dead body of Christ in her lap. The
cross and the implements of the passion are in the background.
 Presumably, the associations of the crucifixion itself: salvation, par-
don of sins, bearing suffering, and so forth.
 1 = 0, 1, 0, 0.

40. Nuestra Señora del Pueblito de Querétaro (Our Lady of the Suburb
 of Querétaro)
 A title of Mary *1 May*

Querétaro is a city about a hundred miles northwest of Mexico City, in the state of the same name; Pueblito is a small suburb. A Franciscan artist's statue of Mary as queen and patroness of the Franciscan Province of San Pedro y San Pablo became a local devotion.

Crowned and wearing a rich robe, Mary floats above Saint Francis of Assisi, who is holding three globes upon his shoulders. There are angels at the sides. The globes probably symbolize the three Franciscan orders, but they might symbolize the realms of heaven, earth, and hell, or perhaps heaven, church, and state, or perhaps the church on earth, in purgatory, and in heaven; see Boyd, *El Palacio* 56 (1949), 353-57.

The Virgin's help might be sought for any favor in any of the possible realms.

3 = 0, 3, 0, 0.

41. Nuestra Señora de la Purísima Concepción (Our Lady of the
 Immaculate Conception)
 A title of Mary *December 8*
 The word "Inmaculada" or "Limpia" is sometimes substituted for "Purísima." This is a devotion to the doctrine of the Roman Catholic Church that Mary from her conception was free from original sin. It is not identical with the asexual conception of Christ and indeed has nothing to do with it directly, nor is it a profession of the asexual conception of Mary herself, which is not held by any Christian sect I am aware of. The Franciscan theologian Duns Scotus developed a plausible defense of the doctrine of the Immaculate Conception in the fourteenth century; Sister María de Jesús de Ágreda, the "Lady in Blue," was a Franciscan "Conceptionist" nun; the Franciscans who staffed New Mexico in the seventeenth century took the color in honor of her bilocations to preach to the Indians of the region (see *Fray Alonso de Benavides' Revised Memorial of 1634* (1945). The doctrine was solemnly proclaimed by Pius IX in 1854.

Mary stands on an angel-supported moon or on a serpent, often wears a crown, holds her hands folded, and holds in them sometimes a flower; she may be surrounded by emblems like monstrance, rose, lily, palm, ladder, star, and so forth.

41a. La Alma de la Virgen (The Virgin's Soul)
 An allegorical variant of the Immaculate Conception
 A young woman, looking very demure, with a dove (the Holy Spirit) at her breast; she wears either a hat or a crown of roses, and she may also hold a lily or a scepter.

For all favors, especially purity and repentance of sin; against all evil.

Shalkop, *Wooden Saints* (1967), 40, notes that a bulto usually identified as the Purísima Concepción but probably technically La Alma was known in Abiquiú as Our Lady of Innocence.

21 = 4, 11, 4, 2.

41.5. Nuestra Señora de la Redonda (Our Lady of the Rotunda)

A title of Our Lady *Saturday before the first Sunday of August*

Mary, a variant of the Assumption, standing in the classical vault of a Mexico City sanctuary modeled on the Pantheon in Rome.

Mary stands crowned and with long hair in a draped opening, her hands folded in prayer and a palm held behind her right forearm; there are three trios of angels at the bottom of her skirt. See *Artes de Mexico* 113 (1968), 25, 35-36, and 100; Boyd, *Popular Arts of Spanish New Mexico* (1974), figs. 95, 116.

(?)

42. Nuestra Señora Refugio de Pecadores (Our Lady Refuge of Sinners)

A title of Mary *July 4*

An Italian Jesuit devotion introduced into Mexico, especially into Zacatecas, during the eighteenth century. See Boyd, *El Palacio* 57 (1950), 274-77.

Mary is crowned, holds a sceptre or a palm and the Niño, who may hold Mary's thumb. There are often roses and angels in the background, and frequently the letters or a monogram "MA." Mary is generally shown half-length, often with clouds at the bottom front.

For protection from sin, repentance of sin, both for self and others.

10 = 0, 9, 1, 0.

43. Nuestra Señora Reina de los Cielos (Our Lady Queen of Heaven)

A title of Mary *Second Sunday of May*

This subject is probably connected with Revelations 12:1 and with the fifth glorious mystery of the rosary, the coronation of Mary as queen of heaven.

Mary holds a Niño and a sceptre, and she wears a crown; she stands on a crescent moon.

Probably protection from preternatural dangers.

0 = 0, 0, 0, 0.

+ Remedies—see Socorro, # 47.

44. Nuestra Señora del Rosario (Our Lady of the Rosary)

A title of Mary *October 7*

Because of the association of the rosary with the sea victory over the Muslim fleet at Lepanto on 7 October 1571, there is probably by analogy

a New Mexican application to conflicts with non-Christian Indian foes. The Spanish-made La Conquistadora of the Santa Fe Cathedral, a sixteenth or early-seventeenth-century Asunción, was made first into a Purísima Concepción and then into a Rosario. It was very much connected with the military reconquest of the colony under De Vargas in 1692-93. Her official name was changed to Our Lady of Peace in 1992. Cortéz gave the original Mexican Conquistadora now in Puebla to a Tlascaltecan cacique ally; Holweck, *Calendarium Liturgicum Festorum Dei et Dei Matris Mariae* (1925), 306; Castro, *Artes de Mexico* 113 (1968), 40-42.

The Virgin holds the Niño and a rosary; she is crowned though the Child is usually not; she stands on a crescent moon. Sometimes she is shown giving the rosary to Santo Domingo Guzmán, whose Order of Preachers especially spread the practice of reciting the rosary.

Acceptance of death in the family (saying the rosary is a central part of velorios [wakes] for the dead; see Lorin Brown, *Hispano Folklife of New Mexico* (1978), 134-35, where the crucifix of the rosary is the key to the gates of heaven); for peace, for help in danger and protection from accidents.

9 = 1, 7, 1, 0.

45. Nuestra Señora de San Juan de los Lagos (Our Lady of San Juan de los Lagos)

A title of Mary *February 2*

The city of San Juan de los Lagos is about two hundred miles northwest of Mexico City. This title originated in the veneration of a statue of the Immaculate Conception. The settlers of Talpa south of Taos fostered the devotion during the first half of the nineteenth century. As has been noted in connection with Nuestra Señora de las Candelarias, there is great confusion between the two titles; symptomatic is Frances Toor's statement that the Señora of San Juan was a Virgin of the Purification (de la Candelaria; see *A Treasury of Mexican Folkways* [1947], 184); and the fiesta of the Virgin of San Juan falls indeed on Candlemas, the feast of the Purification. See Jay F. Turner, "The Cultural Semiotics of Religious Icons: La Virgen de San Juan de los Lagos," *Semiotica* 47 (1983), 317-61, especially 321-27.

The Lady of the Immaculate Conception standing between two lighted candles; her cape widens to show a broader expanse of her skirt from her knees down.

(?)

22 = 6, 13, 3, 0.

46. Nuestra Señora con el Santo Niño (Madonna and Child)
A title of Mary *December 25 (?)*
This advocation is perhaps only a misidentification of pictures or statues of Mary meant to be other titles but vague and incomplete in their iconography. Mary may bear the title Belen or Leche.
The Virgin holding the Child, with no other significant traits.
Perhaps motherhood.
1 = 0, 1, 0, 0.

47. Nuestra Señora del Socorro, or de los Remedios (Our Lady of Help)
A title of Mary *September 1*
This is not the same as the more famous Lady of Perpetual Help, a Greek devotion not introduced into western Europe till the eighteenth century. Our Lady of Remedios was Cortés' and de Vargas' Conquistadora, and she was patroness of the *gachupines* and the Mexicans loyal to Spain during the Hidalgo rebellion of 1810.
Mary wears a crown and holds the Niño, who may or may not be crowned. Occasionally she holds a triple staff of office, and he may hold a globe like the Santo Niño de Praga's.
Freedom from sickness of soul or body.
2 = 0, 2, 0, 0.

48. Nuestra Señora de la Soledad (Our Lady of Solitude)
A title of Mary *Good Friday, Holy Saturday*
Between her son's crucifixion and resurrection and between his ascension and her own death, Mary lived (according to Christian folklore) like a nun. With neither father, brother, husband, nor son, Mary is the archetype of the crone, a very powerful figure.
Mary is dressed in a very nun-like black and white or occasionally black and red; she rarely holds anything in her hands, but bultos of La Soledad are often designed with arms that can hold a towel on which the implements of the passion (*Arma Christi*) are placed, one after another, as they become available during an enactment of the deposition of the Santo Entierro (thirteenth station of the Way of the Cross). She often has a rosary hanging from her neck; retablos usually show implements of the passion in the background. See Wroth, *Images of Penance, Images of Mercy* (1991), 21-28, 60. (The Arma Christi, the Weapons of Christ by which He accomplished our salvation, are the implements of the passion—not weapons Christ used against others but weapons he allowed to be used against Himself.)
Patroness against loneliness; consolation in bereavement; happy death; reminder of Christ's wounds; protection in general. —In certain

parts of Mexico, La Soledad is feared as Our Lady of Death, and a woman will not stay alone in the same room with an image of her. There is probably a Soledad-Sebastiana connection (see subject # 143 below), just as there is surely a strong connection among Dolores (# 31), Manga (# 35), Piedad (# 39), Soledad, Verónica (# 139), and perhaps Rita da Casia (# 134).

14 = 0, 7, 6, 1.

49. Nuestra Señora de Talpa (Our Lady of Talpa)
A title of Mary *(October 7)*
Some sources state that this is Our Lady of Talpa as venerated in the village of Talpa near Ranchos de Taos, for the iconography differs from that of Our Lady of the Rosary of Talpa as venerated elsewhere in the Spanish world; see Wroth, *Christian Images* (1982), 143, 205; Wroth, *The Chapel of Our Lady of Talpa* (1979), 21-29; Wroth, *Images of Penance, Images of Mercy* (1991), 102.

Mary holds an arrow; there is a cross-topped tower in the background. Compare Santa Bárbara.

(?)
1 = 1, 0, 0, 0.

50. Nuestra Señora de Valvanera (Our Lady of Valvanera)
A title of Mary *September 8 or 10 or 23, November 21*
According to legend, during the tenth century an image of Mary carved by Saint Luke was found in the Basque country near Burgos next to a hive of wild bees in an oak. See Bernard Fontana in Weigle et al., eds., *Hispanic Arts and Ethnohistory in the Southwest* (1983), 80-92.

Mary, in a red gown and blue cape and wearing a crown, holds the Niño who holds a pear; the Niño is not crowned. European arts shows an eagle in the background.

(?)
0 = 0, 0, 0, 0.

51. Nuestra Señora de la Victoria (Our Lady of Victory)
A title of Mary *October 7*
This is Our Lady of the Rosary as particularly associated with the victory over the Islamic fleet at Lepanto, 7 October 1571; there are other battles with which Our Lady of Victory has become connected.

Mary is crowned, winged (like the Greco-Roman "Winged Victory"); she stands on a plant or oversized flower and holds the Niño.

Success in battle; here again, the New Mexican Hispanics transferred to unruly non-Christian Indians their traditional opposition to the Moors in Spain and to Muslims throughout Europe.

1 = 0, 1, 0, 0.

ANGELS

52. San Gabriel Arcángel (Saint Gabriel the Archangel)

Biblical (Dan. 8:16, 9:21; Lk. 1:11-19, 26-38) *March 22 or 24*

Gabriel is the preeminent messenger, appearing to Daniel to explain things to him and to Zechariah and Mary to announce and explain the coming births of John the Baptist and Jesus. The Franciscans revered him greatly because of his association with Christ's humanity. Hence he is also associated with the Eucharist and often holds a monstrance. The *angelito* on a few New Mexican crucifixes who holds a chalice to catch the blood from the wound in Jesus' side should probably be identified as Gabriel.

Winged, holding a monstrance, a chalice, a censer, or the trumpet with which he will announce the end of the world; he sometimes also holds a lily or a palm and is occasionaly crowned.

Enlightenment; informing God of our good works, announcing our arrival in heaven; protecting small children.

9 = 0, 7, 2, 0.

53. San Miguel Arcángel (Saint Michael the Archangel)

Biblical (Dan. 10:13; Rev. 12:7) *May 8, September 29*

Michael's main task is battle against the devil and all his symbols.

Clad often in armor and crowned, holding balance-scales and a sword or spear, standing on a snakelike monster. He weighs souls in the pans of his balance scales, sometimes marked with a cross for eternal life and a zero for punishment. As guide of the soul in its journey to heaven, he may hold keys. In a few retablos, there is an as-yet-unexplained bracket over his left wing.

Opponent of the devil (see Brown, *Hispano Folklife of New Mexico* [1978], 131-32) and all evil; patron of soldiers; guardian of small children.

34 = 5, 25, 4, 0.

54. San Rafael Arcángel (Saint Raphael the Archangel)

Biblical (Book of Tobit) *October 24*

Raphael is the guide of travelers and pilgrims and the source of spiritual and physical health. He is also a protector against monsters. Clad in pilgrim's garb, carrying a staff and a fish. The staff often has a gourd of water at its top.

Patron of travelers, protector against eye trouble, protector against monsters.

30 = 9, 15, 4, 3.

55. Ángel Guardián (The Guardian Angel)

Biblical (Ps. 91:11-12; Mt. 18:10; Acts 12:7-11) *October 2*

Angels are pure spirits, less powerful than the archangels and not known by proper names, who are thought to protect each individual human. They have the same general duties as the archangels, particularly guiding humans through this world and guiding the souls of the dead from this world to the next.

A winged figure.

Guide on journeys; protector against evil spirits, especially of small children.

2 = 0, 1, 1, 0.

MALE SAINTS

56. Abraham (Abraham)

Biblical (passim, but especially Genesis) *October 9*

Abraham is the progenitor of the Hebrew nation; the episode shown on a unique New Mexican panel is told in Genesis 18.

Abraham wearing a conical hat or crown, bearded, with a staff or perhaps an axe; attended by two angels who stand by a fruitbearing tree with a dove in it.

(?)

1 = 0, 1, 0, 0.

57. San Acacio (Saint Acacius of Mount Ararat)

Second century (legendary) *June 22*

In German understanding of him, San Acacio was the leader of about ten thousand Roman soldiers who were converted to Christianity in Armenia and crucified; he was unheard of before the late fourteenth century. See Espinosa, *Saints in the Valleys* (1960, 1967), 92-93; Lange, *El Palacio* 94 # 1 (Summer-Fall 1988), 18-24, notes that Acacio was never much venerated in Spain or the southern portion of New Spain but only in New Mexico and what is now northern Mexico and that the crown of thorns rather than the traveler's or vaquero's hat was the headgear of the original iconography.

Usually bearded, on a cross, wearing an eighteenth-century military uniform, crucified, wearing a crown of thorns, laurel, or occasionally roses or a hat, flanked by two or more soldiers, each of whom holds a drum, pennant, sword, or musket.

The penitential Brothers took an interest in this patron of those who experience crucifixion; Acacio is also a military protector against any intruders (see Brown, Hispano Folklife of New Mexico [1978], 216).

16 = 2, 9, 5, 0.

57.5. Adán y Eva (Adam and Eve)
Biblical (Gen. 2-4) *December 24*
The first parents of the human race.

An early Rafael Aragon panel, structured like a triptych with what may be Garden-of-Eden symbols in the side panels, shows the separation of Eve from the original bisexual Adam, the acceptance of the apple, and the expulsion from Eden; see Wroth, *Christian Images* (1982), 137 and color plate 103. Note the mobile creatures of the fourth day (sun and moon), fifth day (birds; no fish are shown), and sixth day (animals and humans).

A reminder of human sinfulness, perhaps.

58. San Agustín (Saint Augustine of Hippo)
Lived 354-430 *August 28*
A great convert, preacher, and doctor of the Latin Church, his Neoplatonic theology dominated Western Europe for 1400 years.

A dove, a shell, a bishop's crozier, wearing bishop's robes.

Perhaps learning.

1 = 1, 0, 0, 0.

+ Aloysius—see San Luis Gonzaga

59. San Antonio de Padua (Saint Anthony of Padua)
Lived 1195-1232 *June 13*
Born in Lisbon, became a Franciscan, was trained by San Francisco himself, became a great preacher and miracle-worker. New Mexicans sang several hymns in his honor.

Dressed in a blue Franciscan robe, holding a palm, a lily, or a flowering branch, occasionally a heart. He holds the Niño who is dressed in red. San Antonio is clean-shaven and wears the tonsure.

Finder of lost articles, and probably of lost animals; patron of animals, especially burros and cattle; patron of the home; invoked by married women who want to have children, by girls to find a worthy husband; for orphans; patron of miracles.

73 = 19, 45, 5, 4.

60. San Antonio Abad (Saint Anthony Abbot, Hermit, of Egypt)
Lived 251-356 [sic] *January 17*
Initiated religious communities among the solitary hermits of Egypt. He is said to have exorcised a pig by ringing a bell.

E. Boyd identified a head from an Antonio Abad on the body of a San José bulto in the Nolie Mumey Collection (# 443): an old white-bearded man's head in a raised brown cowl. A bell; a Greek Tau on the

shoulder of his habit; a bell in his hand and pig by his side.

Protection from ghosts and devils; perhaps against erysipelas, by analogy with Europe. The original patron of Potrero de Chimayó, the immediate locale of the Santuario de Chimayó.

0 = 0, 0, 0, 0.

61. San Athenogenes (Saint Athenogenes)
 Died about 305 *July 16*

A theologian, bishop, and martyr who seems to have died in Armenia. He defended the divinity of the Holy Spirit.

All the depictions of this subject were probably meant to be San Gil Atenogenes—Saint Giles of Athens.

(?)

[3 = 1, 2, 0, 0—these numbers will be assigned to # 84]

+ Augustine—see San Agustin.

62. San Bartolomeo (Saint Bartholomew)
 Biblical (Mk. 3:18, the Nathaniel of John 1:45) *August 24*

He is traditioually supposed to have evangelized India and Armenia and to have been flayed alive.

Kneeling, in a red robe, praying before a cross or crucifix.

Patron against lightning and other fearful deaths; for women in childbed (Espinosa, *Saints in the Valleys* [1960, 1967], 92; Boyd, *Popular Arts of Spanish New Mexico* [1974], 372).

1 = 0, 1, 0, 0.

62.5. San Benito (Saint Benedict of Nursia)
 Lived 480-543 *March 21*

Founder of Benedictine monasticism. Perhaps he and Augustine of Hippo were the main forces in Western Christianity from their lifetimes until Bernard of Clairvaux and the rise of the Dominican and Franciscan orders in the thirteenth century.

A bearded man dressed in a white robe and brown hooded cape with a black scapular, holding a crozier and a book.

Against poison, disease, and witchcraft; for a good death (one in the state of grace).

63. San Bernardo de Claraval (Saint Bernard of Clairvaux)
 Lived 1090-1153 *August 20*

Abbot, founder of the Cistercians, preacher of the second crusade, writer of devotional and polemical works, especially against Abelard. He was the founder of late medieval spirituality by turning attention to the humanity of Christ in his infancy and his passion.

Crowned and bearded, holding a crucifix and a staff, with candles in the background; his appearance on a Talpa reredos may be unique.

Perhaps his anti-Turk bias may have made him a patron against the Indians; but the donor of the Talpa reredos was named Bernardo Duran, so it is probably a personal patronage rather than a practical one.

0 = 0, 0, 0, 0.

64. San Blas (Saint Blaise)

Died about 316 *February 3*

Supposedly a bishop and martyr, he is reputed to have been a physician and to have cured a boy with a fish-bone in his throat. San Blas seems to have meant nothing special in New Mexican liturgy until the Jesuit Father Biaggio (Blasius) Schiffini introduced the blessing of throats in 1887.

Dressed as a priest in a long chasuble, with his hands out, bareheaded and cleanshaven.

Against ailments of the throat, since he was beheaded.

0 = 0, 0, 0, 0.

65. San Buenaventura (Saint Bonaventure)

Lived 1221-1274 *July 14*

The great Franciscan theologian and doctor of the church, biographer of Francis of Assisi, who reputedly cured him when he was ill as a child. He later became a cardinal.

Holding a red staff, a book, and sometimes a model of a church or the Eucharist in a ciborium, he wears a blue Franciscan robe with red trim and a cardinal's hat, a miter, or a crown.

Perhaps learning.

0 = 0, 0, 0, 0.

66. San Camilo de Lelis (Saint Camillus de Lellis)

Lived 1550-1614 *July 14 or 18*

An Italian soldier who joined the Capuchins but had to leave them because of a disease of the feet, he founded an order of male nurses.

Standing bearded in a long robe, he blesses a sick man lying in front of him; two figures kneel at the side.

For health, perhaps especially of the feet.

0 = 0, 0, 0, 0.

67. San Cayetano, or Calletano, or Gaetano (Saint Cajetan)

Lived 1480-1547 *August 7*

A co-founder of the Theatine Order who devoted himself to the care of the poor and sick and founded non-profit pawnshops.

Wears a black cassock with a jeweled collar or necklace, often with a cross hanging from it; carries a palm, often kneels by a table with a biretta and cross on it. Occasionally he appears crucified, though he may be meant merely to be standing against a cross.

Because of the pawnshops noted above, patron of gamblers; people used to bet him a rosary or a blessed candle that he would *not* do some favor for them. There may be penitential implications in the crucifixion, though nothing in his biography suggests it.

8 = 1, 6, 1, 0.

67.5. San Clemente Papa (Pope Saint Clement of Rome)
End of the first century *November 23*

Converted by Saint Paul, Clement became the fourth pope. Exiled with two thousand other Christians to Chersonesus in the Crimea, he was thrown into the sea with an anchor around his neck. His Epistle to the Corinthians establishes him as one of the earliest apostolic Fathers of the Church.

In oriental garb (strange hat, short coat, tight trousers called anaxyrides), bearded, an anchor upon his breast, with a book in his left hand and his right hand held in blessing.

Protection against devils (an old New Mexican prayer calls him "San Clemente mi pariente / para que el Malo no me tiente / ni de noche ni de dia—Saint Clement my cousin / so that the Evil One may not tempt me / either at night or during the day"), and perhaps for tanners.

68. San Cristobal (Saint Christopher)
Legendary, the third century *July 25 or 30*

A cluster of legends attached to a supposed giant or near-giant of Asia Minor, who lived by a ford and carried people across the river on his back. One night the Niño came and asked to be taken across, and when Christopher found he could scarcely carry him despite his small size, he took his new name ("Christbearer") and became a martyr.

A barelegged man in a kilt-like garment, standing in water, holding the Niño on his shoulder; the Niño (dressed like Praga) holds a globe with a cross atop it, and Christopher usually has a staff.

For travelers.

4 = 1, 2, 0, 1.

69. San Dámaso (Saint Damasus)
Died 384 *December 11*

Of Spanish descent, as pope he opposed the Arians and Apollinarians.

Clad in a cape over a long robe, holding a palm and a crozier, wear-

ing the papal triple crown.
 (?)
 1 = 1, 0, 0, 0.
+ Denis—see San Dionysio.

70. San Diego (Saint Didacus of Alcala)
 Lived c. 1400-1453 *November 13*
 A Franciscan lay brother with great devotion to the Eucharist, in-
voked for the cure of Don Carlos, heir to the Spanish throne, in 1562.
He is the patron of Jémez Pueblo.
 Standing, holding a large cross which rests on the ground, wearing
a Franciscan robe, without a tonsure. A doubtful identification of a hide-
painting which E. Boyd later rescinded.
 For health, probably.
 0 = 0, 0, 0, 0.

71. San Dionisio (Saint Denis the Areopagite, or of Paris)
 First century, reputedly. *October 9*
 There was a Dionysius converted by Paul (Acts 17:34); to this name
various legends (of different ages) and written works (of the sixth cen-
tury) were attached. He was supposed to have become bishop of Paris
and, after decapitation, to have walked back to town carrying his head
in his hands.
 Wearing a red cloak over a surplice over a cassock, holding a palm
and his severed head.
 (?)
 0 = 0, 0, 0, 0.

72. San Dimás (Saint Dismas)
 Biblical (Lk. 23:40-43), but the name is folklore *March 25*
 This is the "Good Thief"; according to one legend, years before he
had ransomed the Holy Family when they were taken prisoners during
the Flight into Egypt.
 A man not in military garb but in a loincloth, without a crown of
thorns, tied to a cross; a part of a full crucifixion scene in which three
crosses appear.
 For repentance, probably.
 0 = 0, 0, 0, 0.

73. Santo Domingo (Saint Dominic)
 Lived 1170-1221 *August 4*
 A Castilian, an Augustinian priest who founded a new order to com-
bat the Albigensian heresy.

Bearded, tonsured, wearing black and white habit, holding rosary.
Patron of the rosary.
0 = 0, 0, 0, 0.

74. Elias el Profeta (Elias or Elijah the Prophet)
Biblical (Books of Kings) *July 20*
A great prophet, associated with Mount Carmel and therefore with
the Carmelites.
An old bearded man clad in a loincloth, holding a staff, accompanied
by a raven.
(?)
0 = 0, 0, 0, 0.

75. San Estanislao Kostka (Saint Stanislaus Kostka)
Lived 1550-1568 *August 15 or September 13*
A Polish youth who ran away from home to join the Jesuit Order and
died as a novice.
A youth wearing a surplice over a black cassock, holding a cross and
a palm, he is neither tonsured nor bearded.
Patron of youth, along with Luis Gonzaga, with whom he is often
confused.
3 = 0, 3, 0, 0.

76. San Esteban (Saint Stephen)
Biblical (Acts 6:8-7:60) *December 26*
The first martyr and one of the first seven deacons, stoned to death.
Standing in the robes of a deacon, tonsured, holding sometimes a
palm, sometimes a book, sometimes a monstrance, with the right hand
meanwhile raised in blessing. There are stones in the background.
0 = 0, 0, 0, 0.

77. San Felipe de Jesús (Saint Philip of Jesus)
Died 1597 *February 5*
A native of Mexico City, he became a Franciscan, left the order, trav-
eled to the Philippines as a merchant, rejoined the Franciscans, suffered
shipwreck in Japan, and was martyred by being tied to a cross and
pierced with two lances. He is the patron of Mexico City and (somewhat
incorrectly and unofficially) of San Felipe Pueblo.
Two crossed lances behind him are the distinguishing characteristics;
otherwise, he is either kneeling with arms outstretched or standing
against a cross (he may be shown nailed to it, though historically he was
not). He may be bearded and tonsured, or either, or neither; he wears
blue Franciscan robes.

One informant told me he is a good antidote for mischievous children.

3 = 1, 2, 0, 0.

78. San Felipe Neri (Saint Philip Neri)

Lived 1515-1595 *May 26*

A native of Florence who founded the Congregation of the Oratory and evangelized the people of Rome. The addition of "de" to his name is not correct.

A dove hovers over him; he wears a cassock, biretta, and beard and holds a rosary and sometimes a palm or a book.

For the poor; for rain.

2 = 0, 2, 0, 0.

79. San Fernando Rey (Saint Ferdinand III, King of Castile and Aragon)

Lived c. 1199-1252 *May 30*

He wears a kingly robe with an pattern and a crown (or it sits on the arm of his throne), and he hold a pennant, a staff of office, or a flowering staff. He is usually cleanshaven.

He fought the Moors throughout his reign, during which he also gained a reputation for wisdom and sanctity.

Perhaps the Moor-Indian configuration (Chapter IV).

4 = 0, 4, 0, 0.

80. San Francisco de Asís (Saint Francis of Assisi)

Lived 1181-1226 *October 4*

The son of a merchant, founder of the Franciscans, dedicated to poverty and the passion of Christ, marked by the stigmata (the wounds of Christ in hands, feet, and side). His Order of Friars Minor had almost sole responsibility for New Mexico until the early nineteenth century.

Wearing a blue robe with a cowl and a white cord with several knots in it around the waist, bearded and tonsured, marked with the stigmata on his hands and his bare or sandaled feet, he holds a crucifix or a cross and a skull or occasionally a book.

80a. San Francisco con su Cuerda (Saint Francis with his Cord)

Very occasionally, Francis is shown holding his Franciscan cord (the emblem of his Third Order as the small brown scapular is of the Carmelite) down to souls in purgatory to rescue them as Nuestra Señora del Carmen does.

Patron of birds and animals (a romantic-period emphasis, though with some warrant in the Wolf of Gubbio tale); for reconciliation within

the family; for deceased members of the Third Order; for all virtues and all needs.

20 = 2, 14, 3, 1.

81. San Francisco Javier, or Xavier (Saint Francis Xavier)
 Lived 1506-1552 *December 3*
 Born in Spain, student at the University of Paris, one of the first companions of Ignatius in the founding of the Jesuits; a missionary in India and Japan, he died on an island off the coast of China.
 Wears a black cassock and a biretta, holds a palm and a cross or crucifix; usually has a cape over his shoulders.
 Perhaps of missionaries or for faith.
 5 = 1, 3, 1, 0.

82. San Francisco Solano (Saint Francis Solano)
 Lived 1549-1610 *July 13, 14, or 24*
 As a Franciscan missionary in Peru, he suffered shipwreck; he had the gift of tongues. He appears on the Cristo Rey stone altarscreen from the Castrense.
 Wears a cloak over a black cassock (rather than the usual Franciscan blue), with a miter or loose "nightcap" on his head, is bearded, and holds what may be a meant as a scourge.
 1 = 0, 1, 0, 0.
+ George—see San Jorge

83. San Geronimo (Saint Jerome)
 Lived 342-420 *September 30*
 Well educated in Rome, he lived as a hermit for a time, then acted as secretary to the pope, then went to Palestine where he lived as a monk and translated the Bible from Hebrew and Greek into the Latin Vulgate version. In a variant of the Androclus-and-Lion tale from classical folklore, Jerome removed a thorn from a lion's paw, and the beast then served as wrangler for the monastery's donkey. When some traveling merchants stole the donkey, the monks accused the lion of having eaten it, so the lion went out, found the real culprits, rounded them up like so many cattle, and herded them and the donkey home. The story (like many others told of founders of religious orders) identifies the cloister as an unfallen Eden where humans are restored to God, humans live together without sexual competition, and humans and animals are once again at one. Rice, *Saint Jerome in the Renaissance* (1985), 37-46.
 Bearded, often tonsured, clad in a red mantle, striking a stone against his bare breast as he kneels in prayer, often before a small cross

or crucifix; there is almost always a lion at his feet, and the trumpet of God's voice speaks in his ear.

Patron of children and especially orphans; against lightning.

13 = 3, 10, 0, 0.

84. San Gil Atenogenes (Saint Giles the Athenian, of Languedoc)
Died about 712 *September 1*

A Benedictine hermit and abbot whose tomb in Provence became a place of pilgrimage in the middle ages.

Shown as an old man in a long hermit's robe protecting a deer; there is often a church door (looking like anything but) in the background. Compare this subject with San Procopio, #112, and with San Athenogenes, # 61. See Schiller, *Iconography of Christian Art* 1:131; Boyd, *El Palacio* 57 (1950), 163-65; and Espinosa, *El Palacio* 59 (1952), 3-17.

For animals, cripples, the snake-bitten, and perhaps epileptics. The door symbolizes salvation; see John 10:9.

3 = 1, 2, 0, 0 (these numbers pertained originally to # 61).

85. San Gregorio (Saint Gregory the Great)
Lived c. 540-604 *March 12*

Mayor of Rome, he became a Benedictine monk, papal nuncio, and finally pope. He is a doctor of the church.

A cross in his right hand with three crossbars, a miniature church in his left, in a cape and decorated garment, wearing the pope's triple crown.

85a. La Misa del San Gregorio (The Mass of Saint Gregory)

A legend dating from much later than Gregory's lifetime claims that during a Mass Gregory said, Christ appeared in visible form on the altar as the Man of Sorrows (# 13a) to prove his real presence in the consecrated host.

Alan Vedder identified a panel on the side altarscreen in the Truchas chapel with a cross on an altar before a kneeling figure labeled "San Gregorio," apparently Fresquis' try at rendering the subject.

Devotion to the Eucharist; perhaps for the needs of the church.

0 = 0, 0, 0, 0.

86. San Hipolito (Saint Hippolytus)
Died c. 235, or perhaps 258 *August 13*

A very confused conflation of varions persons, probably including the Hippolytus of Euripides' tragedy who, like the saint, was dragged to death by horses, and various more-or-less historical Christian figures. He was associated with San Lorenzo.

An armored Roman centurion on horseback.

Success in warfare, perhaps, though there is nothing in the saint's multiplex biography suggesting he was a soldier.

0 = 0, 0, 0, 0.

87. San Ignacio de Loyola (Saint Ignatius Loyola)

Lived c. 1491-1556 *July 31*

A Basque soldier, wounded in battle, becoming very devout during his convalescence, prepared for the priesthood and hoped to be a missionary to Palestine; founded the Society of Jesus on the basis of his *Spiritual Exercises*, a program of prayer.

Dressed in a chasuble or a black cassock with or without a surplice, shown sometimes with a biretta, sometimes tonsured or bald; holding a monstrance or a book or plaque marked "IHS"; sometimes there is an apparition of Christ.

Against witchcraft and the evil eye; for repentance and return to the sacraments; against illness. The penitential Brothers of Our Father Jesus the Nazarene thought of him as the founder or organizer of their *cofradía*, perhaps because his *Exercises* and his *compañía* sound like their exercises and their *cofradía*.

11 = 1, 9, 1, 0.

88. San Ildefonso (Saint Ildephonsus)

Lived 607-667 *January 23*

A Spanish monk and abbot who became archbishop of Toledo; he defended the doctrine of the virginity of Mary.

I have never seen a santo I could identify as a San Ildefonso, but since none of the other pueblo churches, much less whole pueblos, were named for saints unrepresented by the santeros, I assume there were santos of San Ildefonso made.

(?)

0 = 0, 0, 0, 0.

89. San Isidro Labrador (Saint Isidore the Plowman)

Died 1170 *May 15*

A farmer, married to Santa María de la Cabeza, whose praying God enjoyed so much he used to send an angel to do the saint's plowing and free him for prayer.

Shown in farmer's garb, usually with a broadbrimmed hat, often with a walking staff, oxgoad, or hocking iron; an angel guides a plow pulled by two oxen.

Patron of farmers, of crops, petitioned for rain; patron of all workers.

14 = 2, 8, 4, 0.

+ Jerome—see San Geronimo

90. San Joachim (Saint Joachim)
 Legendary *March 20, August 16, 10, or 20*
 The father of the Virgin Mary.

He appears as an elderly man in a blue cloak over a white alb in a retablo by Pedro Fresquis, Museum of New Mexico A.60.8.1, that is probably better interpreted as "La Santa Parentela—The Holy Extended Family" rather than as an Allegory of the Redemption. See Wroth, *Christian Images* (1982), 182.

 Perhaps fatherhood.
 1 = 1, 0, 0, 0.

+ James the Greater—see Santiago

90.5. Job (Job)
 Biblical

I used to accept the prevailing opinion that no New Mexican santos were correctly identified as Job, that those that seemed to actually represented Christ in his passion (subject # 12a especially); but recently some figures have been identified as images of Job by the persons or groups who have owned them for years. A cult to Saint Job was especially strong in the Low Countries, great sources of graphics for the Spanish Empire. Since Job is a type of innocence suffering patiently and redemptively, he is not adequately distinguishable from his perfect antitype Christ, and hence the ambiguous iconography is a fine instance of creative ambiguity. The presence of a crown of thorns or a rope would, of course, indicate a Christ figure—Jesús Nazareno, Ecce Homo, or El Varón de los Dolores. Reau 2:1:310-18, especially 315; Boyd, *El Palacio* 61 (1954), 65-69; Shalkop, *Wooden Saints* (1967), 44-45; Frank, *New Kingdom of the Saints* (1992), 157-58.

 A bearded man wearing a loincloth, covered with wounds or sores, seated with head on hand.

 Patience in trials, acceptance of God's mysterious will.

91. San Jorge (Saint George)
 Legendary, supposedly third or fourth century *April 23*
 There may have been a Palestinian martyr named George, but the legends tell of a dragon-killing maiden-saving warrior, model of knighthood.
 In soldier's garb, on horseback, piercing a dragon with a spear.
 For success in battle.
 0 = 0, 0, 0, 0.

92. San José Patriarca (Saint Joseph)
 Biblical (Mt. 1 and 2; Lk. 1 and 2) *March 19*
 Spouse of Mary and foster father of Jesus, traditionally a carpenter.
 Shown in New Mexico as a younger man than in most European art,
he has a dark beard and dark hair, carries a flowering staff, holds the
Niño, and wears a brightly colored and often intricately patterned robe.
He is sometimes crowned; occasionally there is a basket of carpenter's
tools by his feet.
 Patron of a happy death (since Christ traditionally was said to have
been with him); of fathers and of families; of carpenters and all workers.
 59 = 14, 30, 14, 1.

93. San Juan Bautista (Saint John the Baptist)
 Biblical (all gospels) *June 24 and August 29*
 The forerunner of Christ, a preacher hermit who baptized Christ
among his converts and recognized him as the Messiah, calling him the
Lamb of God. Dressed in a hermit's cloak, holding a shepherd's crook
or a staff with a cross on top and a banner hanging from it; with a lamb
in his arms or by his side.
 Patron of sheep and shepherds and of the purity of water, all of
which was believed to become pure on June 24.
 1 = 1, 0, 0, 0.

93.5. San Juan de Dios (Saint John of God)
 1495-1550 *March 8*
 After a sudden conversion, Juan founded a variant of the Franciscans
dedicated to aiding the ill and needy.
 The Millicent Rogers Museum has a Fresquis panel of the saint,
plainly labeled "San Juan de dios," wearing black Franciscan robes and
holding a staff topped with cross in one hand and a book and rosary in
the other. There is an altar with a crucifix and a reliquary or monstrance
in the background.

94. San Juan Evangelista (Saint John the Evangelist, the Divine)
 Biblical *December 27*
 Apostle and evangelist, usually identified as the "beloved disciple,"
one of the "Sons of Thunder," who was traditionally believed to have
lived into the second century and died on the Island of Patmos.
 Bearded, wearing a biretta and a dark cloak over a light tunic, holding
a book and pointing to it; or, wringing his hands, bareheaded and usually
beardless, especially as part of a Calvario (crucifixion group).
 Compassion with Our Lady of Sorrows and through her with Jesus
in his passion.
 4 = 0, 2, 2, 0.

95. San Juan Nepomuceno (Saint John Nepomucene, or Nepomuk)
 Lived 1345-1393 *May 16*
 The confessor to the queen of Bohemia, he refused to report her sins
to the jealous King Wenceslaus and was drowned. Later research sug-
gests that the occasion for his killing was a simply political power strug-
gle between king and archbishop.
 Usually bearded, wearing a surplice, black cassock, and biretta,
holding a cross and palm.
 Patron of silence and secrecy, especially for the humbly anonymous
penitent Brothers; protector against gossip and slander; patron of
irrigation.
 30 = 9, 15, 3, 3.

96. San Longino (Saint Longinus)
 Biblical-legendary *March 15*
 Longinus is the name assigned to the soldier in John 19:34 who
pierced Jesus' side; it derives from the Greek word for spear. He was said
to have spoken clearly after his teeth and tongue were removed during
his martyrdom.
 Dressed as a soldier, with a bloodied spear; there is a church in the
background, and other soldiers usually accompany him.
 Patron of soldiers, protector against injustice.
 2 = 1, 1, 0, 0.

97. San Lorenzo (Saint Lawrence)
 Died c. 258 *August 10*
 Traditionally said to be of Spanish birth, he was a Roman deacon
in service to the pope, martyred by being burned on a gridiron.
 Clad in a deacon's dalmatic, usually tonsured and beardless, holding
a palm and a gridiron, often a cross, a book and/or a chalice.
 Protector against fire; patron of the poor, of crops during August,
and of chickens (Brown, *Hispanic Folklife* [1978], 140). San Lorenzo will
control the wind if you light a palm blessed on Palm Sunday and throw
it into the wind while reciting a prayer to the saint.
 5 = 0, 5, 0, 0.

98. San Luis Gonzaga (Saint Aloysius Gonzaga)
 Lived 1568-1591 *June 21*
 Of a noble Italian family, he joined the Jesuits; while a seminarian,
he died of the plague contracted when nursing the sick.
 Clad in a white alb and a dark cloak with sleeves, holding a palm
and a crucifix, tonsured but not bearded.
 Patron of youth and especially their purity; patron or protector of

dancers (see Brown, *Hispano Folklife* [1978], 187; Weigle and White, Lore of New Mexico [1988], 193-94).
 1 = 0, 1, 0, 0.

99. San Luis Rey (Saint Louis IX, King of France)
 Lived 1214-1270 *August 25*
 A prayerful man, a Franciscan tertiary, and a good king, he went on two crusades, being captured on the first and dying of dysentery on the second.
 Standing, sometimes in armor but sometimes in the Franciscan robe and cord, wearing a crown, with a skull, a crown of thorns, and the three nails of the passion nearby.
 Probably patron of war against Moors and hence in New Mexico against uncooperative Indians.
 0 = 0, 0, 0, 0.

100. San Martin de Tours (Saint Martin of Tours)
 Lived c. 315-397 *November 11*
 While a soldier, he divided his cloak with a beggar who turned out to be Christ in disguise; he left the army to become a Christian; he was later bishop of Tours.
 On horseback, clad in soldier's uniform, holding half of a short cloak cut in two; Christ as a scantily-clad beggar (halo, crown of thorns, stigmata) holds the other half.
 Presumably of soldiers and the poor.
 0 = 0, 0, 0, 0.

101. San Martiniano (Saint Martinian)
 see Santos Processo y Martiniano

101.5. San Mateo (Saint Matthew)
 Biblical *September 21*
 Converted from his tax-collector's table, he authored the gospel that bears his name; he was martyred with lances.
 Robed and bearded, hands clasped in prayer, large monstrance before him, small monstrance beyond—a unique José Aragon panel.
 (?)

102. Melquisedec (Melchizedek)
 Biblical (Gen. 14:18; Hebr. 7:1-19). *No Feast Day.*
 A gentile priest-king to whom Abraham did homage, taken as a prefigurement of Christ as priest of the Eucharist because of Melchisedek's association with bread and wine.
 Beardless, wearing a red robe with a blue sash and a beehive crown

with a cross on top, holding a chalice with a cross-topped host emerging from it. He is paired with Moses on either side of Gabriel.

Eucharistic connections, probably.

1 = 0, 1, 0, 0.

103. Moises (Moses)

Biblical (Exodus, especially) *September 4*

The leader of the Hebrew people from Egypt to the Promised Land.

A black-bearded man in a long robe holding the tablets of the law; three rays come from his head (see Ex. 34:35).

(?)

1 = 0, 1, 0, 0.

104. San Nicolas Obispo (Saint Nicholas of Myra)

Died c. 350. *December 6*

A bishop renowned for good works (giving money to dower poor girls) and miracles (raising to life three children who had been pickled in a brine tub).

Wearing a bishop's cape over a white alb and a miter, bearded, holding a palm and a dove in a cup or shell.

For children and marriageable girls, probably.

1 = 0, 1, 0, 0.

105. San Onofre (Saint Onophrius or Humphrey)

Died c. 400. *June 12*

An Egyptian hermit, reputed to have worn only a loincloth of leaves and his own abundant hair.

Kneeling in a loincloth or a hermit's cloak, either holding a crucifix or with one on a ledge before him, perhaps showing the wounds of penance.

Probably a patron of penitence.

2 = 0, 2, 0, 0.

106. San Pascual Bailón (Saint Pascal Baylon)

Lived 1540-1592 *May 17*

This shepherd became a Franciscan lay brother and worked in the dining room or as doorkeeper; very devoted to the Eucharist.

Standing in priest's chasuble, bearded, holding a monstrance, surrounded by sheep.

Patron of sheep and shepherds; his patronage of cooking may be a twentieth-century addition.

0 = 0, 0, 0, 0.

107. San Patricio (Saint Patrick)

Lived c. 389-c. 461 *March 17*

Perhaps British, perhaps Italian in origin, he was taken to Ireland as a slave, escaped, became a priest, returned to Ireland as a missionary and became the first bisbop.

I have never seen this subject, but it is listed in Espinosa, *Saints in the Valleys* (1960, 1967), 92.

(?)

0 = 0, 0, 0, 0.

108. San Pedro Apostol (Saint Peter the Apostle)

Died c. 55 *June 29*

The leader of the apostles, the first pope, the custodian of the "keys of the kingdom of heaven" (Matthew 16:19), hence in folklore the keeper of the gates of heaven. In Mexican and New Mexican religious folklore, he takes the trickster's role; see Hynes and Steele, "Saint Peter: Apostle Transfigured into Trickster," in Doty and Hynes, eds., *Mythical Trickster Figures* (1993), 159-73.

In long robes, bearded, with a key or keys, sometimes also holding a book; he often wears the triple papal tiara and sometimes carries a crozier.

Patron of happy death and admission to heaven; for the freedom of prisoners (see Acts 12:6-11); patron of church unity; protector from fevers.

6 = 2, 3, 1, 0.

109. San Pedro Claver (Saint Peter Claver)

Lived 1580-1654 *September 8*

A Spanish Jesuit who did missionary work among the slaves imported to Central and South America.

I have never seen an example of this subject, but Willard Hougland, *Santos, A Primitive American Art* (1946), 42, describes "San Francisco Xavier" as depicted with "crucifix, bell, vessel, and negro. Portrayed as standing figure with beard, in white surplice." This is surely Claver's iconography, not Xavier's.

Missionary work, probably.

0 = 0, 0, 0, 0.

110. San Pedro Nolasco (Saint Peter Nolasco)

Lived c. 1182-1258 *January 31*

Fought as a soldier against the Albigensians, a co-founder of the Mercedarians, an order to ransom captives of the Moors.

Wears chasuble or full scapular, bearded but not tonsured; hands

clasped; one angel holds a book in one hand and places the other on the saint's head, another angel holds a crucifix.

Protector against the Moors in Spain, hence probably against Indians in New Mexico; patron of freedom for their captives.

0 = 0, 0, 0, 0.

110.5. San Policarpio (Saint Polycarp of Smyrna)
Died 155 *January 26 (formerly February 1)*
A convert of the Johannine church and the bishop of Smyrna, he was burned to death.

Standing in a short robe, holding three nails (?) in one hand and a three-branched palm in the other, with spots on his lower legs. His sole New Mexican appearance resulted from Policarpio Córdova's donating the side altarscreen of Ranchos de Taos; see Boyd, *Popular Arts of Spanish New Mexico* (1974), 353, 357; Wroth, *Chapel of Our Lady of Talpa* (1979), 29, pl. 13.

Patron against earaches.
+ Philip (of Jesus, Neri)—see Felipe de Jesus, Felipe Neri.

111. Santos Processo y Martiniano (Saints Processus and Martinian)
Perhaps second century *July 2*
Roman martyrs whose tomb and basilica on the Appian Way were venerated from early times; legend identifies them as jailers converted by Peter and Paul.

Both clothed in Roman tunics and cloaks, holding spear and palms, being baptized by an angel with a shell of water; a prisonlike structure in the background.

Perhaps military patrons.
1 = 1, 0, 0, 0.

112. San Procopio (Saint Procopius)
Lived c. 930-1053 *July 4*
A Bohemian, by some accounts a king, who became a hermit in the forest where a deer took refuge with him when hunters pursued it; the saint later founded an abbey.

Wears a biretta or miter and a black cloak over a white robe and holds a book or a cross, a palm or a staff; there is a deer (rarely well drawn) nearby. Compare San Gil Atonogenes, # 84.

Protector of animals; perhaps there is a Diana-Artemis syndrome, with chastity, hunting, and protection of young animals being found together.

2 = 0, 2, 0, 0.

113. San Ramón Nonato (Saint Raymond Nonnatus)
Died 1240 *August 31*
A Mercedarian (see #110), he traded himself into captivity to free some prisoners from the Moors; while a slave he refused to quit preaching as told, so his lips were padlocked; once released, he became a cardinal. His epithet refers to his being a Caesarian birth from a dead mother.

Wearing orange or red chasuble or cloak over white robes; holding a monstrance and a wand with three crowns on it; bearded; sometimes with dots above and below his lips.

Patron of pregnant women, women in childbed, and the unborn; a husband whose wife was in labor might sing and dance to San Ramon (Lamadrid in Herrere-Sobek, *Reconstructing a Chicano/a Literary Heritage* [1993], 194). Patron of anonymity and secrecy for the Penitentes; protector against being slandered or cursed; protector of captives and those oppressed by the infidel, with a possible application to Anglo land-grant manipulators (Robb, *Hispanic Folk Music of New Mexico and the Southwest* [1980], 709).

22 = 6, 9, 4, 3.

114. San Roque (Saint Roch)
Died 1337 *August 16*
A French layman who devoted his life to the care of the plague-stricken.

Usually dressed in a tunic, cloak, and boots with a traveler's hat and a staff, sometimes as a beggar; occasionally he is shown in a blue Franciscan habit. A dog licks his prominently displayed sores, and sometimes an angel brings him bread.

Against plague, especially smallpox; against wounds; against cancer; pardon from sins and punishment for them. (New Mexicans confuse San Roque with Job and with Lazarus the beggar of Luke 16:19-31.)

3 = 1, 2, 0, 0.

115. Santiago (Saint James the Greater, Apostle; of Compostella)
Biblical *July 25*
Brother to John the Evangelist, with whom he may take the Castor role of the Dioscuri, James was reputed to have been the apostle of Spain; his shrine at Compostella in northwest Spain was a famous medieval pilgimage goal. The six Jameses in the New Testament are constantly confused and conflated. Santiago appeared numerous times during the history of Spain (especially at Clavijo) as well as in the early days of Christianity in Mexico, New Mexico, and southern Colorado. See

Rafael Heliodoro Valle, *Santiago en América* (1946), 19-20; Joseph Winter, *New Mexico Magazine* (March 1986), 53-57; Robert Torrez, *El Palacio* 95 # 2 (Spring-Summer 1990), 46-55.

Bearded, in a soldier's uniform with a spear or sword and a pennant, he rides his horse over the bodies of fallen Moors.

115a. Santiago como Peregrino (Saint James as Pilgrim)
When a figure remarkably resembling the Santo Niño de Atocha appears standing rather than sitting, he is possibly meant to be Santiago as Pilgrim (to his own shrine at Compostella). When the figure sports a beard, he is surely Santiago whether he is standing or sitting; see Boyd, *Saints and Saint-Makers* (1946), 85; *Américas* 22 # 9 (September 1970), cover; Wroth, *Christian Images* (1982), 141, 152.

Patron of warriors, especially when fighting the enemies of the church; patron of horsemen, of corridas del gallo, of the sowing of fields. He appeared at various battles fought by the Spanish against both Moors and Native Americans; see Chapter IV above and Donna Pierce, *Santiago: Saint of Two Worlds* (1991), 37.

14 = 6, 4, 2, 2.
+ Stanislaus—see San Estanislao
+ Stephen—see San Esteban

115.5. Santo Tomás Apóstol (Saint Thomas the Apostle)
Biblical *December 21*
After his doubt and his profession of faith (John 20), he went to India, converting the Indians until he was martyred by being pierced with lances.

Bearded and bare-headed, he wears a long green cloak over a red-brown robe. He might hold the lance of his martyrdom.

For faith; perhaps for the conversion of the (American) Indians.

116. Santo Tomás Aquino (Saint Thomas Aquinas)
Lived c.1225-1273 *March 7*
Of Italian birth, became a Dominican theologian at the University of Paris, composed eucharistic hymns.

Wearing a red mantle over white Dominican garb; holding a book and a shepherd's staff, tonsured and bearded; occasionally with a miter.

Patron of studies and students, of priests; protector against witchcraft; patron of faith (here perhaps confused with "Doubting Thomas" the apostle of John 20, # 115.5).

1 = 0, 1, 0, 0.

117. Santo Toribio (Saint Turibius of Mogrobejo)
 Lived 1538-1606 *Variously April 27, March 23, June 8*
 A lay lawyer, he served as head of the Inquisition at Granada; later
he took orders and became bishop of Lima.
 Wearing a bishop's robe and miter; cleanshaven.
 (?)
 0 = 0, 0, 0, 0.

118. San Vicente Ferrer (Saint Vincent Ferrer)
 Lived 1350-1419 *April 5*
 Son of an English father and Spanish mother, he was a Dominican
preacher who worked especially among Spanish Jews and Moors and
also worked to heal a papal schism. He advocated corporal penance and
salutary fear of God. He was reputedly a wonderworker.
 Winged, holding a crucifix with his left hand and pointing to God
with his right index finger; wearing a tonsure, a black cloak over a white
gown, a rosary around his neck; a skull in the background. See Boyd,
El Palacio 57 (1950), 193-97.
 Patron of charity; perhaps a patron of penitents; patron of a good
death. Padre Martínez printed a prayer for a good death derived from
him (*New Mexico Historical Review* 12:38), and Rubén Cobos collected a
prayer-poem: "San Vicente está en la gloria, / lo debemos venerar; /
dichosas las criaturas / que en ella pueden entrar—Saint Vincent is in
heaven, / so we should reverence him; / happy those persons / who can
enter there."
 2 = 1, 1, 0, 0.

FEMALE SAINTS
+ Agnes—see Santa Inés

119. Santa Ana (Saint Ann)
 Legendary name of the mother of Mary *July 26*
 Joachim and Ann were the legendary names given the parents of
Mary, the grandparents of Jesus; in the extended families of New Mex-
ico, grandparenthood was a very important relationship.
 A woman holding or standing near a small girl.
 Mother-child relationships, family needs; patron of women riding
horses, since her feast immediately follows that of Santiago the patron
of horsemen.
 5 = 0, 3, 1, 1.

120. Santa Apolonia (Saint Apollonia of Alexandria)
 Died 249 *February 9*

An aged deaconess, she had her teeth broken off, then was led to a bonfire and asked to renounce Christ, whereupon she jumped into the flames.

In a long dress, with long hair and no veil; hands tied; having teeth broken by a Roman soldier with large pliers.

Against toothache.

1 = 1, 0, 0, 0.

121. Santa Bárbara (Saint Barbara)
Legendary, third or fourth century *December 4*

A legend originating in the tenth century or so avers that her father shut her up in a tower and killed her for her faith, whereupon lightning killed him. She owes a lot to Danaë.

Wearing a crown, often with red plumes, holding a palm and a monstrance; a long dress with three flounces (honoring the Trinity); a tower in the background, often with three windows, and a thundercloud with lightning.

Against lightning and tempests; a rhyming prayer ran, "Santa Bárbara doncella, Libera nos del rayo y la centella—Holy virgin Barbara, protect us from the thunderbolt and the flash."

16 = 4, 10, 2, 0.

122. Santa Caterina, or Catalina, de Siena (Saint Catherine of Siena)
Lived c. 1347-1380 *April 30*

A Dominican nun who lived at home, worked with the poor, and persuaded the pope to return to Rome from Avignon.

A white or white-and-black nun's habit, holding a sceptre with what seem to be three diamonds on it and a cross with a pennant; a crown of thorns, the three nails of the passion, and two candles are nearby.

Against talking uncharitably of others, against infection, and against hunger.

0 = 0, 0, 0, 0.

123. Santa Clara (Saint Clare)
Lived c. 1193-1253. *Angust 12*

A native of Assisi, foundress with Francis's help of the Franciscan nuns (Poor Clares); a very committed penitent.

Wearing Franciscan nun's habit, holding a monstrance.

Probably penitence.

0 = 0, 0, 0, 0.

124. Santa Coleta (Saint Colette)
Lived 1351-1448 *March 6*

A carpenter's daughter who dropped out of two orders of nuns, became a recluse, then revived the local Franciscan convent and eventually became superioress of the entire order of Poor Clares.

Wearing a white nun's habit with a black veil, holding a crucifix.

Possibly penitence.

1 = 1, 0, 0, 0.

125. Santa Deluvina (Saint Lydwina of Schiedam)
Lived 1380-1433 *April 14*

A Dutch peasant's daughter who met with an accident at the age of sixteen, was permanently bedridden, became a mystic.

Wearing a red and white dress without hood or veil, long hair, not holding anything in her clasped hands, praying to a crucifix. See Boyd, *El Palacio* 59 (1952), 101, and Espinosa, *El Palacio* 61 (1954), 70-73.

Patron of those who suffer for the sins of others.

1 = 0, 1, 0, 0.

+ Elizabeth of Portugal—see Santa Isabel

125.5. Santa Felicia (Saint Felicity)
Died about 165 *November 23*

The Folk Art Museum researchers identified a bulto at Córdova as Felicity, a Roman matron who encouraged her seven sons to accept martyrdom under Marcus Aurelius, then accepted her own death. The legend derived from 2 Maccabees 7, the name from the folklore that came to surround it.

Standing in a gown, with pictures of seven young men's heads on a scapular-like piece of cloth that falls from her neck to her feet.

For the birth of a son.

126. Santa Flora de Córdova (Saint Flora of Cordova)
Died 856 *November 24*

One of two Christian maidens who were beheaded by the Moors; there is a legend that Flora's brother, a Moor, threatened the pair with prostitution.

Wearing a dress with a crossed sash in front, holding a cross, with a wound in the back of her neck.

For sexual purity; against rape, perhaps.

1 = 0, 1, 0, 0.

127. Santa Gertrudis (Saint Gertrude the Great)
Lived 1256-1302 *November 16*

A German Benedictine nun and mystic with a great devotion to the heart of Christ as a symbol of mystical union with him; she is patron of

the West Indies, then understood to include New Mexico.

Wearing a black nun's habit, holding a crosier or simple staff with a pennant, holding a heart which is occasionally circled with thorns.

Patron of the medieval devotion to the Sacred Heart; patron of the young, especially students; perhaps for faith and for souls in purgatory.

15 = 6, 8, 0, 1.

128. Santa Inés del Campo (Saint Inez, Agnes, or Josepha—her name in religion—of Benigamin)
1625-1696 *January 21 or 22*
A discalced Augustinian nun of a convent near Valencia, especially devoted to the eucharist.

A long garment, sometimes a nun's veil or wimple, sometimes long hair; holding a palm and candle or a staff which is in flower; in a landscape of sorts sometimes with lambs.

Of persons and animals lost in the wilderness, of those who work outdoors, of transients and runaways; for purity; for trees, flowers, crops, and flocks. There is a great alabanza in her honor, and Pedro Fresquis wrote on a retablo of her, "Santa Ynes deve ser Abogada de lo perdido en el campo—Saint Inés, you must be the advocate of anyone or anything lost in the outdoors."

2 = 1, 1, 0, 0.

129. Santa Isabel de Portugal (Saint Elizabeth of Portugal)
Lived 1271-1336 *July 8*
Grand-niece of the king of Hungary, daughter of the king of Aragon, wife of the king of Portugal (a very bad husband to her), she served as a peace-maker and retired in her widowhood to live with the Franciscan nuns as a member of the Third Order.

Dressed in a queen's crown and royal robe, holding a cross.

Possibly for peace, possibly with penitential Brotherhood associations; of midwives and curanderas.

2 = 0, 2, 0, 0.

+ Kummernis—see Santa Librada
+ Ledwina or Lydwina—see Santa Dulubina

130. Santa Librada (Saint Liberata, Kmmernis, Uncumber, or Wilgefortis)
Legendary *July 20*
Reputedly the daughter of a Portuguese king, one of nine sisters born of a single birth, she wished to devote herself to Christ; her father, who at first had tried to kill all nine and subsequently wanted to marry them off to his advantage, was somewhat thwarted when Librada grew a beard, so he had her crucified. The whole tale grew up, it seems, from

a misinterpretation of an early-medieval clothed crucified Christ; see Hippolyte Delahaye, *The Legends of the Saints* (1961; original 1907); Roland Dickey, *New Mexico Village Arts* (1949), 157; Espinosa, *Saints in the Valleys* (1960, 1967), 93-94.

A crucified woman in long robes, with a hood or long hair; in New Mexico she never sports a beard.

A penitential saint for women.

9 = 0, 8, 1, 0.

131. Santa Lucia (Saint Lucy)
Died 304 *December 13*

A Sicilian maiden, reputed to have been denounced as a Christian by her rejected suitor; her virginity was saved despite her being sent to a house of prostitution, and her life was saved despite her being thrown into the fire, but finally her throat was successfully cut. In some accounts, she was blinded ("lucia" means "light" in Italian).

A young girl in long robes carrying a palm and a pair of eyes (duplicates of her own) on a dish.

Against disease of the eyes.

0 = 0, 0, 0, 0.

132. Santa Margarita de Cortona (Saint Margaret of Cortona)
Lived 1247-1297 *February 22*

The mistress of a young nobleman, bearing him a child; seeing in his death a warning, she publicly repented her sins, joined the Franciscan Third Order, and served the sick, living otherwise the life of a recluse.

A woman in nun's garb carrying a cross and a handkerchief.

For charity to the poor; against eye trouble.

3 = 3, 0, 0, 0.

133. Santa María Magdalena (Saint Mary Magdalen)
Biblical (the real Magdalen is treated in Lk. 8:2, Mk. 15:47, and 16:1-9; she is generally identified with the woman in Lk. 7:36-50, occasionally with the woman in John 8:3-11, and sometimes with Mary the sister of Martha and Lazarus in John 11) *July 22*

Mary, not the sister of Martha and Lazarus, was a harlot converted by Christ, a witness of his crucifixion and resurrection.

In a long green dress, red cloak, no veil, praying.

Patron of conversion from an evil life especially for women; she is particularly prayed to on Good Friday, since she stood beneath the cross.

1 = 0, 1, 0, 0.

134. Santa Rita de Casia (Saint Rita of Cascia)
 Lived 1381-1457 *May 22*
 By her parents' wish, she married a man who turned out to be a
bad husband; became a nun when he and her two sons all died; had
mystical experiences during one of which a thorn from Christ's crown
pierced her forehead.
 Wearing a nun's habit, holding a cross and a skull, occasionally with
a wound on her forehead or the full stigmata.
 Patron of girls in need of husbands, of marriage, of mothers, of those
in bad marriages, of all who must bear suffering; for the impossible;
against sickness. There was a fear that too great a devotion to Santa Rita
might bring a woman both the virtue of patience and a bad husband to
help her exercise it. She probably also had penitential associations.
 18 = 3, 12, 2, 1.

135. Santa Rosa de Lima (Saint Rose of Lima)
 Lived 1586-1617 *August 30*
 Like Catherine of Siena, she lived in her parents' home as a Domin-
ican tertiary; a friend of Santo Toribio.
 In a nun's garb of white dress and blue cloak, holding a crucifix and
sometimes a scourge and a crown of thorns, with roses in background.
 (?)
 2 = 0, 2, 0, 0.

136. Santa Rosa de Viterbo (Saint Rose of Viterbo)
 Lived 1234-1252 *September 4*
 A poor girl, she preached in the streets of Viterbo against the Ghibel-
lines and for the Guelphs, the papal faction; reputed to have been sub-
jected to an ordeal by fire; refused entrance to the Franciscan nuns but
eventually buried in their convent.
 Wearing a white dress with a green cloak and a crown of thorns; car-
rying a basket and a staff or cross.
 Possible association with penance.
 0 = 0, 0, 0, 0.

137. Santa Rosalía de Palermo (Saint Rosalia of Palermo)
 Died c. 1160 *September 4*
 According to a Sicilian legend, she was a girl of good family who
became a hermit; many years after her death, she saved Palermo from
a plague and so became its patron.
 Wearing a black, brown, or grey dress, a crown of roses, long hair,
holding a cross, usually a skull, sometimes a book or a scourge.
 Protector against plague, prayed to at velorios for the dead; patron

of engaged couples; probably patron of penance for the women aux-
iliaries of the Brotherhood. One stanza of an alabanza praises her: "Con-
tigo el demonio / se muestra impaciente / de ver a tu cuerpo / haces
penitente—With you the devil / shows himself exasperated / seeing that
you make / your body a penitent."
 12 = 2, 6, 0, 4.

138. Santa Teresa de Ávila (Saint Theresa of Avila)
 Lived 1515-1582 *October 15*
 A Discalced Carmelite, leader of the reform of the order, mystic.
 Wearing a nun's garb usually of white and black, often a cloak;
holding a crucifix, a crozier with a banner reading "IHS" and having the
same emblem on her breast, and/or a palm.
 Patron of faith; protector from "the ditch of perdition."
 5 = 1, 4, 0, 0.
+ Uncumber—See Santa Librada

138.5. Santa Ursula (Saint Ursula)
 Legendary *October 21*
 Perhaps someone misunderstood the letters XI MM VV (eleven
virgin martyrs) as eleven thousand virgins and then rationalized his
misunderstanding by borrowing some Niebelungen traits and concoct-
ing a wild tale of a Christian British princess who did not want to marry
a pagan prince, proposed extravagant conditions all of which were
dutifully met, and was finally killed by the Huns, who were thereupon
(not a moment too late) chased off by angels.
 Rich robes, crown, pennant in her right hand, and in her left a
scepter or spear elaborately decorated with flowers and a pennant; see
Christian Images (1982), 152.
 (?)

139. Santa Verónica con el Rostro (Saint Veronica with the Veil)
 Legendary (Sixth Station of the Way of the Cross) *Good Friday*
 This subject has been dealt with above, #15.
 When the saint holds the veil, she usually is clad in a nun's habit.
 Imprint of Jesus in our hearts; miracles, converts, sexual purity. Also,
through association of Santa Verónica with the woman in Mt. 9:20-22
and Mk. 5:25-34, against hemorrhages.
 8 = 4, 3, 1, 0.
+ Wilgefortis—see Santa Librada

OTHER SUBJECTS

140. La Alma Sola (The Last Soul Left in Purgatory)
Allegorical *No Feast Day*
 The last soul to remain in Purgatory after all others had been cleansed from sin and united with Christ in Heaven. See Lange, *Santos de Palo* (1991), 18 and 23-24 and fig. 31.
 A standing or kneeling-and-floating figure of indeterminate sex in a white robe with arms crossed on breast; something like a star in the background. A particolored skirt may be meant to represent the supposed flames of Purgatory. This subject very much resembles # 41a except for that figure's crown of roses.
 Probably a sort of patron of retaining baptismal innocence.
 1 = 0, 1, 0, 0.

141. Las Calveras (Skulls)
Allegorical *No Feast Day*
 These allegorical reminders of death, sometimes occurring as attributes of saints, here occur by themselves.
 Various skulls, possibly meant to serve as an altar frontal during funerals, on November 2, and at other appropriate times.
 A reminder of death and of the need to die in the state of justification.
 1 = 0, 1, 0, 0.

142. El Escudo de San Francisco (The Franciscan Shield)
Allegorical *No Feast Day*
 The emblem of the Franciscan Order.
 A cross, with two men's arms crossed in front of it, the one (of Christ) bare, the other (of Saint Francis) in the sleeve of the blue Franciscan habit, each palm marked with a nail wound.
 A reminder of the passion of Christ.
 1 = 0, 1, 0, 0.

143. Doña Sebastiana, La Carreta, El Ángel de Muerte (The Death Cart)
Allegorical *No Feast Day*
 A reminder of death, not to be prayed to; used as a penitental instrument in Holy Week processions. All death carts date from after the middle of the nineteenth century. Arrows symbolize epidemic sickness (cf. *Iliad* I). Death may bear the name "Sebastiana" because St. Sebastian was martyred with arrows.
 An allegorical figure of death as a skeletal or corpselike woman with a bow and arrow or a club. Most often recognized as only a reminder, it was perhaps in some places superstitiously prayed to for longer life. Steele, *Colorado Magazine* 55 (1978), 1-14; Wroth, *Images of Penance, Images*

of Mercy (1991), 149-59.
 5 = 0, 0, 4, 1.

144.0. El Flagelante Espectral (The Ghostly Penitent)
 Allegorical *No Feast Day*
 A reminder to each Brother of Our Father Jesus to do promptly anything of obligation, or he might have to return after death to perform his duties.
 A skeletal figure kneeling before a cross with a scourge in its hand; see Weigle, *Western Folklore* 36 (1977), 135-47.
 For prompt fulfilment of duties.

145.0. Relicario (Reliquary)
 This seems to be a santero subject *as such* wherein the artist depicts the reliquary and its content, a relic of some saint, shown in the form of his or her body. See TM 1136 in the Colorado Springs Fine Arts Center, where a dead male Franciscan in shown lying in a monstrance-like reliquary. Reliquaries occur commonly in early eighteenth century New Mexican inventories.

Addendum

This is a list of the thirty most commonly represented subjects of the New Mexico santeros, according to my analysis of a thousand santos. The list includes all saints represented ten times out of a thousand or oftener; hence it includes all who make up one percent or more of the sample. The top five subjects total 31.6% of the sample, the next five only 11.4%. The thirty account for 74.3% of the thousand. Our Lady is represented in 22.7% of the thousand.

81 Cristo Crucificado (Crucifijo)
73 San Antonio de Padua
59 San José Patriarca
53 Nuestra Señora de los Dolores
50 Nuestra Señora de Guadalupe
34 San Miguel Arcángel
30 San Rafael Arcángel
 San Juan Nepomuceno
26 El Santo Niño de Atocha
24 Nuestra Señora del Carmen
22 Nuestra Señora de San Juan
 de los Lagos
 San Ramón Nonato
21 Jesús Nazareno (Ecce Homo)
 Nuestra Señora de la Purísima
 Concepción

20 San Francisco de Asís
18 Santa Rita de Casia
16 San Acacio
 Santa Bárbara
15 Cruz
 Santa Gertrudis
14 Nuestra Señora de la Soledad
 San Isidro Labrador
 Santiago
13 La Santísima Trinidad
 La Sagrada Familia
 El Santo Niño de Praga
 San Gerónimo
12 Santa Rosalía
11 San Ignacio de Loyola
10 Nuestra Señora Refugio de
 Pecadores

Appendix C

SANTO-IDENTIFICATION CHART

This chart will help identify any New Mexico santo, whether retablo or bulto. It is divided into five main sections: Multiple Main Figures; Single Main Male Child; Single Main Male Adult; Single Main Female Figure; Not Complete Person. Within some of these sections there are appropriate subdivisions. First choose the proper section, then identify the main features of iconography—how the figure is dressed, what he or she is holding, and so forth. Then work through the section in question and any appropriate subdivisions, copying down the numerals as they occur, noting numbers that occur repeatedly, and finally referring to the subjects as numbered in Appendix B.

Not all santos can be identified, especially bultos which have lost items once attached to them, but also retablos, and those even if they are in good condition. This chart came into existence twenty years ago because I had been trying for four years to identify a José Aragon retablo in the Regis University collection; that I am *still* unsuccessful indicates the continuing limitations of this chart.

Multiple Main Figures

> (Not including an adult holding a child, an altarscreen,
> or a retablo with different subjects separated from each
> other by interior borders)

More than three persons:
> Two women embracing in the center, a man on each side—3.7
> Crucified man in soldier's garb plus soldiers—57
> Christ, virgin, angels, priest, deacons—20
> Christ Child above, cross below, each flanked by two figures—5.5
> Christ on donkey, crowd holding palms—11
> Rising Christ, angels, soldiers, etc.—22

Three persons:
> Angels—52-54 (Archangels, sometimes presented as a group)
> Abraham with two angels and a dove (Trinity)—56

Crucified man in soldier's garb plus soldiers—57
Men, especially with triangular halos—1
Man, angel, woman on donkey holding Niño— 4
Man, woman, child in middle—5
Man on cross with loincloth, two standing figures—16
Man's face repeated three times on veil (perhaps held by woman)—15a

Two persons:
> Men, one old, one young (perhaps lying dead), dove—1
> Man and angel, with oxen and plow—89
> Man with flowering staff, woman, dove—3.3
> Woman, angel, dove—3.5
> Man and woman kneeling on either side of a manger—3.9
> Man leading donkey ridden by woman holding child—4
> Nude man and woman in garden—57.5
> Soldier pulling woman's teeth—120

Single Main Male Child

Reclining or sitting figure of infant—6 (Niño—but probably if very small
> meant to be an attribute of a larger bulto)
Sitting on a chair, or occasionally standing, with baskets of roses, holding
> basket of roses and a pilgrim's staff with a gourd of water; in legirons,
> hat, sandals or shoes—7
Standing figure in loincloth—8
Holding globe with cross on top, in red robe, crowned—9
Floating in air, wearing white garment, star in background—140

Single Main Male Adult

Single Main Male Adult, ON or IN:

air—22
casket—18
cross—16, 57, 67, 72, 77
cross with three "buds" on upright and four on crossbar—16a
donkey—11

horseback—86, 91, 100, 115
knees—77, 83, 85a
representation of cloth (head only—15 (cf. 139)
seat/throne—12, 79
serpent/snake—53
stream of water—68

Single Main Male Adult, WEARING: on head:

biretta—78, 81, 87, 94, 95, 112
crown (papal beehive)—2, 69, 85, 102
crown (royal)—2, 11.5, 56, 63, 65, 79, 92, 99
crown (of thorns)—12, 13, 14, 15, 16, 57
halo of three sets of rays—16c, 103
halo, triangular—2

hat, broadbrimmed—10, 57, 89, 115a
hat, cardinal's—65
hat, cocked—114
hat, strange Oriental—67.5
helmet of armor—53, 91
hood of brown—60, 62.5
miter—65, 82, 104, 112, 116, 117
tonsure—59, 61, 73, 76, 77, 80, 83, 87, 97, 98, 116, 118

Single Main Male Adult, WEARING: as garment:

alb—90, 94, 98, 104, 112, 113, 116, 118
armor—53, 86, 91, 99
bishop's robes—58, 104, 117
breeches—67.5, 89
cassock—see robes.
chasuble—64, 87, 106, 110, 113
cloak/cape—22, 62.5, 69, 71, 81, 82, 85, 90, 94, 98, 111, 112, 114, 116, 118
coat—67.5, 89
cope—104
dalmatic of deacon—76, 97
hermit's cloak—83, 84, 93, 105
king's robes—79
jeweled collar/necklace—67
loincloth/"kilt"—11.5, 16, 18, 68, 72, 74, 105
pilgrim's garb—54, 115a

robes of black—61, 66, 67, 71, 75, 78, 81, 82, 87, 90.5, 93.5, 95
 of black and white—73
 of blue—59, 65 (with red trim), 70, 77, 80, 114
 of brown—60
 of purple—12, 13, 14
 of red—62, 83, 102, 108
 of white—11, 22, 62.5, 69, 116
 patterned—92
rope around neck—11.5, 12, 13, 14
rosary—118
sash—102
scapular, large, of black—62.5
soldier's uniform—57, 86, 96, 100, 115
surplice—71, 75, 95
tunic—110.5, 111, 119
wings—2, 52, 53, 54, 55, 118

Single Main Male Adult, WEARING: on feet:

boots—53, 54, 89, 114, 115
laced sandals—54
nothing—12, 13, 14, 16, 18, 68, 72, 74, 80, 83, 84, 93, 105

sandals—80
stockings (sometimes without toes)—53, 54, 89

Single Main Male Adult, HAVING "as mark":

anchor on breast—67.5
dots above and below lips—113
no beard—59, 64, 75, 79, 94, 97, 98,
 102, 117
sores—90.5, 110.5

stigmata—10, 13a, 16, 18, 22, 80
three rays coming from head—103
white beard—60
wounds of penance—83, 105

Single Main Male Adult, WITH (in foreground or background):

altar with cross or crucifix—85a,
 93.5
angel or angels—22, 56, 89, 110,
 111, 114
apparition of Christ—87
apparition of Mary—67
beggar—100
biretta—67
black man—109
bodies (of Moors)—115
bread—114
church—65, 85, 96
church door (often looks like
 ladder)—84
column of the scourging—11.5,
 12, 13
cross or crucifix—62, 67, 77, 83, 105,
 110
crown—79
deer—61, 84, 112
demon/dragon—91
dog—114
dove—56, 58, 78, 104
drum—57
globe with cross on it—68
gridiron—97
halo (triangular)—2

lamb—10, 93, 106
lances/spears—77
lion—83
men lying and/or kneeling—66
oxen—89
palms—11
passion implements—99
pattern of squares—16c
pennant—57
persons bearing palms—11
pillar—12, 13
prison—111
raven—74
serpent (sometimes winged)—87,
 91
sheep—10, 93, 106
ship—109
shell—58, 111
skull—99, 118
snake (sometimes winged)—87, 91
soldiers—57, 96
souls in purgatory—80a
stones—76
tomb—22
tree—56
trumpet—83

Single Main Male Adult, HOLDING:

balance-scales—53
bell—109
book—62.5, 65, 76, 78, 80, 87, 93.5,
 97, 108, 112, 116

candles—63
chalice—52, 97, 102
child—59, 68, 92
church (miniature model)—65, 85

Single Main Female Figure

Single Main Female Figure, ON:

Single Main Female Figure, WEARING: on head:

Single Main Female Figure, WEARING: as garment:

body-halo—33
cape/cloak—50, 133, 135, 136, 138
gown of black—127, 137, 143
 black and red—48
 black and white—48, 122, 138
 blue—123
 brocade—33.5, 138.5
 brown—30, 137
 green—133
 red—31, 35, 38, 50, 125
 white—122, 124, 125, 135, 136

 with vertical panel showing
 seven men's heads—125.5
hoop skirt—26
nun's habit—48, 132, 134, 135, 138, 139, 143
rosary—48
royal robes—129
sash—126
scapular (large)—30, 33.5
skirt with three flounces—121
skirt of flame colors—140
wings—51

Single Main Female Figure, HAVING "as mark":

flexible arms—48
hair extremely long—41.5
is a skeleton—143
stigmata—134

sword or swords in beast—31, 35
wound in back of neck—126
wound in forehead—134

Single Main Female Figure, WITH (in foreground or background):

altar—121
angel or angels—23, 28, 34, 40, 41.5, 42
angels in Franciscan robes—22.5
basket of roses—26, 34
body halo—33
candles—45, 122
cave shaped like church bell—30.5
child—119
cross/crucifix—39, 121, 125
crown of thorns—39, 48, 122
dove—41a
eagle—50
font—121
globes—40
implements of the passion—39, 48, 122
lamb or lambs—128

lightning, thundercloud—121
monogram of "MA"—42
monstrance—24
Niña—119
piece of fruit—50
pliers (pulling teeth)—120
roses—42, 135
rotunda of church—41.5
Saint Dominic—44
Saint Francis of Assisi—40
sheep—128
soldier pulling teeth—120
souls in purgatory—30
star—140
teeth—120
tree with buds—24
tower—49, 121

Single Main Female Figure, HOLDING:

arrow—49, 143
basket—136
body of Christ—39, 48
book—137
bow and arrow—143
candle—128
child—23, 26, 27, 28, 29, 30, 33.5, 34,
 35.5, 38, 42, 43, 44, 46, 47, 50, 51,
 119
cloth with face of Christ imprinted
 on it—139
club—143
crosier—127, 138
cross/crucifix—23, 122, 124, 126,
 129, 132, 134, 135, 136, 137, 138
crown of thorns—48, 135
dove—23, 41a
flower or flowers—29, 41, 128
globe—27
handkerchief—132
heart—127
lily—36, 41a
monstrance—121, 123
Niña—119

Niño—23, 26, 27, 28, 29, 30, 33.5,
 34, 35.5, 38, 42, 43, 44, 46, 47, 50,
 51
nothing—31, 33, 35, 41, 45, 48, 120,
 125, 133
palm—28, 41.5, 42, 121, 128, 131,
 138
pennant on a staff—122, 127, 138,
 138.5
plate with eyes—131
rosary—44
rose—35.5
scapular (small)—30, 35.5
scepter—35.5, 38, 41a, 42, 43, 122,
 138.5
scourge—135, 137
skull—134, 137
soul (being drawn from monster's
 mouth)—34
spear decorated with
 flowers—138.5
staff—28, 47, 128, 136, 138
sword—23

Not Complete Person

a dove—3 (Espíritu Santo)
a cross—17 (Santa Cruz); with
 cloth draped over the
 crossbar—17a
a heart with no sword sticking in
 it—19 (Sagrado Corazón)
a heart with a sword or swords
 sticking in it—31 (Corazón de
 N.S. Dolores)
a metal reliquary (like a
 monstrance)—145.0

skulls—141 (Calveras)
two arms, one bare and the other
 clothed in blue, each pierced
 through the palm, in front of a
 cross—142 (El Escudo de San
 Francisco)
skeleton of a woman in a cart—143
 (Doña Sebastiana)
skeleton of a kneeling man
 scourging himself—144.0

Appendix D

CALENDAR OF NEW MEXICAN SAINTS

Included are all that appear twice or more in the sample of 1000 and that have a designated feast day. The final number in the listing indicates the frequency of occurrence in the sample. The lunar symbol ○ marks the part of the calendar that varies from year to year as does Easter (the first Sunday after the first full moon of spring). By contrast, feasts of the solar part of the liturgical calendar occur annually on the same day of the same month.

JANUARY
 Sunday after Epiphany: Sagrada Familia—13
 21 or 22: Inés del Campo—2

FEBRUARY
 5: Felipe de Jesús—3
 17: Huida en Egipto—2
 22: Margarita de Cortona—3

MARCH
 15: Longino—2
 19: José Patriarca—59
 22: Gabriel—9
○ Friday before Palm Sunday: N.S. Dolores—53 (also September 16, solar)

APRIL
 5: Vicente Ferrér—2
○ Good Friday: Nuestro Padre Jesús Nazareno—21
 Jesús es Cargado con la Cruz—5
 El Divino Rostro y Verónica—8
 Cristo Crucificado—81
 La Santa Cruz—15 (also 3 May, solar)
○ Holy Saturday: El Santo Entierro—2
○ Easter Sunday: Resurrección—2

MAY
 3: La Santa Cruz—15 (also Good Friday, ○)
 8: (also September 29) Miguel—29
 15: Isidro Labrador—14
 16: Juan Nepomuceno—30
 22: Rita de Casia—18
 26: Felipe Neri—2
 ○ Pentecost: Espíritu Santo—2
 30: Fernando Rey—4

JUNE
 ○ Trinity Sunday: Santísima Trinidad—13
 12: Onofre—2
 13: Antonio de Padua—73
 22: Acacio—16
 29: Pedro Apostol—6

JULY
 4: N.S. Refugio de Pecadores—10
 4: Procopio—2
 8: Isabel de Portugal—2
 18: N.S. Carmen—24
 20: Librada—9
 25: (or 30) Cristóbal—4
 25: Santiago—14
 26: Ana—5
 30: (also 25) Cristobal—4
 31: Ignacio—11

AUGUST
 2: N.S. Angeles—3
 7: Cayetano—8
 10: Lorenzo—5
 15: (also September 13) Estanislao Kostka—3
 16: Roque—3
 30: Rosa de Lima—2
 31: Ramón Nonato—22

SEPTEMBER
 1: N.S. Soccoro—2
 1: Gil Athenogenes—3
 4: Rosalía—12
 13: (also August 15) Estanislao Kostka—3

16: N.S. Dolores—53 (also Friday before Palm Sunday, ○)
29: (and May 8) Miguel—34
30: Gerónimo—13

OCTOBER
2: Angel Guardian—2
4: Francisco de Asís—20
7: N.S. Rosario—9
15: Teresa de Avila—5
24: Rafael—30

NOVEMBER
16: Gertrudis—15

DECEMBER
3: Francisco Javier—5
4: Bárbara—16
8: N.S. Purísima Concepción—21
12: N.S. Guadalupe—50
27: Juan Evangelista—4

Addendum

The liturgical calendar used in the universal Roman Catholic Church was supplemented by two sorts of calendars, one for nations and the other for religious orders. Thus in eighteenth-century New Mexico, bound at the back of the Roman Missal (mass book) and the Roman Breviary (book of divine office) were a supplement for the Spanish Empire and a supplement for the Franciscan Order. In this way, saints of particular Spanish or Franciscan interest and devotion were venerated at special masses and in special variants of the priest's daily recitation of the office. Some saints (like Santiago for Spaniards and Antonio de Padua for Franciscans) appeared in the missals and breviaries for the whole church, but the supplements provided the texts for rituals of greater solemnity than were performed in other lands or in the churches of other orders. Because they are equally important in all lands and for all religious orders, the great lunar-cycle feasts of the universal church do not appear in the supplements.

In examining sixteen to twenty books of this sort about ten years ago, I was able to find definite feast days for eighty-two santero subjects. Since eleven of these subjects appear in both supplements and are counted twice, the eighty-two turns into ninety-three. The following pattern emerged: One third (29 of 93, 31%) occur only in the universal calendar; another third (34 of 93, 36%) occur in the Spanish-Empire supplement (and perhaps also in the universal calendar and/or the Franciscan supplement); and a final third (30 of 93, 32%) occur in the Franciscan supplement (and perhaps also in the universal calendar and/or the Spanish-Empire supplement).[1]

Note

1. See Larry Frank, *New Kingdom of the Saints* (Santa Fe: Red Crane Books, 1992), 16. —The study on which this Addendum is based includes many more santo subjects that the body of Appendix D does, restricted as the latter is to subjects appearing twice or oftener in the sample of a thousand.

Appendix E

MOTIVATIONAL CHART

I created the following chart after reading David Birch and Joseph Veroff, *Motivation: A Study of Action* (Belmont: Brooks-Cole, 1966) and Abraham Maslow, *Motivation and Personality* (New York: Harper and Row, 1970), adding a few particulars to suit it to a peasant culture and devising some subdivisions to contain specific New Mexican Hispanic concerns. The number that follows a saint's name designates the number of times his or her santo occurred in the sample of a thousand.

It is divided into two main sections, the first dealing with individual needs, the second with social. The three subdivisions of "individual" deal with sensation, curiosity, and achievement; the three subdivisions of "social" are affiliation, power, and aggression. Within each of these six subdivisions there is a further cleavage into negative (fears) and positive (hopes).

1.	INDIVIDUAL
1.1	SENSATION
1.11	NEGATIVE
1.111	vs. hunger: Isidro 14
1.112	vs. earthquake, storms, etc.: Trinidad 13, N S Candelarias 22, Bárbara 16
1.113	vs. sickness

general: Niño Atocha 26, Corazón 9, N S Socorro 2, Benito, Juan de Dios, Rita Casia 18 (perhaps for impossible cases)

special: of throat: Blas 0
 of teeth: Apolonia 1
 of eyes: Rafael 30, Lucía 0
 of ears: Policarpio
 of skin: Roque 3
 plague: N S Manga 1, Roque 3, Rosalía 12
 burns: Lorenzo 5
 hemorrhages: Verónica 8
 poison: Benito
 of mind

1.114 vs. intemperance: N S Purísima Concepción 21, Luis Gon-
 zaga 1, Inés 2, María Magdalena 1
1.115 vs. death in state of sin: José 59, Pedro 6, Vicente 2,
 Flagelante Espectral
1.1151 vs. lightning: Gerónimo 13, Bárbara 16
1.12 POSITIVE
1.121 sex and fertility: Antonio 73, Felicia
1.1211 help in childbirth: N S Dolores 53, N S Manga 1, Ramón 22
1.122 rain: Juan Bautista 1, Isidro 14, Lorenzo 5
1.1221 irrigation: Juan Nepomuceno 30
1.123 crops, food: Isidro 14, Lorenzo 5, Santiago 14
1.124 animals used for food: Antonio de Padua 73, Francisco de
 Asís 20, Juan Bautista 1, Procopio 2, Inés 2
1.125 exercise and relaxation
1.1251 work: Isidro 14, José 59
1.1252 play: Cayetano (for gambling) 8, Luis Gonzaga (for dancing) 1
1.126 sleep
1.127 aesthetic, sense of symmetry
1.2 CURIOSITY
1.21 NEGATIVE
1.211 vs. ignorance (see studies, below)
1.212 vs. boredom (see play, above, and all affiliative, below)
1.213 vs. weakness in the face of the unknown: N S Afligidos, N
 S Carmen 24, N S Guadalupe 50, N S Luz 0, N S
 Purísima Concepción 21, Miguel 34, Rafael 30, Ger-
 ónimo 13
1.22 POSITIVE
1.221 studies: Tomás 1, Gertrudis 15
1.222 more unitary understanding of cosmos, being comfortable
 in nature; enlightenment: Trinidad 13, Padre Dios 3;
 mystical experience
1.223 faith: Trinidad 13, Corazón 9, Tomás Apóstol, Rosa Lima 2,
 Teresa Avila 5
1.3 ACHIEVEMENT
1.31 NEGATIVE
1.311 vs. guilt feelings (see shame and sinfulness, below)
1.312 vs. sinfulness (see shame and sinfulness, below)
1.313 vs. failure in enterprises (see being comfortable in nature,
 above)
1.314 vs. violation of ownership by loss or straying
1.3141 of animals: Juan Bautista 1, Pasquale 0

1.3142	of things: Antonio 73 (and animals, probably)
1.3143	of land: perhaps Ramon Nonato 22
1.32	POSITIVE
1.321	ownership, amassing wealth
1.322	self-satisfaction, self-esteem
1.323	value commitment
1.324	hopes and plans for distant future
2.	SOCIAL
2.1	AFFILIATION
2.11	NEGATIVE
2.111	vs. shame: Jesús Nazareno 21, Jesús Cargado 5, Crucifijo 81
2.112	vs. sinfulness in self and others: Jesús Nazareno 21, Jesús Cargado 5, Crucifijo 81, N S Refugio 10, Acacio 16, Adan y Eva, Gerónimo 13, Librada 9
2.113	vs. loneliness: N S Soledad 14
2.114	vs. effects of death in family: N S Dolores 53, N S Rosario 9, N S Soledad 14
2.12	POSITIVE
2.121	mutuality (including ownership of common lands);
2.122	belonging to tradition; at-home feeling; loving and being loved and esteemed; caring for and being cared for: Gabriel 9
2.123	fulfilment of duties
2.1231	to church
2.1232	to nation or race: N S Guadalupe 53
2.1233	to morada, including humble anonymity: Juan Nepomuceno 30, Ramón 22, Flagelante Espectral
2.1234	to village
2.1235	to family: Desposorios, Santa Parentela, Sagrada Familia 13, Francisco Asís 20, José 59
2.12351	as child: Estanislao 3, Felipe de Jesús 3, Luis Gonzaga 1, Gertrudis 15
2.12352	as father: Padre Dios 3, José 59
2.12353	as mother: Ana 5, Rita 18
2.12354	in choice of husband: Antonio 73, Nicholas 1, Rita 18, Rosalía 12
2.2	POWER
2.21	NEGATIVE
2.211	vs. dependence on others who are not kind; for poor: Felipe Neri 2, Lorenzo 5, Margarita 3
2.212	vs. influence by others

2.2121 by witches: Benito, Clemente, Ignacio 11

2.2122 by devils: N S Angeles 3, N S Luz 0, Miguel 34, Rafael 30, Clemente

2.22 POSITIVE

2.221 fulfilment of interpersonal relationships of responsibility

2.2211 by self (see fulfilment of duties, above)

2.2212 by others toward self or kin Rita: 18 (husband to wife)

2.3 AGGRESSION

2.31 NEGATIVE

2.311 vs. opponents: Acacio 16, Longino 2, Santiago 14

2.3111 of welfare of community: Santiago 14

2.3112 of welfare of church: N S Cueva Santa, Gregorio 0, Pedro 6

2.3113 of welfare of family (children): N S Angeles 3, Angel Guardian 2

2.3114 of welfare of beggars, pilgrims, and other travelers: Huida a Egipto 2, Niño Atocha 26, Niño Perdido 4, N S Atocha 0, Rafael 30, Angel Guardian 2, Cristobal 4, Inés 2

2.3115 of welfare of captives: N S Merced, Niño Atocha 26, Niño Perdido 4, N S Atocha 0, Pedro 6

2.312 vs. anxiety

2.313 vs. frustration

2.32 POSITIVE

2.321 for tolerance of frustration, acceptance: Jesús Nazareno 21, Jesús Cargado 5, Crucifijo 81, Job

2.322 for safety, security, protection, peace: Trinidad 13, N S Rosario 9, Domingo 1

Index

This Index does not include material from the Appendices, each of which is ordered in its chronological, alphabetical, or logical way.